LANDSCAPE
PHOTOGRAPHER OF THE YEAR
COLLECTION 6

Editor: Donna Wood
Designer: Tracey Butler
Image retouching and colour repro: Jacqueline Street
Production: Lorraine Taylor

Produced by AA Publishing
© AA Media Limited 2012

Published by AA Publishing (a trading name of AA Media Limited,
whose registered office is Fanum House, Basing View, Basingstoke RG21 4EA;
registered number 06112600).

A04934

ISBN: 978-0-7495-7365-2

A CIP catalogue record for this book is available from the British Library.

The contents of this book are believed correct at the time of printing. Nevertheless,
the publishers cannot be held responsible for any errors or omissions or for
changes in the details given in this book or for the consequences of any reliance
on the information provided by the same. This does not affect your statutory rights.

Caption information has been supplied by the photographers and the publishers
accept no responsibility for errors or omissions in the details given.

Printed and bound in Italy by Printer Trento SRL.

theAA.com/shop

CATHY ROBERTS ⋯⟩

Winter
Kent, England

I love the way snow transforms a landscape, reducing it to its fundamentals and removing
any extraneous detail. This was taken during last year's snowy spell and I knew, as I was
standing with my camera and no gloves, freezing and excited, that I had the elements
of an image that would sum up the simplicity and the strangeness of the world after an
overnight snowfall. The location is close to my home so I visit it frequently and photograph
it in various conditions, but winter is always my favourite!

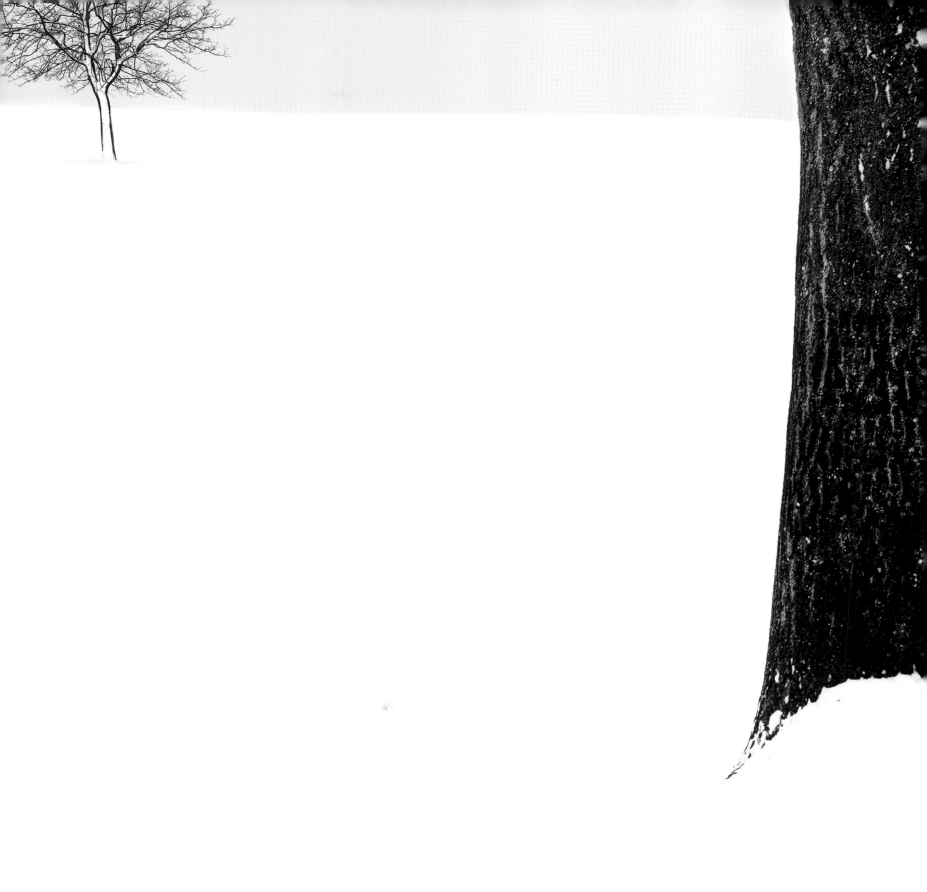

CONTENTS

KEVIN SKINNER ⋯⟩

The Way to You
Union Canal near Linlithgow, Scotland

I came across this romantic scene along the Edinburgh & Glasgow Union Canal; somewhere I had walked hundreds of times. This time, the mist hung still in the early morning air, the trees were as green as I've ever witnessed and the wild garlic blossomed either side of the path as if guiding the way to some distant love just around the curve of the canal – maybe over the picturesque bridge that hung over the glassy waters.

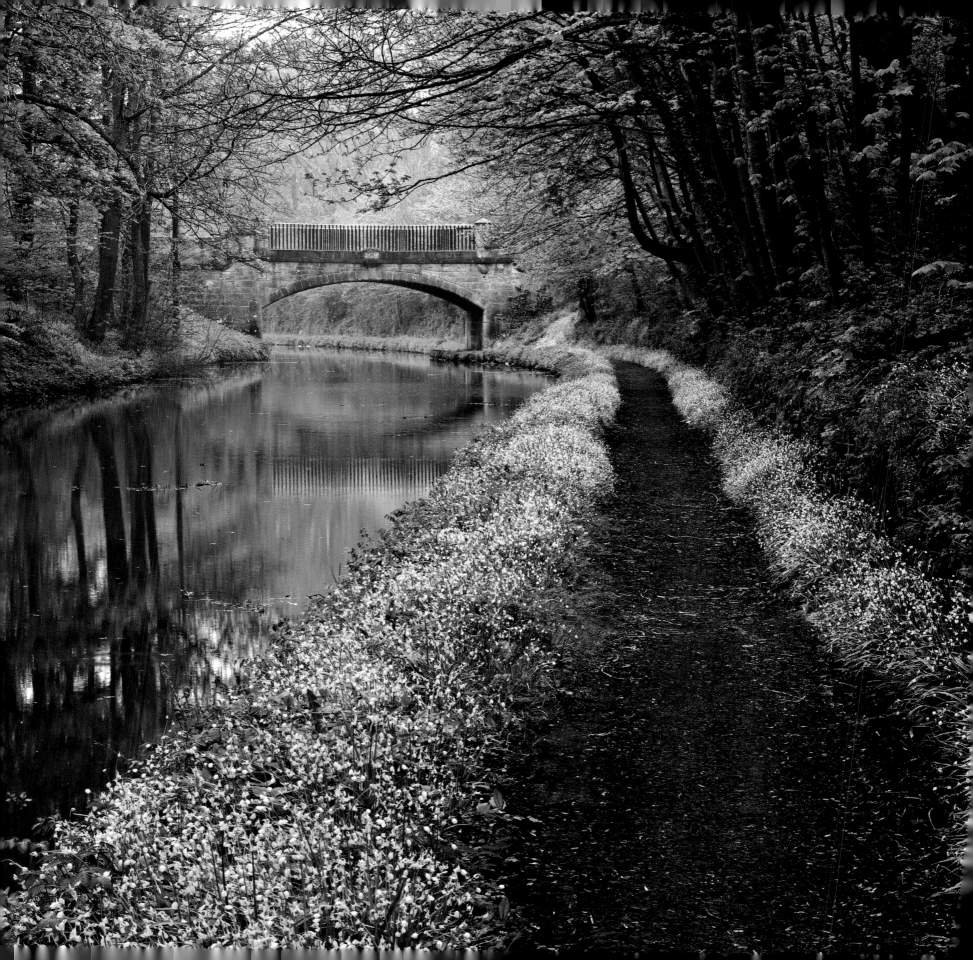

INTRODUCTION

THE COMPETITION

Take a view, the Landscape Photographer of the Year Award, is the idea of Charlie Waite, one of today's most respected landscape photographers. In this, its sixth year, the high standard of entries again proves that the Awards are the perfect platform to showcase the very best photography of the British landscape. This year's Awards would not have been possible without the invaluable help and support of Network Rail.

Open to images of the United Kingdom, Isle of Man and the Channel Islands, Take a view is divided into two main sections, the Landscape Photographer of the Year Award and the Young Landscape Photographer of the Year Award. With a prize fund worth a total of £20,000 and an exhibition of winning and commended entries at the National Theatre in London, Take a view has become a desirable annual competition for photographers of all ages.

All images within this book were judged by the panel as Commended or above, a high accolade and a very small percentage of the total entry.

www.landscapephotographeroftheyear.co.uk
www.take-a-view.co.uk

THE CATEGORIES

Classic view

For images that capture the beauty and variety of the UK landscape. Iconic views, from panoramic vistas and frosted trees to sumptuous lavender fields and summer flowers; all showing the drama of our seasons. Recognisable and memorable – these are true classics.

Living the view

Featuring images of people interacting with the outdoors – working or playing in the UK landscape. From children at play to a shepherd tending his sheep, these images illustrate the many ways in which we connect with our outdoor environment.

Urban view

Statistics suggest that up to 80% of the UK population lives in towns or cities. That's a huge number and this category highlights the surroundings that many of us live in every day. Contemporary buildings, such as London's Shard, vie for attention with traditional tenements and Bath's Royal Crescent and show that all landscapes matter.

Your view

What does the UK landscape mean to you? Sometimes intensely personal and often very conceptual, the parameters of this category are far-reaching, with images showing a whole range of emotions and perspectives. More digital manipulation is allowed in this category and images may not be precise representations of the physical landscape in every case. Details can be found in the technical information for each image.

KEY SUPPORTERS

www.networkrail.co.uk

WITH THANKS TO

AA Publishing
Natural England
VisitEngland
Light & Land
Amateur Photographer
Bayeux
Environment Films Ltd
Campaign to Protect Rural England
Outdoor Photography
Fujifilm
Páramo Directional Clothing Systems
What Digital Camera
Cooltide Interactive

SPECIAL PRIZES

The Network Rail 'Lines in the Landscape' Award
This Award is for the one photographer who best captures the spirit of today's rail network as it relates to the landscape around it. Entries had to be of the operational national rail network anywhere in Great Britain (excluding Northern Ireland).

The Epson 'Exceed your Vision' Award
New for this year, the Epson Award was won by the photograph that was felt best expressed Epson's strapline 'Exceed your Vision'. The judges were also looking for a quality that they felt would work particularly well in print at the exhibition.

The Sunday Times Magazine Choice
As media supporter of the Take a view Awards, *The Sunday Times Magazine* has always been the first to announce the results and to feature successful images from each year's competition. To celebrate this relationship, now in its sixth year, there is an Award for the favourite image of *The Sunday Times Magazine*.

The Calumet Photographic 'This is Britain' Award
This Award is for the image that, for Calumet, sums up the spirit and landscape of Britain in 2012. They were looking for something just a bit different; something that triggers an emotional response relevant to the times we live in today.

FOREWORD

BY DAVID HIGGINS,
CHIEF EXECUTIVE, NETWORK RAIL

This year has seen Britain showcased across the world, first with the Queen's Jubilee and then with the London 2012 Olympic and Paralympic Games. Vivid images of Britain in all its glory have also helped to remind us of all that makes this country a great place in which to live.

As I watched the television coverage and saw the pictures of the Olympic torch being carried across the length and breadth of the country, the wild flowers blooming at the foot of the Olympic Stadium, or the dramatic buildings of the Olympic Park nestled in the heart of vibrant London, it reminded me that Britain really is a photographer's dream. Different countries, bustling cities, tiny hamlets and far-reaching countryside with peaks, forests, lakes and agriculture; diverse doesn't quite cover it. Everywhere you turn, there is a landscape to capture.

I grew up in Australia but have lived here for more than 20 years and I try as much as possible to travel around Britain. I'm a keen hiker and take my camera with me whenever I go on a trip. The most marvellous thing about photography is that no matter where you go, or how many times, the view always changes. Your photograph is evidence of that moment in time, and no one else will ever have it.

Of course, you can reach most of these places by rail and it's one of the reasons why I am proud that, for the third year running, Network Rail has sponsored the *Take a view* competition. Travelling by rail enables you to take a snapshot, in your mind if not with your camera, of all the places on your journey, the train windows framing the landscape.

Network Rail owns a rich hertiage of bridges, viaducts, stations and other structures dating from the Victorian era. While they don't always make the railway easy to run, they provide a rich history and a beautiful backdrop for our modern railway. I think it's this combination of the past and the present that is behind the deep and ongoing affection for the railway in this country and why, each year, we have seen so many spectacular photographs of our railway — an interest and affection underlined by the phenomenal response to the virtual archive we, in Network Rail, launched earlier this year.

Thank you to everyone involved in *Take a view* 2012, from the organisers to the contributors, for yet another stunning competition.

COMMENT

BY AWARDS FOUNDER,
CHARLIE WAITE

The sixth Landscape Photographer of the Year Award continues to celebrate the remarkable variety and diversity of the landscape in the UK and, once again, brings to an ever-growing audience images that many thousands of people are able to wonder at and relish.

It has always been my wish to encourage people to engage with the landscape. Using the camera as a catalyst, to induce that very personal and often very emotional connection between photographer and landscape, has always seemed to me to be the most natural and obvious method to get closer. I have heard some suggest that to photograph 'things' possibly separates the photographer from the experience, but I would strenuously refute this. With rural landscape in particular, the photographer will be monitoring and observing numerous changing circumstances, from the play of light upon a valley to the way in which a breath of wind may disrupt an immaculate reflection and at the same time turn a swathe of corn into a swirling sea of gold. The photographer may be locked on to the sky and will be marvelling perhaps at a ravishing dawn or bemoaning the fact that the sky that appeared to be gifted has now disintegrated, preventing the image from being accomplished in the way that they wished.

The architectural photographer will care deeply about the way in which surfaces of a building may reflect or absorb light and will perhaps find great pleasure from the aesthetics of a building's order or symmetry. The photographer who is intrigued by the minutiae may happily endure considerable discomfort to convey an image of a frond of bracken encapsulated, for a brief time only, in a constricting case of frozen water. The compelling desire to make the image may well have come from the photographer's own reverence and sense of wonder at one of the many astonishing events that take place within the natural world that many pass by.

I very much hope that the categories within the Landscape Photographer of the Year competition will have continued to provide every photographer with the opportunity to find their particular niche. Within the pages of this, 'their' book, I feel there is overwhelming evidence of this being the case. We, the viewers of these images, will ponder, I hope, on all that preceded the final results and if, through gazing at them, we are able to be transported in some way to that same place where they stood and if we may receive something of that same response that the photographer enjoyed, then surely the photograph will have fulfilled its purpose and we will emerge from the exchange all the richer.

Over the last six years of Landscape Photographer of the Year, the many photographers who have been successful have found that their photography has, as a result, reached a wider audience. It is not hard to imagine how delighted I am to learn of their success.

Photography has evolved in a way that the early pioneers of over 180 years ago could never have imagined. It has permeated into so many aspects of our lives, with many millions of pictures being made and shared every day through social networking sites and beyond. Yet, despite this flood of images, I am enormously gratified that Landscape Photographer of the Year has once again upheld the high standards of photography that I saw when I began the competition. My fervent hope is that photographers from this country and further afield will continue to delight in photographing within and around our much-loved United Kingdom and, in doing so, will reveal corners that many of us may never otherwise have an opportunity to see.

Through their photography, we are reminded of the rich treasures that our precious landscape provides and my gratitude goes out to all who have raised the camera to their eye and seen and brought their fine images home to us.

THE JUDGES

Damien Demolder
Editor
Amateur Photographer magazine

Damien Demolder is the editor of *Amateur Photographer* magazine, the world's oldest weekly magazine for photography enthusiasts, and a very keen photographer too. He started his photographic professional life at the age of 18, but since taking up the editorship of the magazine he has been able to return to his amateur status – shooting what he likes, for his own pleasure.

With interests in all areas of photography, Damien does not have a favourite subject, only subjects he is currently concentrating on. At the moment his efforts are going into landscapes and social documentary. When judging photography competitions Damien looks for signs of genuine talent or hard work. Originality is important, as is demonstrating a real understanding of the subject and an ability to capture it in a realistic manner. He says 'Drama is always eye-catching, but often it is the subtle, calm and intelligent images that are more pleasing and enduring.'

Charlie Waite
Landscape Photographer and Awards Founder

Charlie Waite is firmly established as one of the world's most celebrated landscape photographers. He has published over 30 books on photography and there have been many solo exhibitions of his work across Europe, the USA, Japan and Australia, including three very successful exhibitions in the gallery at the OXO Tower in London.

His company, Light & Land, runs courses, tours and workshops worldwide that are dedicated to inspiring photographers and improving their photography. This is achieved with the help of a select team of specialist photographic leaders.

He is the man behind the Landscape Photographer of the Year Awards and they tie in perfectly with his desire to share his passion and appreciation of the beauty of our world.

Monica Allende
Picture Editor
The Sunday Times Magazine

Monica started her career in publishing, commissioning travel photography where sourcing idyllic landscapes was the main objective. For the last 11 years she has been Picture Editor for *The Sunday Times Magazine.*

Although she works with images every day of her life, Monica still gets excited about the variety and creativity of photography and likes to champion up-and-coming photographers. She is interested in the increasing accessibility of photography and the changing attitudes of young people towards the art.

She likes extreme landscapes; raw nature that gives a feeling of infinity and appears unchanged by the human hand. Her favourite element is water and so the coastal landscape, particularly of North Devon and Cornwall, has provided her with unforgettable visual images, but as an urbanite born and bred among concrete, the urban landscape speaks to her in a familiar language.

David Watchus
Head of AA Media

David is responsible for the online and offline delivery of AA Media's extensive content across its core areas of UK travel, lifestyle, maps and atlases and driving titles; areas in which the AA has many market-leading titles.

His involvement in the Landscape Photographer of the Year competition dates back to its original conception and the AA's sponsorship of the first-ever competition. Stunning imagery of the British landscape is a key element of AA Media's future publishing strategy as it delivers a greater variety of engaging and informative content across an ever-growing number of diverse platforms, from books to apps and ebooks to online.

David Noton
Landscape and Travel
Photographer

David Noton is an award-winning landscape
and travel photographer who enjoys an
international reputation as one of the finest
in his field. His work is published throughout
the world.

During his 27-year career capturing
stunning images of our changing
environment, David has travelled to just
about every corner of the globe, exploring
deserts, rainforests, mountains, islands
and ice caps.

David enjoys sharing his ideas and
techniques with other photography
enthusiasts through media such as his
unique films, books, roadshows, the press
and the internet. His extensive knowledge,
enthusiasm and appealing character make
him a natural presenter on the subject.

John Langley
Director
National Theatre

John Langley is the Director of External
Relationships at the National Theatre, on
London's South Bank. Alongside its three
stages, summer outdoor events programme
and early evening platform performances,
the National has become renowned for its
full and varied free exhibitions programme.
Held regularly in two bespoke spaces,
these exhibitions are an important ongoing
part of London's art and photographic
scene. John is responsible for these shows
and has organised over 300 exhibitions
and played a significant role in presenting
innovative and exciting photography to a
wide and discerning audience.

When escaping from the urban bustle of the
capital, John particularly loves the coastal
scenery of the United Kingdom, with the
Pembrokeshire coast and Purbeck in
Dorset being particular favourites.

Robin Bernard
Director
Bayeux

Robin founded Bayeux, the London West
End pro-photo lab, 11 years ago and it is
still going strong today. He, his partners
and their company offer a wide range of
modern imaging techniques, together with
traditional darkroom skills and values.

He deals with every aspect of photographic
post-production, for every genre of
photographer. He has been heavily involved
in digital imaging since the early days in the
1990s but still enjoys getting his hands wet
in the darkroom, hand-printing black-and-
white fibre prints that remain popular.

Robin admires images that reflect the
tranquil peace of the British landscape,
but is inspired by technical excellence,
regardless of location.

Nick White
Epson UK

Nick's photographic life began with his
father's aerial photography company. From
a school holiday job in the black-and-white
darkroom, he later joined full time and was
involved in both commercial and aerial
photography, whilst running the in-house
processing facility.

It was natural that an appreciation of
aerial landscapes developed, and he feels
that this was the origin of his interest in
landscape photography today.

Nick's career switched to the trade side of
photography, with lengthy stints at Durst
and Fujifilm. For the last seven years he has
been part of the Epson large-format team,
whose speciality is photographic and fine
art printing.

A keen sailor for many years, Nick is based
on England's south coast. A former RNLI
crewman, he is the volunteer operations
manager of his local lifeboat station.

PRE-JUDGING PANEL

The pre-judging panel has had the difficult task of selecting the best images to go through to the final shortlist. Every image entered into the competition was viewed and carefully assessed before the resulting list was put through to face the final judging team.

JULIE CHAMBERLAIN, PHOTOGRAPHER

Julie has had a passion for photography for as long as she can remember. She grew up in a small town on the edge of the New Forest National Park, which provided her with plenty of photographic opportunities from an early age. Her professional career has been primarily within the stock photographic industry and she started out in the agency Landscape Only, which, as its name suggests, specialised in landscape photography and represented some of the UK's best-known names. From picture editor to picture research, Julie has worked in a variety of creative roles and has also had a number of her own images published. Julie is based in Brighton but enjoys travelling around the whole of Britain, taking pictures on the way.

TREVOR PARR, PARR-JOYCE PARTNERSHIP

Trevor's lifelong love of photography started at Art College. He became an assistant to a number of fashion photographers before setting up on his own in a Covent Garden studio. He moved into the stock/agency business, seeking new photography and acting as art director on a number of shoots. In the late 1980s he started the Parr-Joyce Partnership with Christopher Joyce, marketing conceptual, landscape and fine art photography to poster, card and calendar companies. Trevor also owned a specialist landscape library that was later sold to a larger agency. He now concentrates on running Parr-Joyce from his base in the south of England.

MARTIN HALFHIDE, DIRECTOR, BAYEUX

Martin is a co-owner and director of Bayeux, a professional imaging company that opened in 2001 and is now the largest in London's West End. With an extensive background in the pro-lab industry, he has experience in many technical areas. Martin was at London-based Ceta in the 1980s and then went on to be responsible for photographer liaison at Tapestry during the 1990s.

PAUL MELLOR, PHOTOGRAPHER

Paul has been a photographer all of his working life and has covered most disciplines from press to travel, as well as a spell in advertising still life. Until recently, he also owned a professional laboratory in London which enabled him to keep abreast of changes in photographic styles and techniques. The last few years have seen him move into the field of reportage, photographing the lives and environments of those living in developing countries. He has exhibited in London and the USA. Frequent commissions in Bahrain and Qatar are mixed with planned charitable projects in the more remote locations of Burma and Mongolia.

AWARDS FOUNDER: CHARLIE WAITE

AWARDS DIRECTOR: DIANA LEPPARD

MESSAGE FROM CHARLIE WAITE:

Once again, my enormous gratitude goes to Diana Leppard for her tireless devotion to Landscape Photographer of the Year. It is very much due to her that the Award, now approaching its seventh year, is truly embedded into the consciousness of the worldwide photography fraternity. Thank you so much Diana.

CHRIS GILBERT ···⟩

On Win Hill
Derbyshire, England

Fabulous late-afternoon January light on the edge of Win Hill in the Peak District reveals that the winter colours and textures can be just as enthralling as the most beautiful of summers. All they need is a great light.

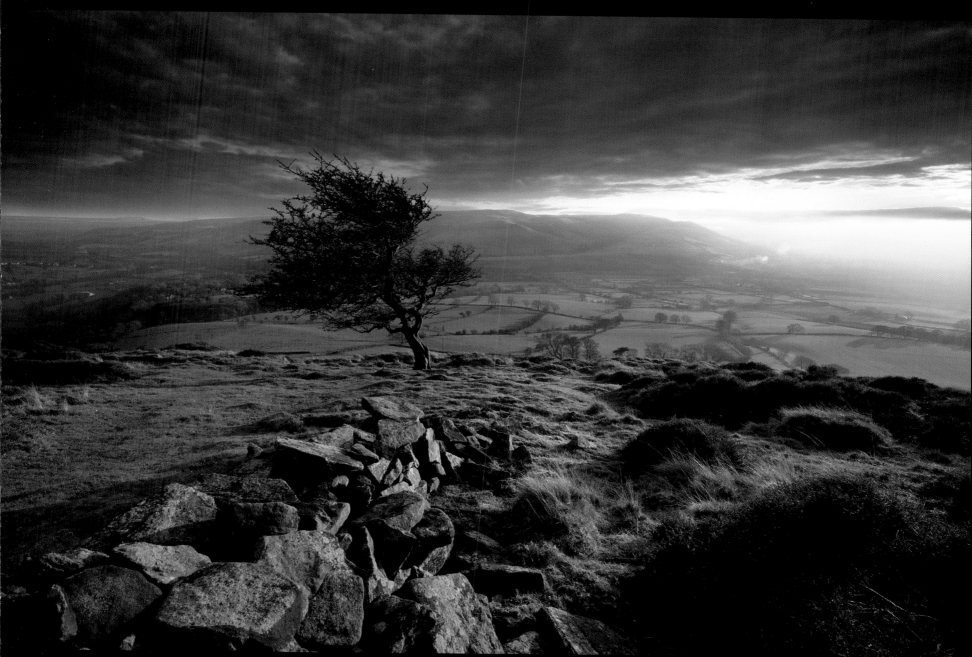

LANDSCAPE
PHOTOGRAPHER OF THE YEAR

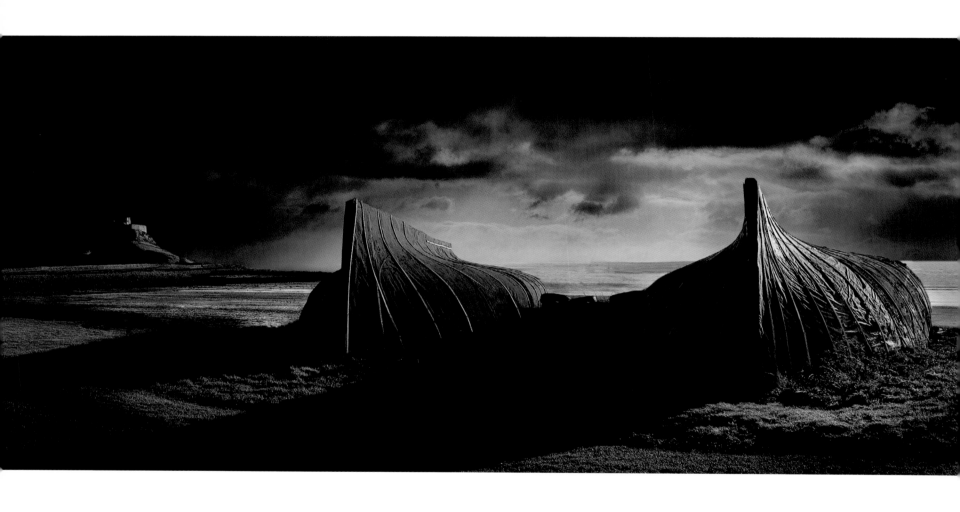

LANDSCAPE PHOTOGRAPHER OF THE YEAR 2012

OVERALL WINNER

⟵···▸ **DAVID BYRNE**

Lindisfarne
Northumberland, England

We stayed the night at Lindisfarne to catch the sunrise, which was a good job as the causeway to the town was covered by the sea. I had been wanting to get these shots for some time. It is an iconic place and these upturned boats, which have been made into fisherman's huts, are quite a sight to see.

Judge's choice Nick White

YOUNG LANDSCAPE PHOTOGRAPHER OF THE YEAR 2012

OVERALL WINNER

STEPHEN COLBROOK ┄┄▹

Man in the Fog
Oxford, England

I love the mysterious and unusual effect that fog creates. This photograph was taken while exploring the city of Oxford in an especially dense covering. The old architecture of the city took on a different, more ominous look from its usual romantic picturesque appearance. The old-style street lamps looked particularly eerie and added drama by creating deep shadows. The diagonal lines of the buildings, combined with the focal point of the lone and distant man, help to draw the viewer in.

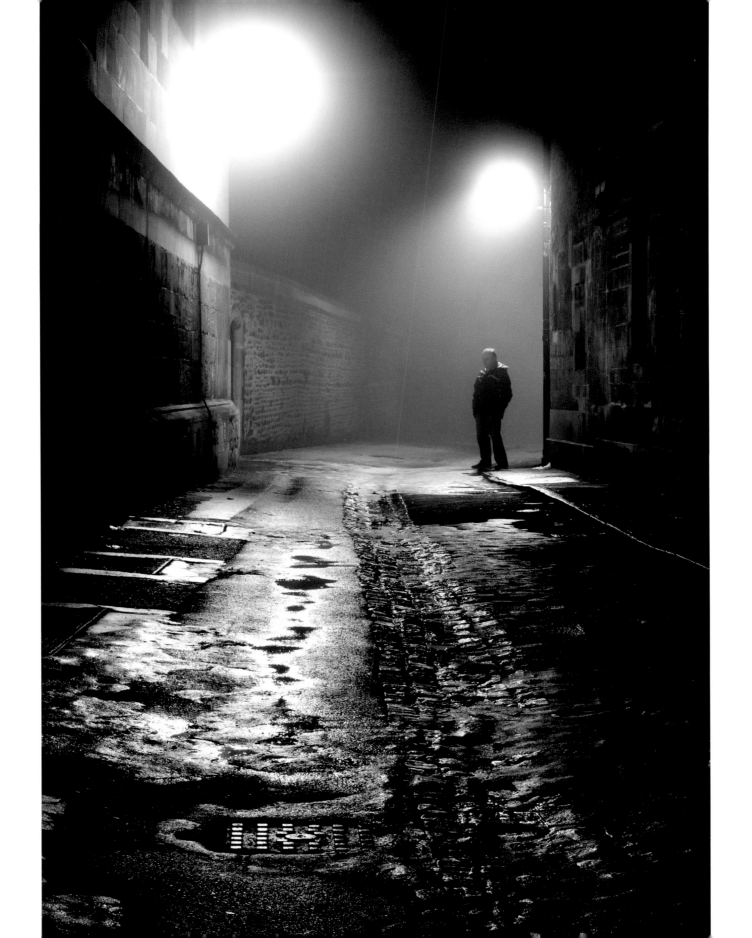

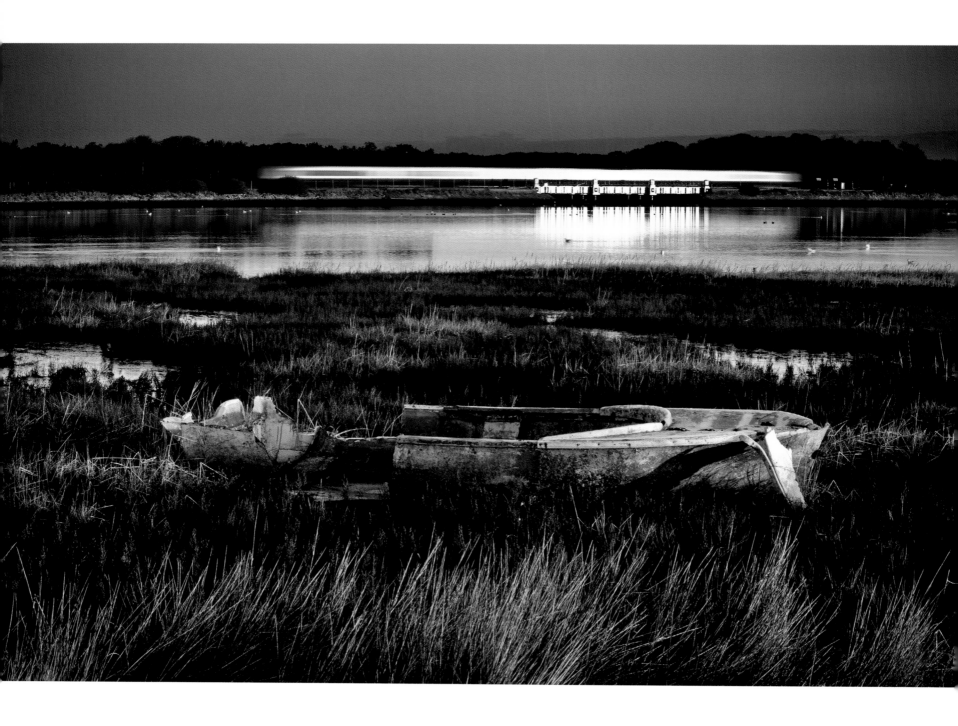

NETWORK RAIL 'LINES IN THE LANDSCAPE' AWARD

THE NETWORK RAIL WINNER

GRAHAM HOBBS

The 08:30 from Hamworthy crosses Holes Bay
Poole, Dorset, England

Although there are more photogenic wrecks around Poole Harbour, this fibreglass canoe, broken and going nowhere, made the right contrast with the sleek trains that cross Holes Bay. I had noticed previously that the rising sun hits the rail bridge full on in midwinter and the bridge reflects the light dazzlingly; this had the makings of a second point of interest strong enough to balance the wrecked canoe. I also knew that the trains left Hamworthy station every half hour – so all I had to do in theory was to get in position on a clear winter's morning before sunrise and wait for a train. The sun was not high enough for the 8am train, but the raking light half an hour later allowed just enough motion blur for the train to make the contrast with the wreck complete without totally blurring out its distinctive livery.

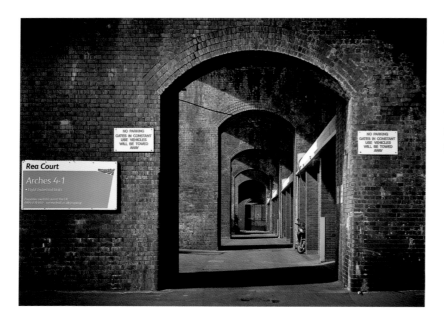

←··· GETHIN THOMAS

Railway Arches
Digbeth, Birmingham, England

This scene was spotted on a photo walk around Digbeth in Birmingham. I was struck by the receding arches and how they were perfectly lit in the morning sunshine. The light came from just the right angle to emphasise all the textures and colours in the brickwork.

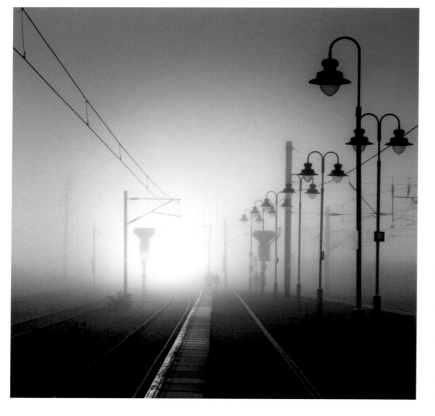

←··· ROHAN REILLY

Ely Train Station
Cambridgeshire, England

Taken at Ely station in Cambridgeshire whilst changing trains on a misty day in December. The various lines and striking lamps leading into the thick fog captured my attention.

MARK VOCE ···→

Over the Rooftops of Halifax
West Yorkshire, England

The afternoon train heads out of town over the viaduct past the rows of terraced houses, mills and chimneys so stereotypical of a northern factory town. These landscapes are changing. Once the centre of commerce and industry, many have fallen into ruin and decay, often demolished to make way for new developments, but a lucky few soldier on.

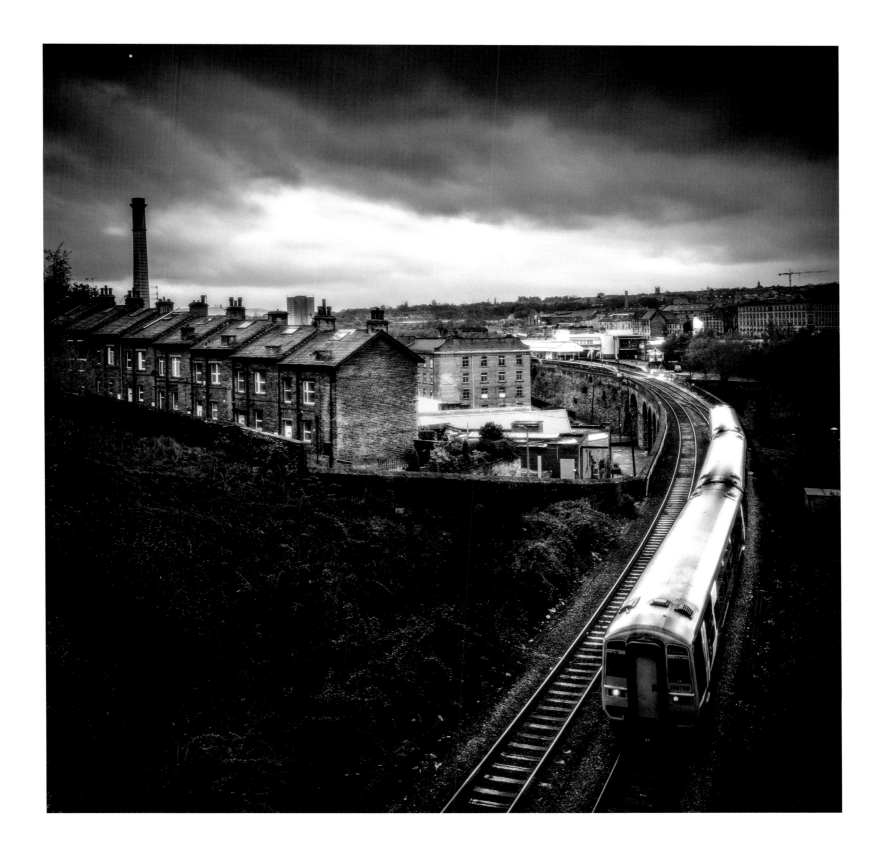

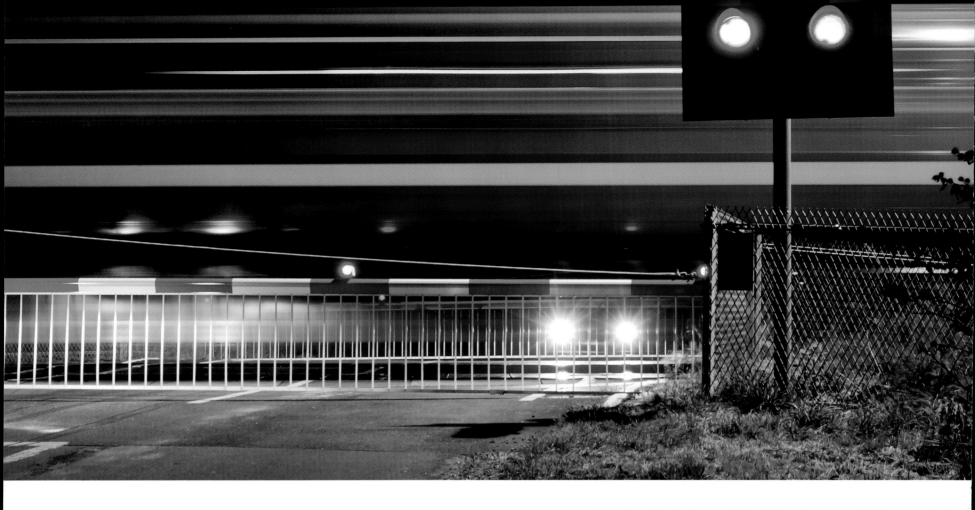

✝ MARTYN BUTTON

800 Milliseconds
Near Newark-on-Trent, Nottinghamshire, England

On a quest to capture images which gave a sense of speed, I ventured out to a local East Coast Mainline rail crossing late in September. Not having a timetable available, I had to wait for each train and tried different shutter speeds each time to see which captured the speeding trains best. The shutter speed which seemed to give the most pleasing result was between a half and one second. This captured the speed and retained sufficient abstract colour of the train.

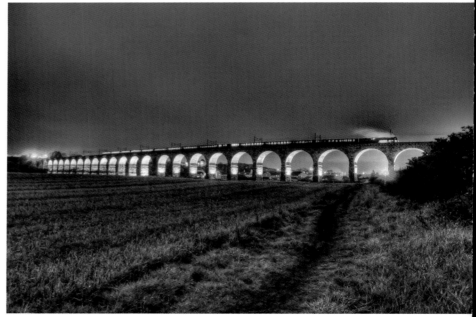

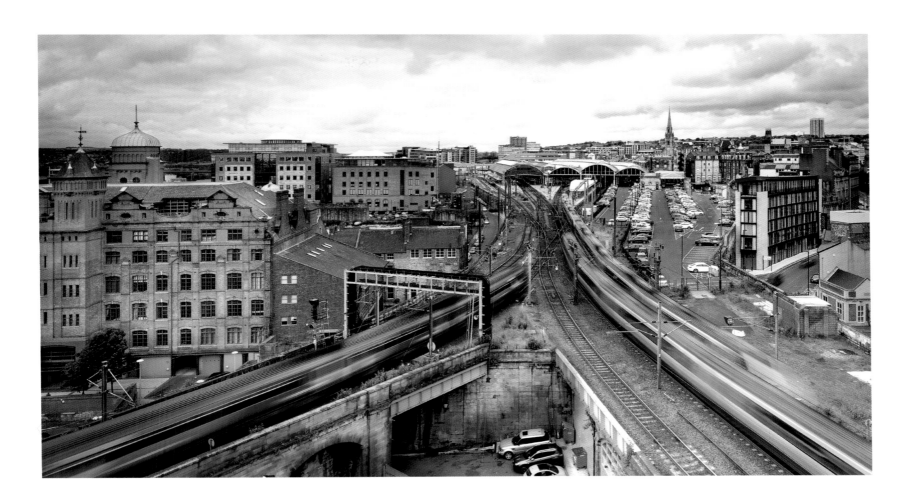

← JACK BEESTON

Crossing the Border
Berwick-upon-Tweed, Northumberland, England

To celebrate the 175th anniversary of the Royal Border Bridge at Berwick-upon-Tweed, the 28-arched architectural masterpiece was spectacularly illuminated in a myriad of colours to show the structure in all its glory. A sneak preview was arranged to coincide with a railway touring company using the world's newest mainline steam locomotive *Tornado* taking a train from Edinburgh back to York. Here we see the train paused on the bridge to display to the assembled spectators what a truly magnificent atmosphere can be achieved using the simple medium of coloured lights and well-chosen subjects.

↑ DAVID BREEN

Energetic 'Toon'
Newcastle upon Tyne, England

The energy of Newcastle is very concentrated due to its compact size. I wanted to get on top of it, to capture its essence. The Castle Keep is the original 'New Castle on the Tyne' from the 13th century, from whence comes the city name. It also has an impressive standing overlooking the quayside and Central Station; a perfect location from which to make this image. Rail features heavily in the region's past and adds so much to the 'energy', with multiple bridges crossing the Tyne, tracks cutting through the city centre and delivering the many visitors who love this special place...The Toon.

⟨··· CLAIRE CARTER

Barmouth Bridge
Wales

Barmouth Bridge taken at dawn from the sands below as the train passes by with carriage lights on. Long exposure set to give a sense of movement.

HILARY BARTON ···⟩

The *Princess Elizabeth* Salutes Queen Elizabeth
London, England

This photograph shows the start of the Royal River Pageant on 3 June 2012. The whistle of the steam locomotive LMS Princess Royal Class 6201, the *Princess Elizabeth*, on Battersea Railway Bridge signalled the start of the pageant, just as the launch with the Queen and Prince Philip (the small boat almost in the centre of the picture) passed underneath it. It was a thrilling and emotional moment! The locomotive was new in 1933 and was named after the then seven-year-old Princess Elizabeth, now Her Majesty the Queen. You can just see the first few hundred boats of the river pageant mustering in the distance in front of Battersea Reach.

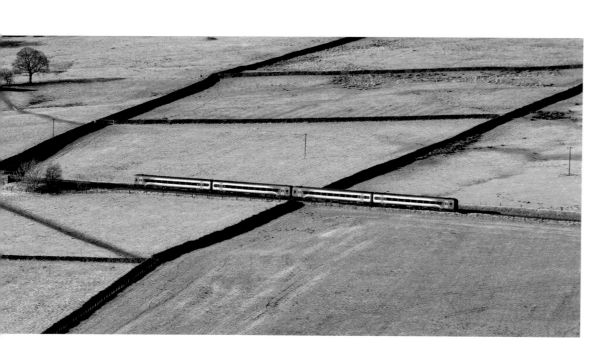

⟨··· KASIA NOWAK

Vale of Edale
Derbyshire, England

I noticed this train while walking from Mam Tor to Lose Hill on a sunny February afternoon. It reminds me of a colourful caterpillar on a green leaf with prominent veins – the dry stone walls.

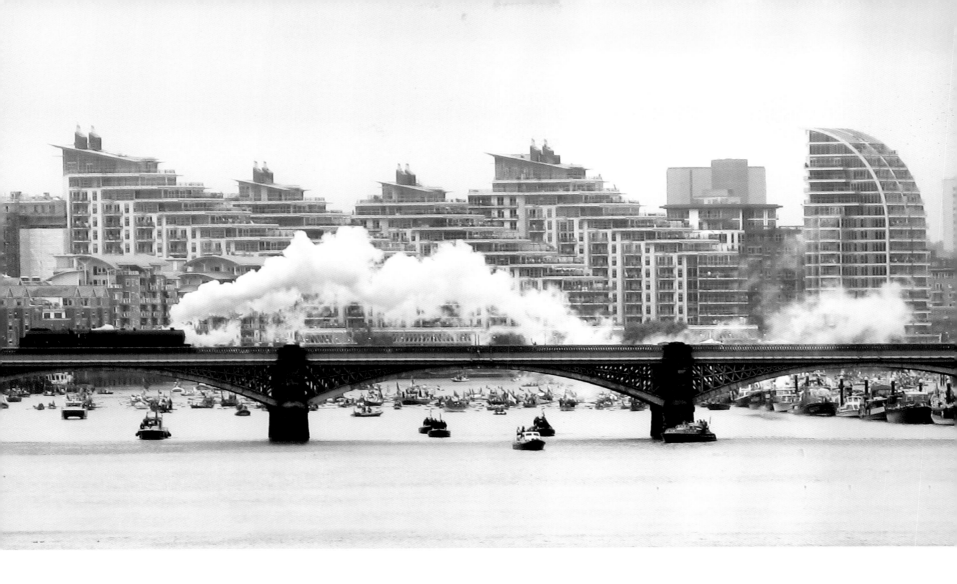

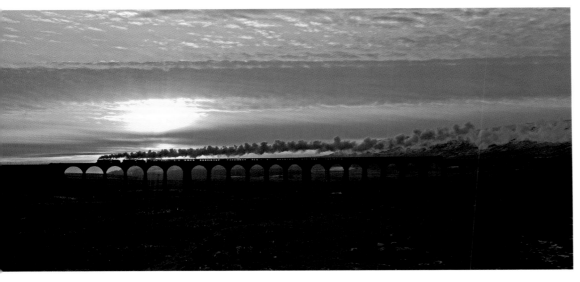

GRAHAM ROOSE

Winter Sunset at Ribblehead Viaduct
North Yorkshire, England

Ribblehead is about an hour's drive from my home and, on my many visits to the area, I have noticed a limestone outcrop near the viaduct. I wondered what the view would be like from this location at sunset in January, as the sun would be shining through the viaduct. I was expecting a steam-hauled train at around sunset, so decided to sit and wait. The sun was shining intermittently into my camera lens. When the train arrived, I was pleased that the sun stayed behind the clouds, reducing the flare into the lens.

CLASSIC VIEW
adult class

CLASSIC VIEW ADULT CLASS WINNER

DAVID BYRNE ···⟩

Delamere Forest
Cheshire, England

I'd seen this group of trees on the web and thought that it would look quite unusual if photographed in infra-red. The lake was frozen solid and, with the long shadows from the winter sun, gave the place an unearthly feel. I tried to get the wrap-around effect of the tall trees by using a wide-angle lens. The Nikkor 10-24mm lens lends itself to IR photography very well, not suffering from any hot spots.

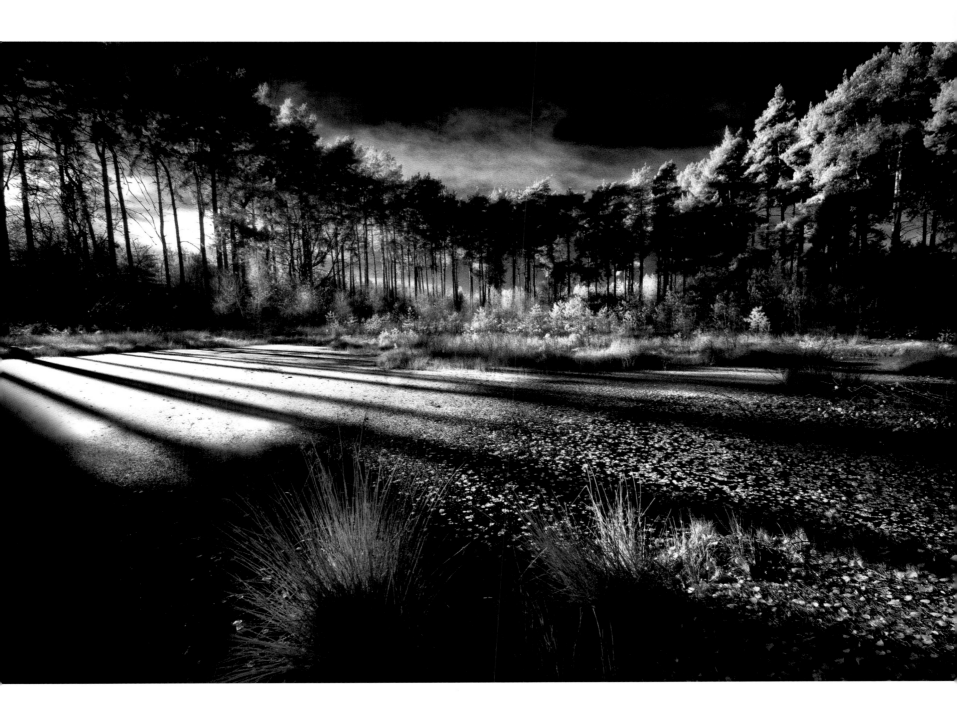

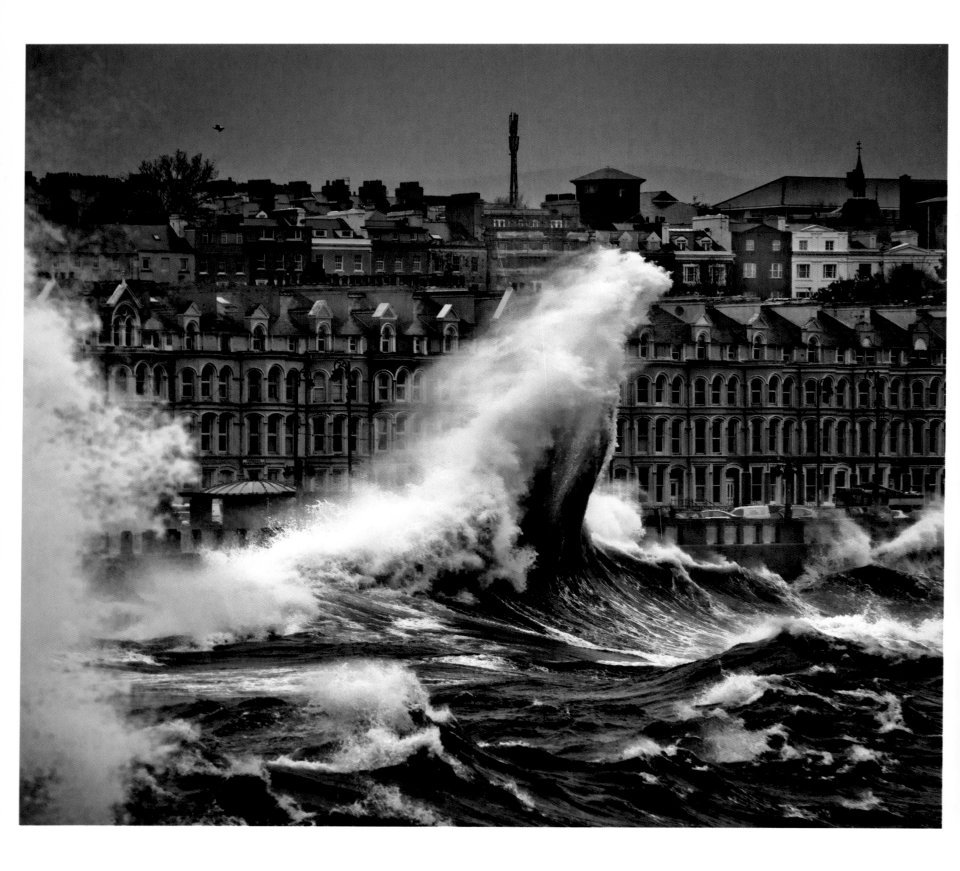

CLASSIC VIEW ADULT CLASS RUNNER-UP

SIMON PARK

The Wave
Douglas, Isle of Man

This is Douglas Promenade and the energy and movement of the sea on this particular day was amazing. I was ready and waiting and got many good frames before I heard a thunder clap and reacted instinctively, tripping the shutter...

Judge's choice John Langley

STEVEN HORSLEY　　　　　　　　HIGHLY COMMENDED

Tranquillity in the Snow
Chatsworth, Derbyshire, England

I originally set out to photograph people sledging in the snow but, on the way up the hill, I noticed this group of trees and liked how the road cuts into the scene. I just love the simplicity and composition of this shot. This road, well travelled by me over the years, cuts through the Chatsworth estate and links the urban dwellers of Derbyshire and Nottinghamshire to the splendid offerings of the Peak District National Park.

Judge's choice Monica Allende

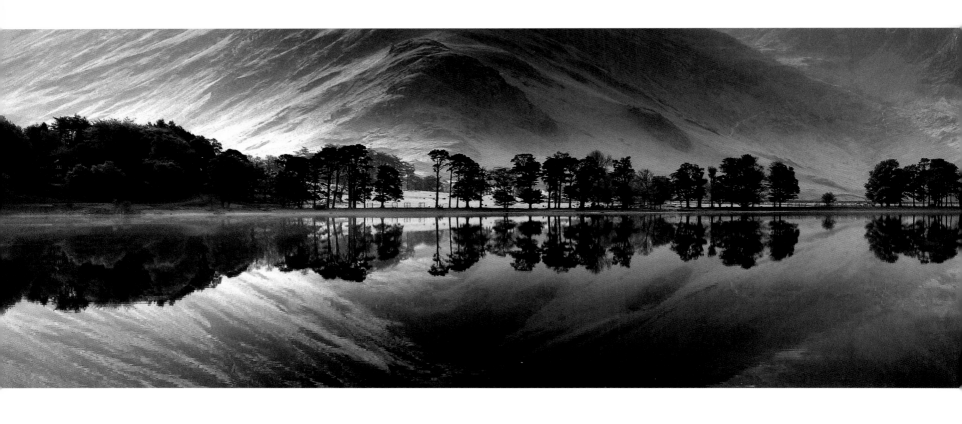

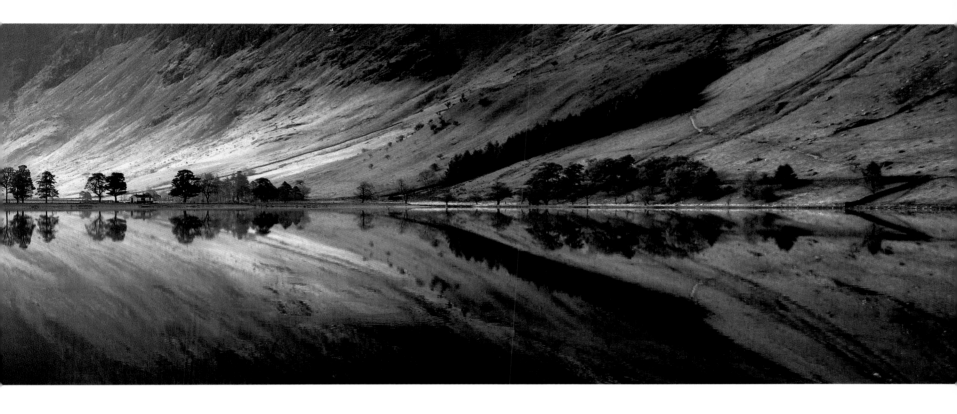

TONY SIMPKINS HIGHLY COMMENDED

Buttermere
Cumbria, England

Early morning photography in the Buttermere valley can be fraught with anxiety, frustration or disappointment but, if you're lucky, it can be an experience you will never forget, no matter how many times you visit this wonderful place. In May, when this picture was taken, the sun rises to the northeast so, since for this view the camera is pointing to the southeast, the early sun was not a problem as it can be in December. Anxiety arose out of deciding how long to wait for what might be the best light. The longer the wait, the more likely was the arrival of the breeze which nearly always follows the early calm; the reflections would disappear and the whole point of the shot would be lost. I was lucky and was rewarded with what is, in my opinion, one of the great sights of Lakeland.

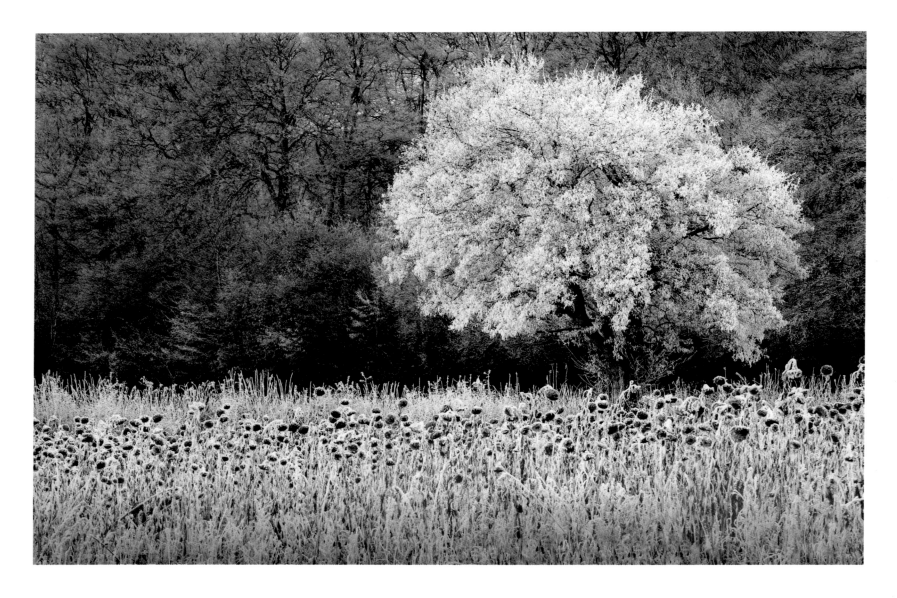

PAUL KEENE HIGHLY COMMENDED

Frosty Sunflowers
The Chilterns, Buckinghamshire, England

This picture was taken in the Chilterns, near to where I live. The owners of the field had turned it into a nature reserve, planting sunflowers in summer and leaving them to seed over the winter. This was clearly a great success because the area was awash with migrant finches when I took this picture. The sunflower heads also made an interesting foreground, as we had a marvellous hoar frost.

ANGUS CLYNE ···> HIGHLY COMMENDED

Beech Trees
Kinclaven, Perthshire, Scotland

This beech tree is not far from home and is in a spot I visit frequently; great for bluebells in spring and also good for autumn colours. I went there to get this picture, having waited weeks for the right combination of fresh falling snow, bright morning sunlight and mist that would even out the light in the forest. The biggest problem I had was getting my tripod steady without disturbing the thick carpet of beech leaves.

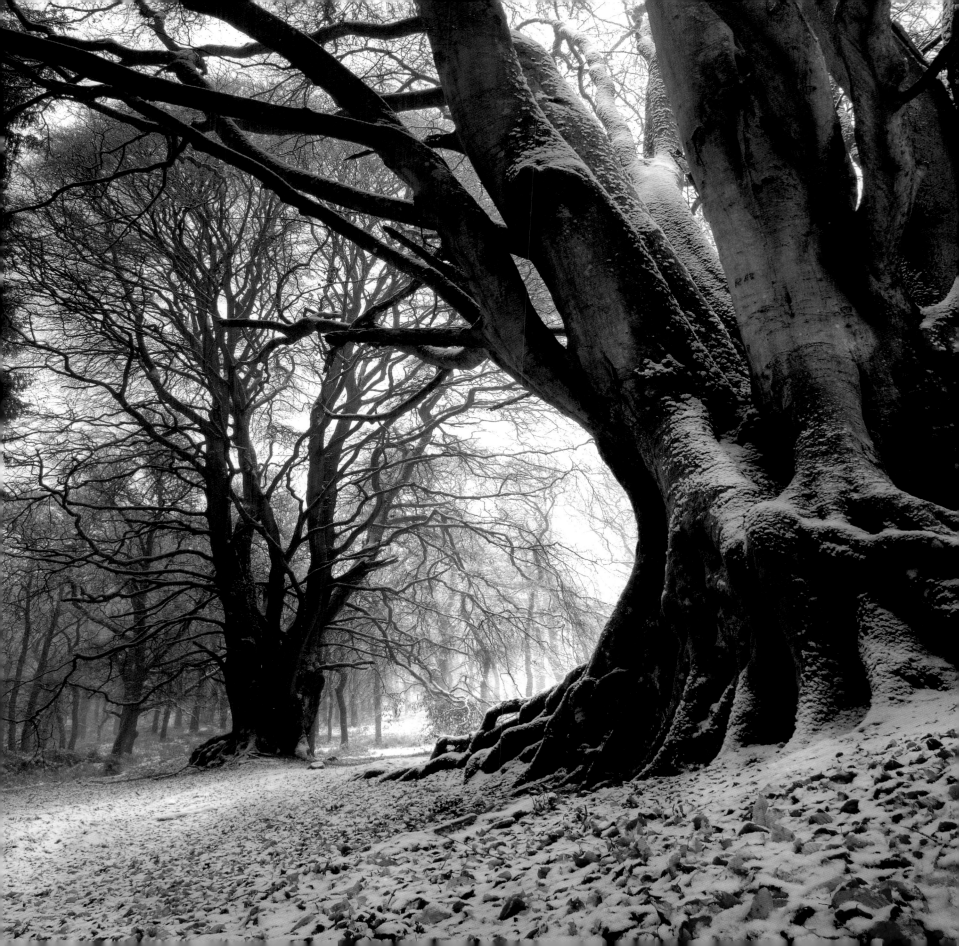

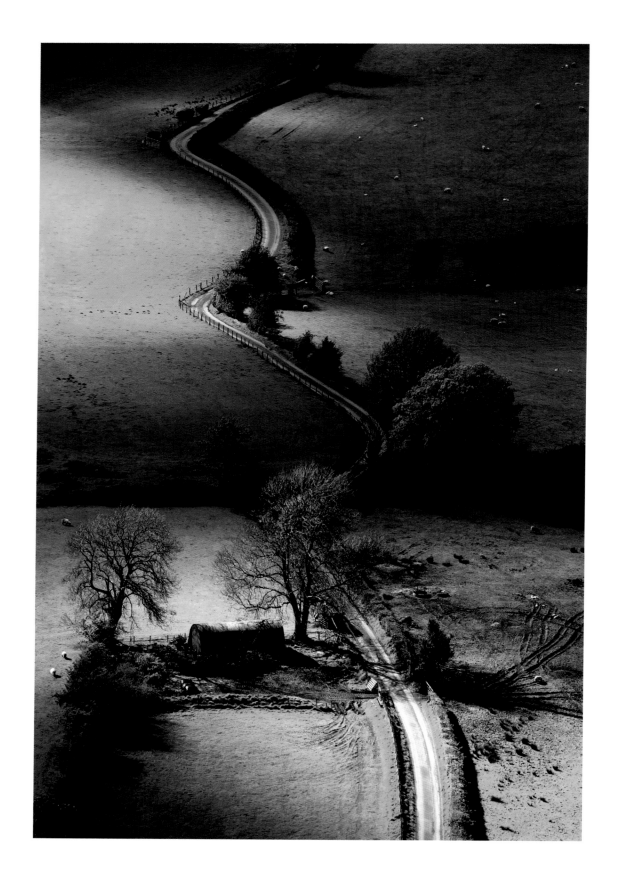

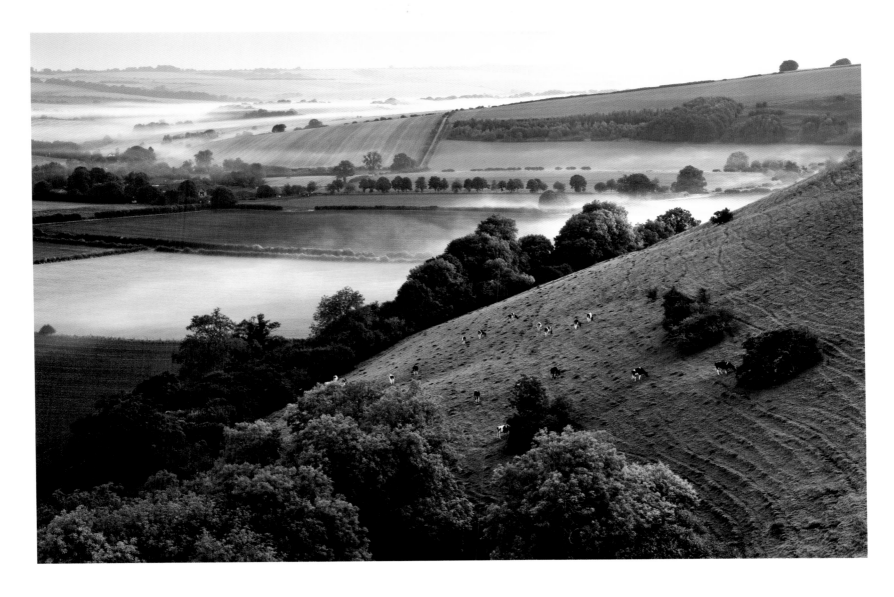

JOHN FINNEY

Newlands Valley
Cumbria, England

I was climbing Cat Bells with two friends and their children on a breezy day in the English Lakes. Whilst taking a break, I noticed the strong rays of light poking through the heavy clouds and working their way along Newlands Valley, west of Skelgill Bank, which is the long ridge leading up to Cat Bells fell. Watching the rays of light catching the fresh spring grass, I noticed an excellent opportunity for a picture and waited for the light to shine on the old rusty tin barn, with an eye-catching twisty lane running along the valley floor.

Judge's choice Robin Bernard

KEN LESLIE

HIGHLY COMMENDED

Grazing Cattle
Marleycombe Hill, Wiltshire, England

This image is a result of using home advantage. I'd got up early for a dawn outing but, once out of the house, some unexpected but welcome early mist called for a change of plan. A quick rack of my brains provided plan B, which was shortly replaced with plan C on realising the mist was very localised. So I headed to one of my favourite spots on nearby Marleycombe Hill, where I knew I could make the most of the conditions. When I arrived the sun's rays were just beginning to reach into the valley. As a bonus, the grazing cattle had thoughtfully arranged themselves to give some scale to a very pastoral scene.

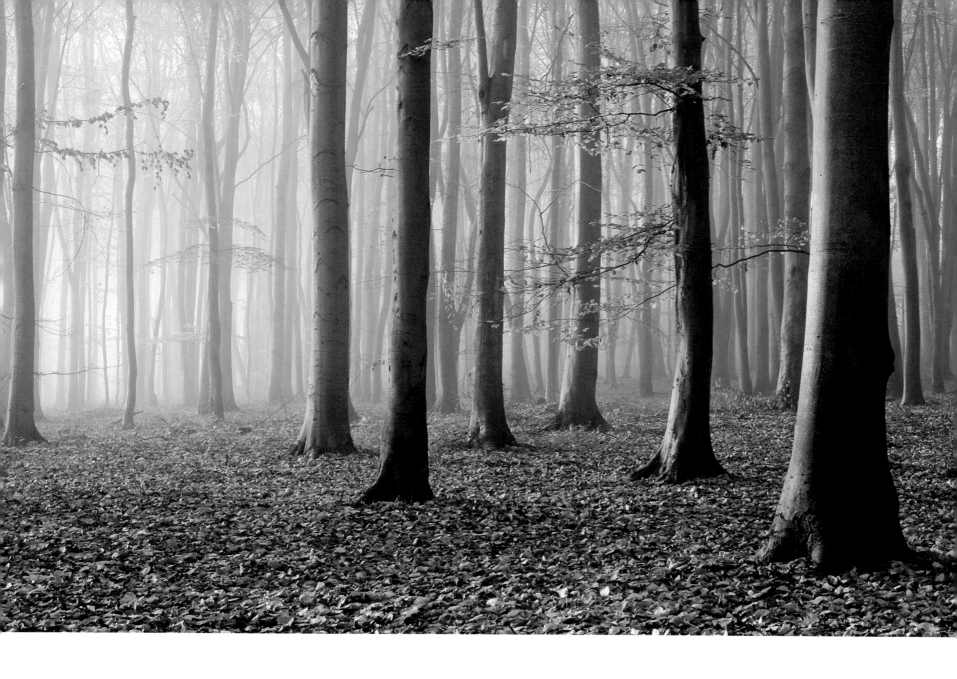

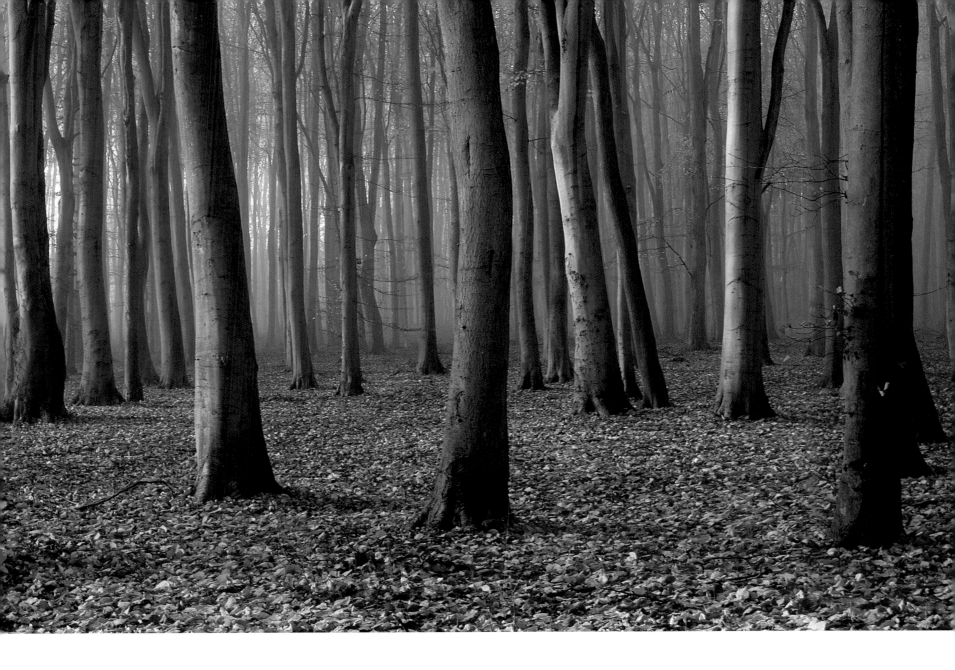

✝ **CRAIG DENFORD** HIGHLY COMMENDED

Beech Trees
Surrey, England

I'd noticed this location the year before, marginally too late, and so resolved to return the following year. As soon as mist and fog were forecast, I set the alarm and made my way over. Conditions were great but things improved further when the sun started burning through the fog, giving form to the trees and creating a beautiful range of tones. Combined with the lovely oranges and browns of the leaves it created the perfect scene.

Judge's choice Charlie Waite

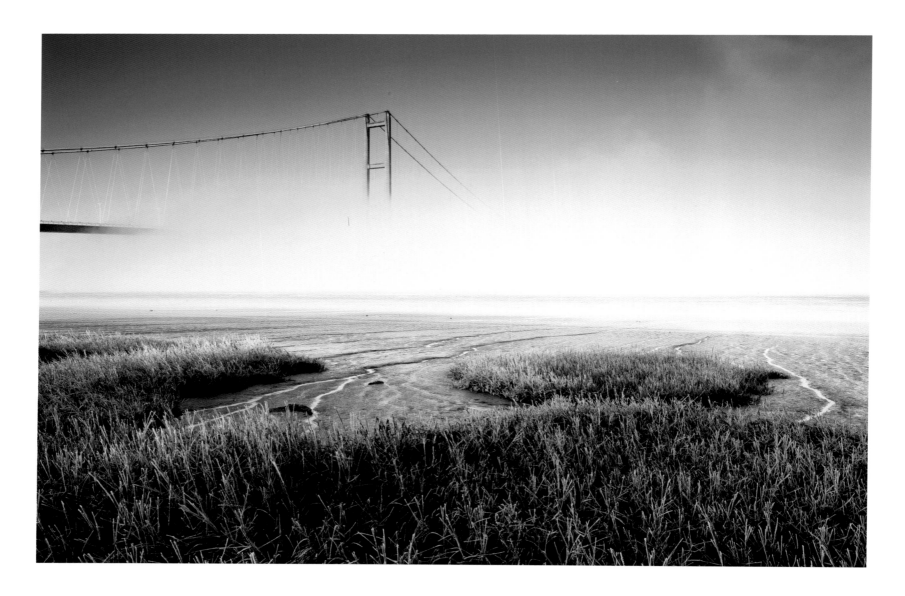

LEE BEEL

The Humber Bridge
North Lincolnshire, England

This shot of the Humber Bridge and the foreshore at Barton-upon-Humber was taken on a bitterly cold day in December. I'd not been able to get the car off the drive for a few days because of snow, but luckily the foreshore and the country parks along it are within walking distance of my home. While looking for subjects to photograph I noticed the mist rolling down the river and that, every so often, it obscured the bridge. This area of foreshore looked particularly frozen and I thought it would make an interesting foreground. I composed a shot that I was happy with and then just waited for the right amount of mist to partially obscure the bridge.

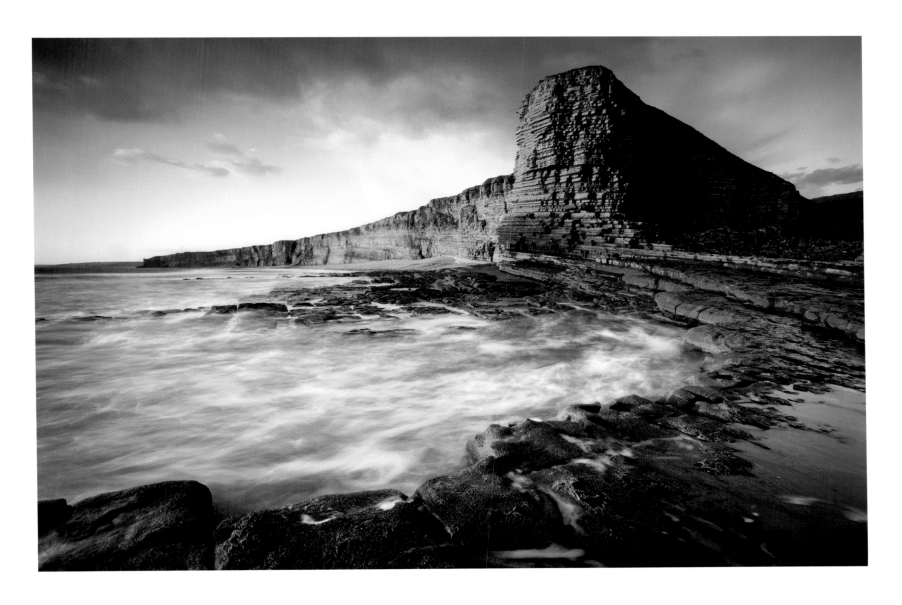

⚜ ALUN DAVIES

Welsh Gold
Nash Point, Glamorgan Heritage Coast, Wales

Nash Point has to be my favourite location along the Glamorgan Heritage Coast. Magnificent limestone cliffs catch the light in both summer and winter, while wave-cut platforms, deep clefts and suddenly advancing tides provide both variety and danger for the unwary. On this visit I knew there would be a turning tide and hoped to get a fine sunset. However, when the cliffs were temporarily transformed to glowing saffron by the evening sunlight, I knew that this had to be my subject, while the obligingly receding tide allowed me to include the sweep of the rock ledge and avoid a soaking.

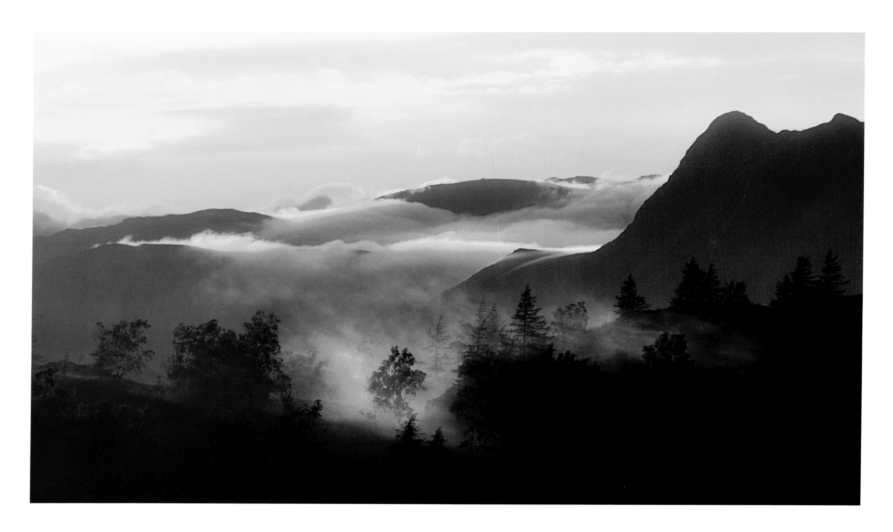

☂ PETER RIBBECK

View from Tarn Hows at Sunset
Cumbria, England

On this particular day it had rained heavily in the Lake District. However, just before sunset the rain lifted and the sun cast some final light and warmth over the saturated land.

HEATHER ATHEY ⋯›

A Bracing Morning
Tynemouth, Tyne & Wear, England

This photo was taken on a stormy September morning during what had been an unsuccessful and rather grey 'golden hour' shoot at Tynemouth (one of my favourite photography locations), about an hour from my home. I had actually packed up and gone back to the car when suddenly the light changed and I dashed back down to the pier, forgetting my tripod in the process, to grab a few hurried shots before the magical light disappeared again. Sometimes it's just about being in the right place at the right time!

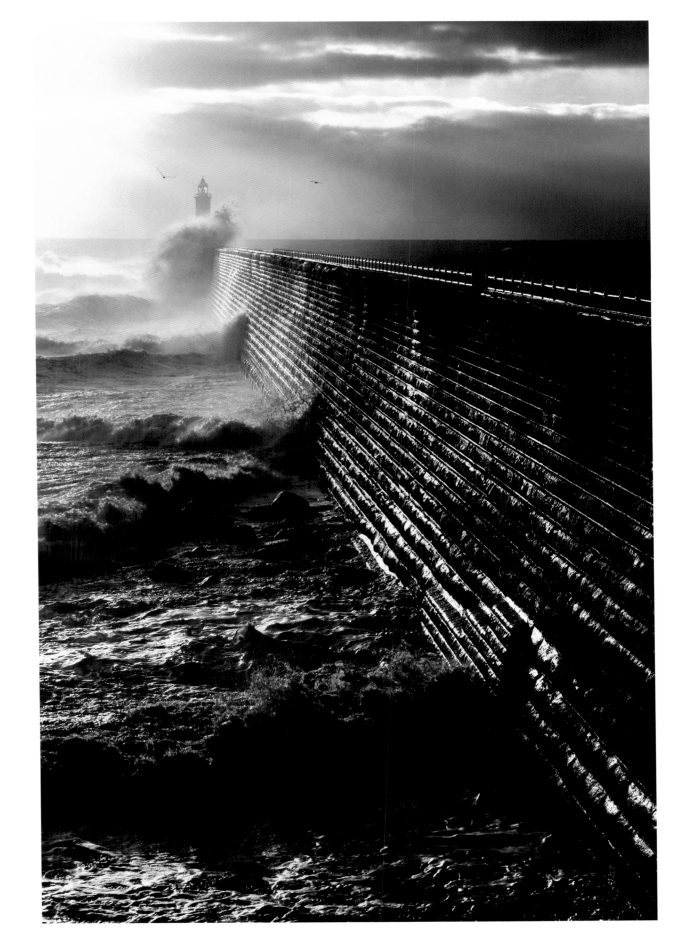

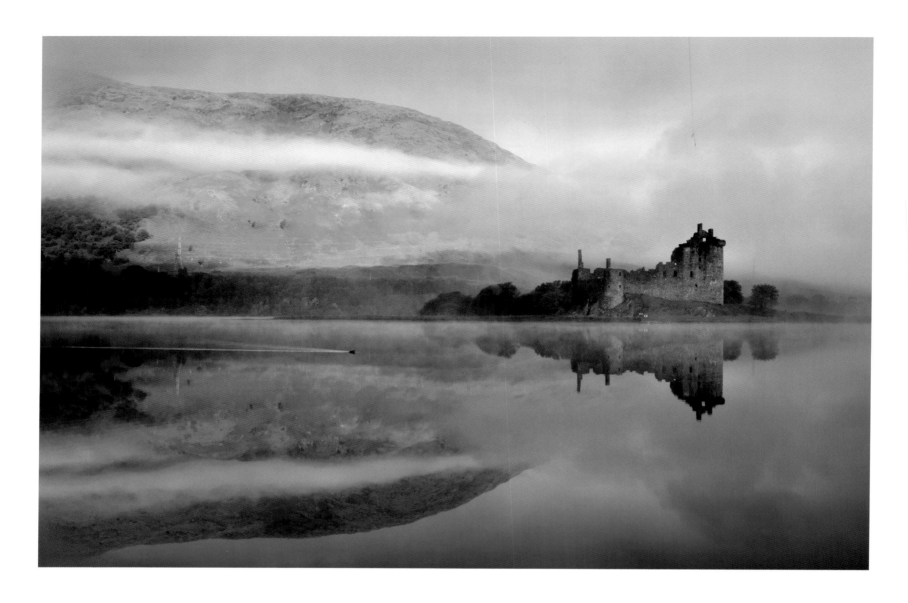

ADAM BURTON

Whispers of History
Kilchurn Castle, Scotland

While on a trip to Scotland one October, I decided to head to Kilchurn Castle for sunrise. I was delighted to notice mist lingering in the darkness, but as the darkness lifted, the castle disappeared completely in the mist. I waited for almost an hour, but eventually lost hope, packed up my gear and left. Fighting off disappointment I began the long journey home, but just a few hundred yards down the road the mist was suddenly clearing, revealing a sunny beautiful day. I quickly returned to the shore, only to be met once again with total murkiness. I decided this time to wait as long as it took, and only a few minutes later I was rewarded as the mists parted, revealing the most magnificent view of the castle.

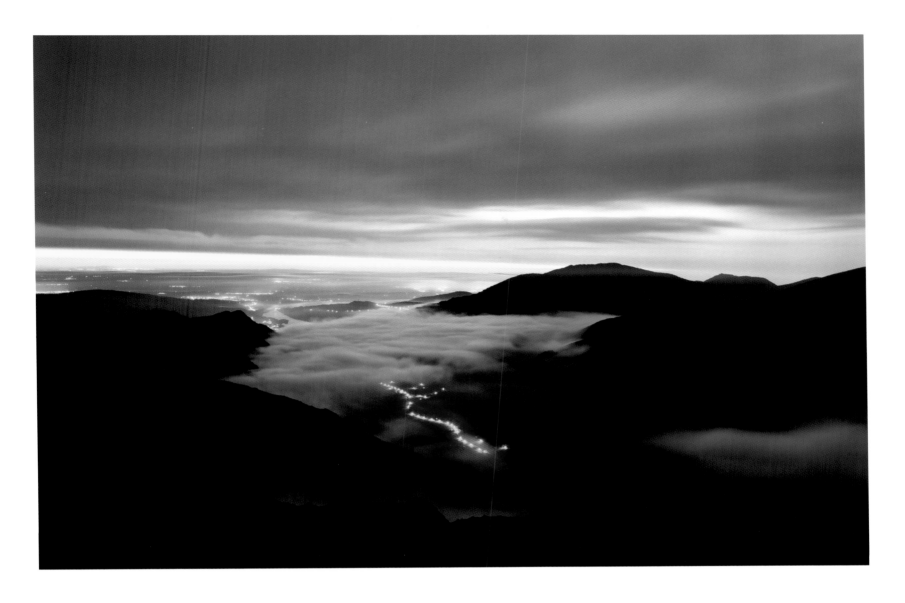

✝ **ESEN TUNAR**

Above the Clouds on Crib Goch
Snowdonia, Wales

I arrived in Snowdonia late in the afternoon and as soon as I saw the cloud inversion forming I rushed to the top of Crib Goch to capture as much as I could. After witnessing a beautiful sunset, I decided to stay up there for the night and sleep on the ridge. While I was in my sleeping bag, I watched the low-level clouds, illuminated by the street lights, move along the valley for hours. It was a night I will not forget...

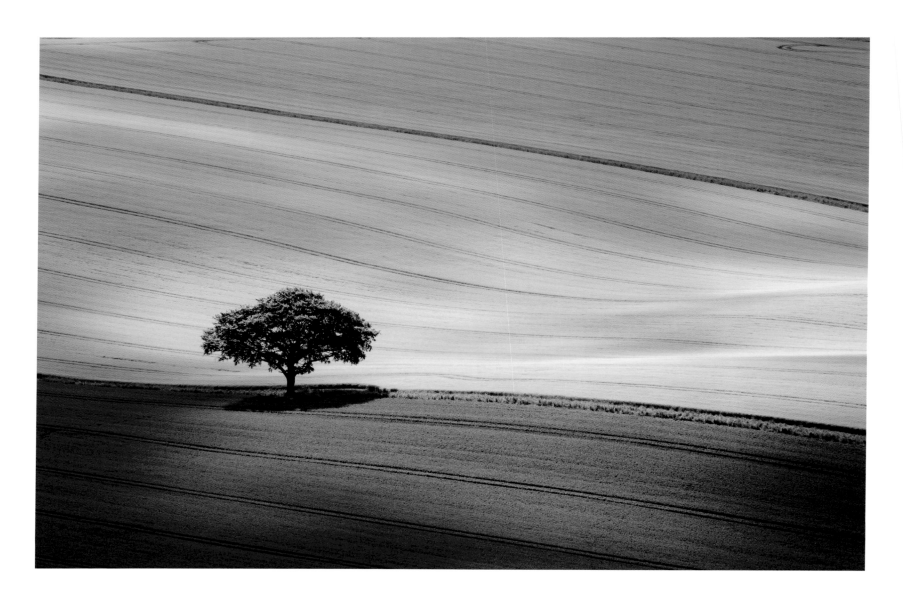

🌲 **ROGER VOLLER**

South Downs National Park
Hampshire, England

I have been to this destination twice before in hazy conditions and immediately knew this view had great potential. On the third return at dawn, the morning was again hazy and fairly cloudy but I waited for any backlit opportunities or change in weather. After a further wander and a few more hazy shots, I noticed the clouds breaking behind me. I swiftly backtracked as glorious pockets of light were pouring in and, thanks to the wet spring and summer, the land was vibrant. I chose my composition and waited for the shadows from the fast-moving clouds to shape nicely round this wonderful well-watered tree.

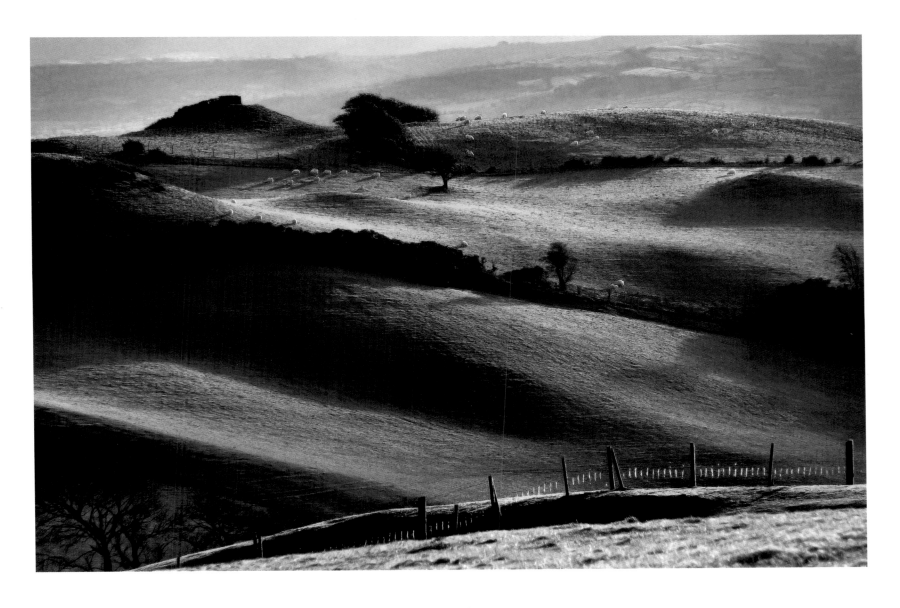

KEVIN BLEASDALE

Land of My Fathers
Offa's Dyke, Wales

I was walking the line of Offa's Dyke in North Wales when I happened upon this scene. The slanting late afternoon winter light was raking across the landscape, illuminating the folds in the gently rolling hillside grazed by sheep. It was captured on my ever-present point-and-shoot; justification, I like to think, for always carrying a camera (of any sort) in every kind of situation. Though personally not of Welsh lineage, the title immediately came to mind.

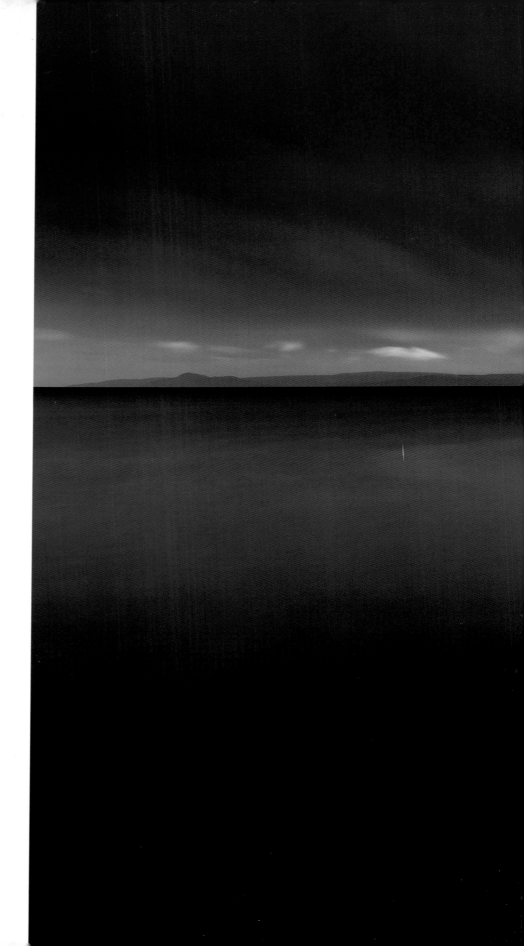

FORTUNATO GATTO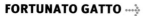

Portencross in Spring
North Ayrshire, Scotland

Despite returning from a demanding photographic journey to Ardnamurchan, the sky from my home looked too inviting to stay in and miss an opportunity for some good photos! So I decided to travel to Portencross where, under a few raindrops, I saw one of the most beautiful sunsets.

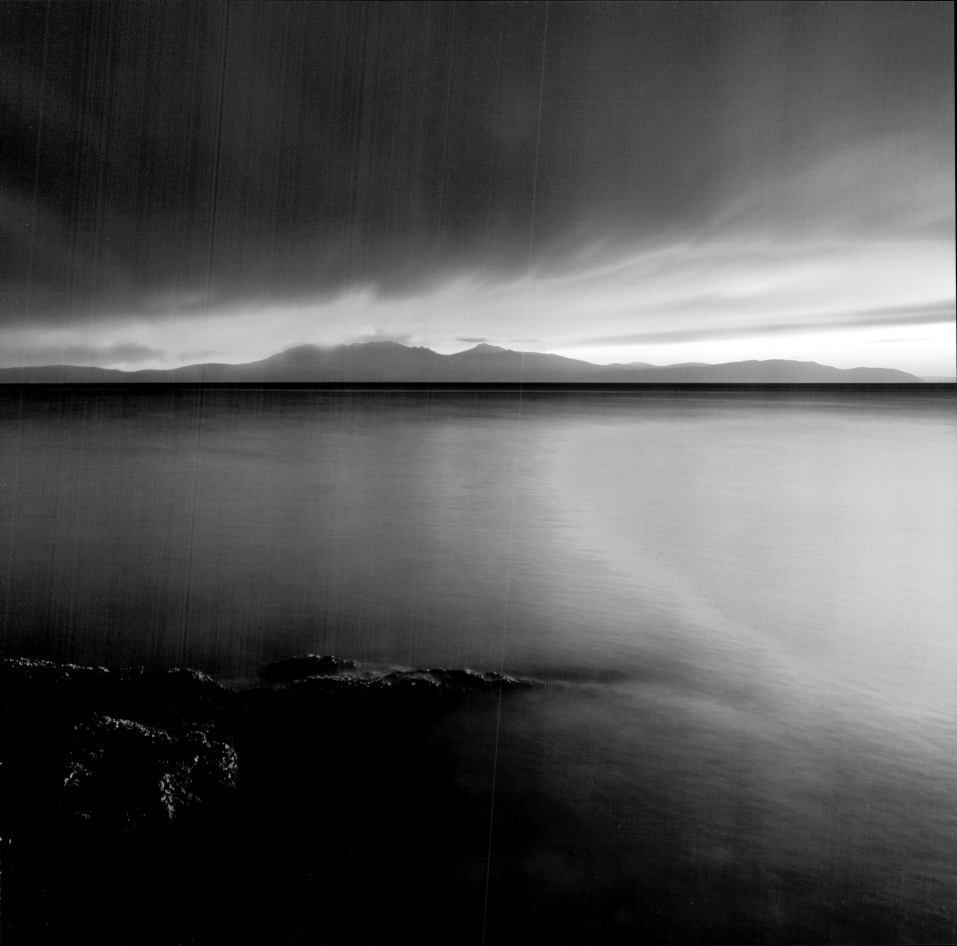

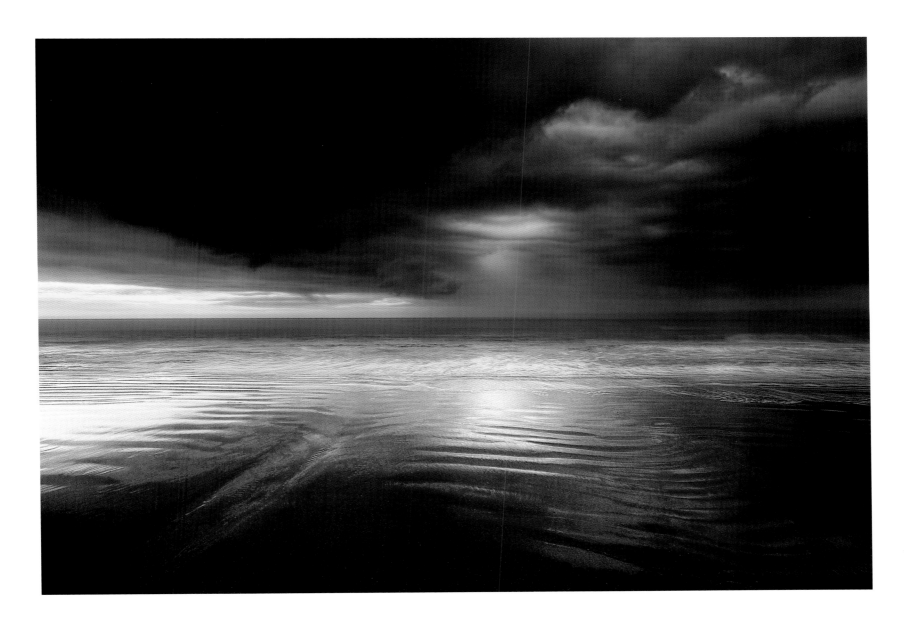

⬅ DUDLEY WILLIAMS

Scarista Beach
Isle of Harris, Scotland

I love this beach on the Isle of Harris. Surf is blown off the rollers just before they crash onto the huge expanse of soft golden sand. A seal bobbed in the waves, watching me, as cows grazed on top of the dunes behind. It was raining and blowing hard and I had the place to myself.

⬆ DAVID SMITH

Down on the Beach
Nash Point, Wales

Just before sunset I was visiting Nash Point on the Glamorgan Heritage Coastline in South Wales. I followed the tide to get the foreground texture of the soft, wet, untouched sand.

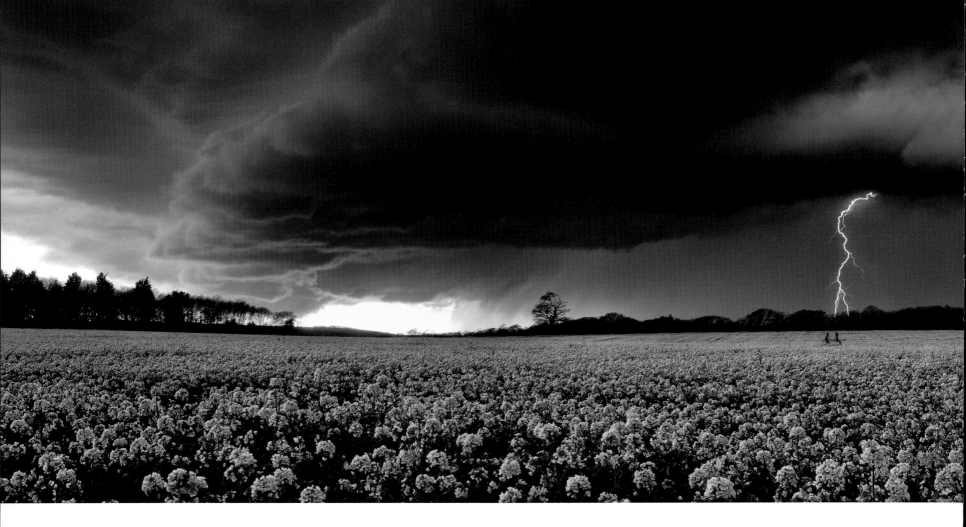

JAMIE RUSSELL

Evening Storm over Ashey
Isle of Wight, England

I watched a big line of storms approach from the northwest during the evening, so I decided to drive to Ashey to capture the storm coming in over a field of oilseed rape. Little did I realise that I was about to see the most dramatic sky I think I have ever seen!

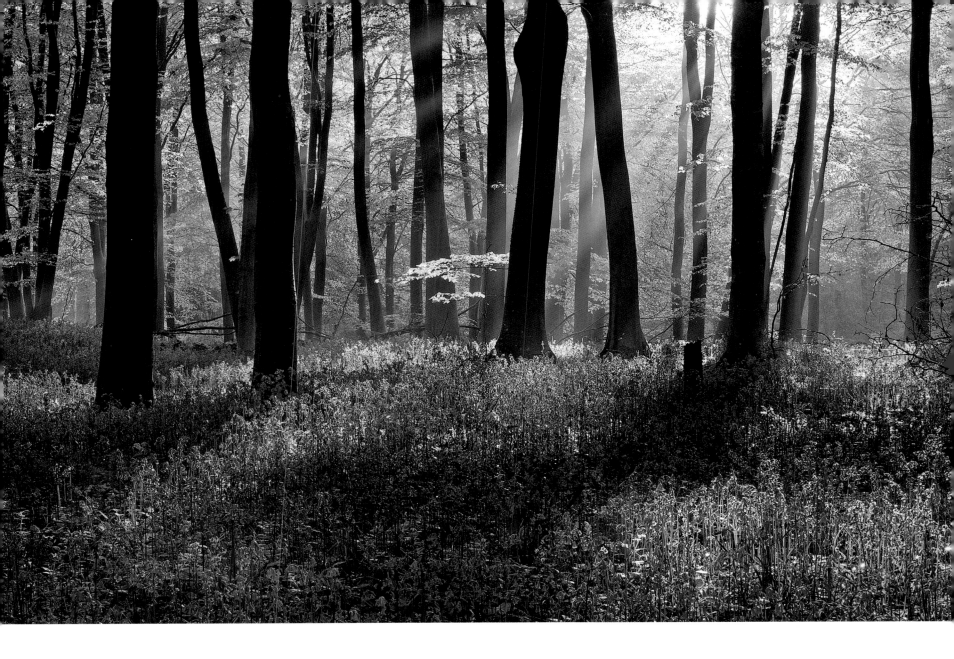

LOUIS NEVILLE

Bluebell Dawn
Micheldever Wood, Hampshire, England

I left home at one in the morning to reach this perfect spot, deep in the ancient Micheldever Woods. I have never captured a shot of bluebells before, so I was very excited and once I found this location knew that I was in the right place. Before long, the early morning sun and the disappearing veil of mist created some fantastic light rays that illuminated the bluebells on the forest floor.

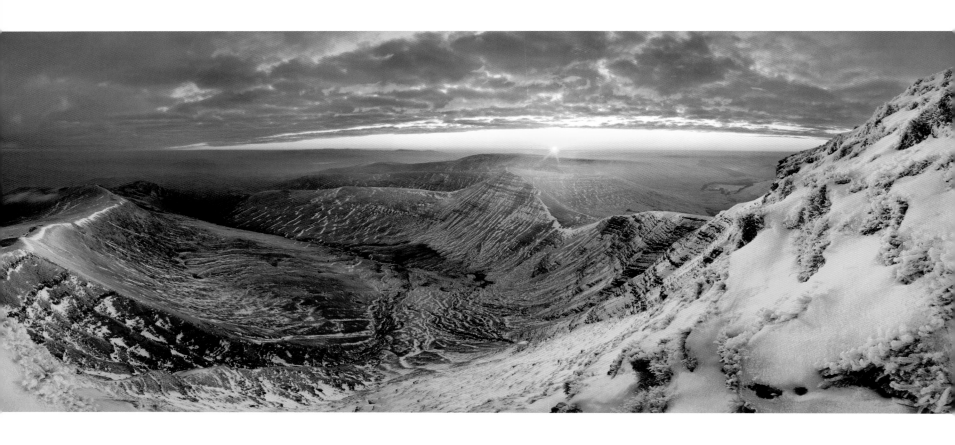

EPSON® EXCEED YOUR VISION THE EPSON 'EXCEED YOUR VISION' AWARD WINNER

 ALEX NAIL

Pen y Fan
Brecon Beacons, Wales

Pen y Fan is the highest peak in the Brecon Beacons and in southern Britain. At 886m it is diminutive by continental standards but can still provide spectacular views and unforgiving conditions. I walked up the mountain the night before in what can only be described as very unpleasant conditions. The freezing rain gave new meaning to the term 'waterproof shell'. I set up camp on the snow-covered summit. A windless night passed and I awoke to see high-altitude clouds and a gap on the horizon. At that point I knew I was in for a good sunrise; the excitement is hard to describe!

 IAN CAMERON

Loch Achanalt
Strathbran, Scotland

A sliver of caramel light at sunrise turns the frosted birch trees at the edge of Loch Achanalt to powdered ginger, a colour that contrasts warmly with the cool reflected hues of an arctic blue and cloudless sky. Temperatures dipped to −20°C, which ironically gave me firm-footed access to areas I would likely to be unable to reach at any other time of year.

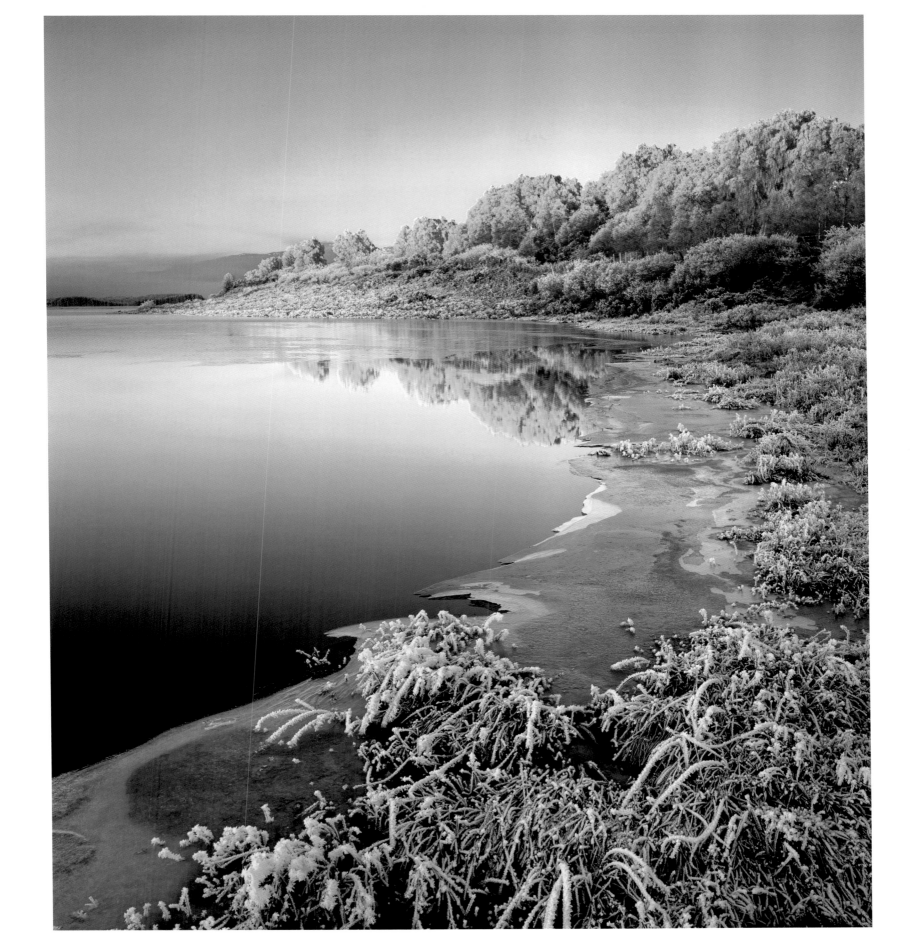

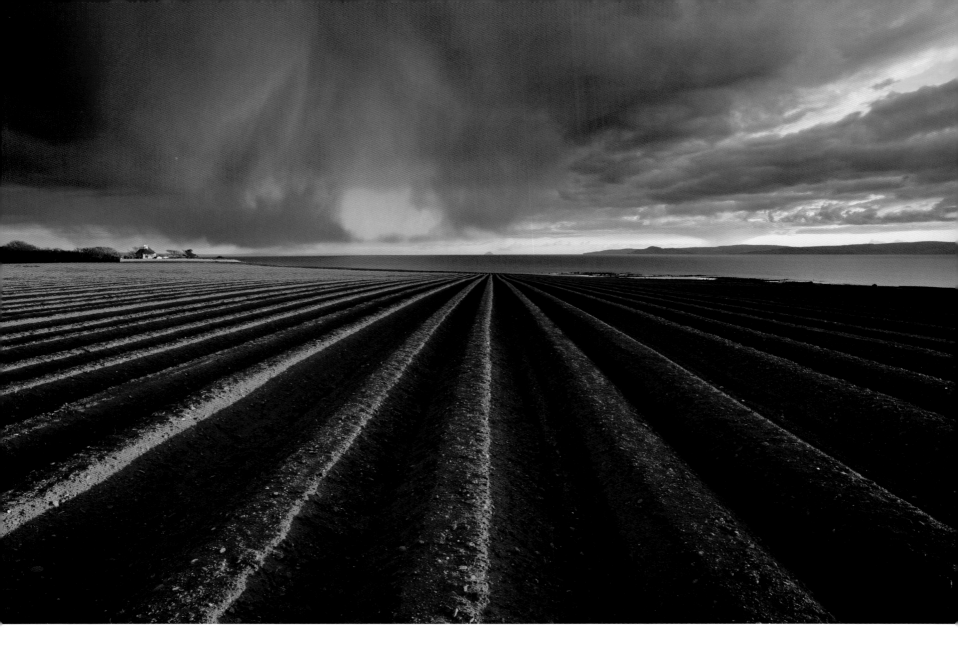

FORTUNATO GATTO

Seamill in Spring
North Ayrshire, Scotland

On a journey one night, my wife advised me to stop in this beautiful field near Seamill. Leaping over the gate, I composed this image using the roughness of the ground as a guideline, directing the view towards Ailsa Craig, a curious conic island. The dramatic sky and the last rays of light made the scene so special.

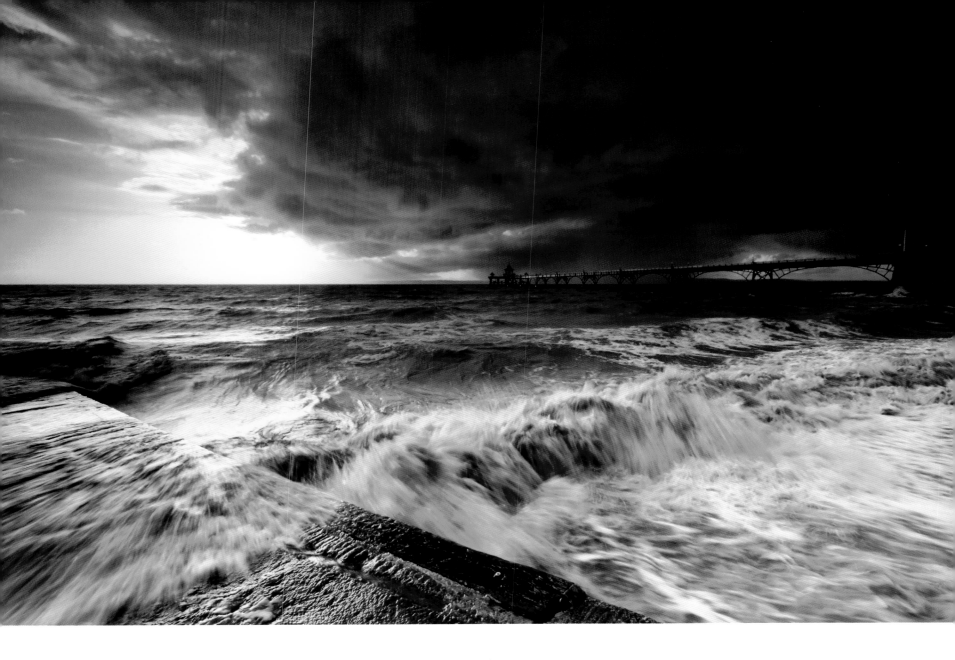

✝ **BILL BARRACLOUGH**

Clearing Storm
Clevedon, Somerset, England

An unexpected trip to Clevedon produced this image. Although the weather was dreary, overcast and raining for most of the day, the forecast was for it to clear from the west in the early evening, which by a stroke of luck coincided with the high tide. I spent a fun-filled hour trying various compositions as this storm developed. A very tricky shoot, as the spray was horrendous in the stiff on-shore breeze and I seemed to be spending more time cleaning the filters than shooting. As the sun emerged from behind the storm the brightness range went through the roof!

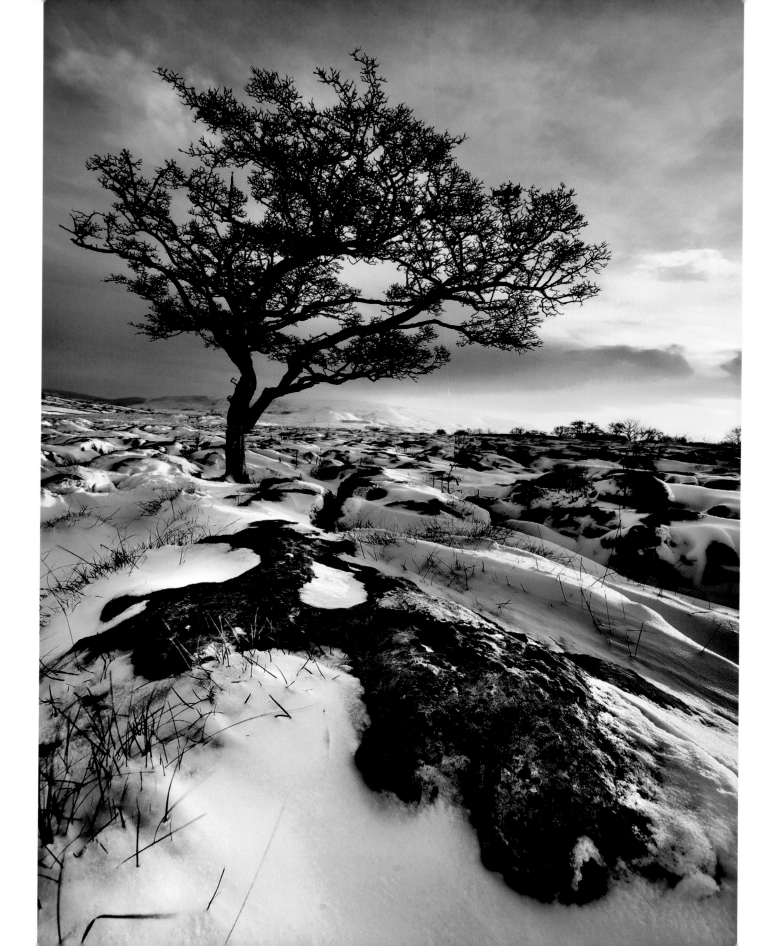

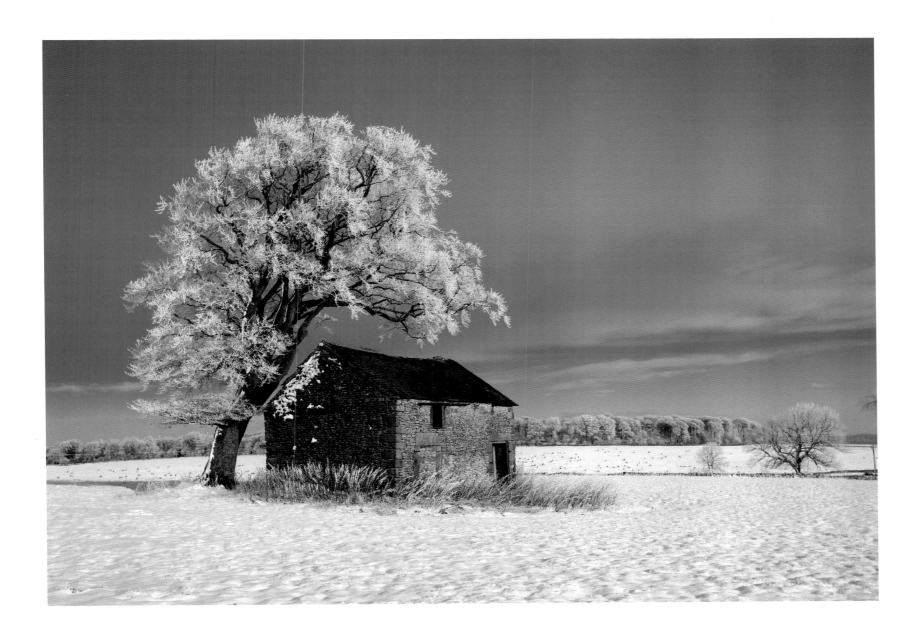

⟵ **ANDY AUGHEY**

Grassington Moor
North Yorkshire, England

This shot was the culmination of a long and enjoyable day spent hiking the snow-covered moorland between Grassington and Conistone in the Yorkshire Dales. I found an interesting composition with the exposed limestone and tree then waited for the sun to set, enjoying the tranquillity and sense of occasion and hopeful that the shot would capture this and do justice to the dramatic lighting and scenery that surrounded me.

⟰ **IAN LEWRY**

Derbyshire in the Snow
Derbyshire, England

I am not sure of the exact location of this barn in Derbyshire as, at the time, I was lost in thick snow. When you see such beautiful scenery as this, it is a wondrous pleasure to be lost.

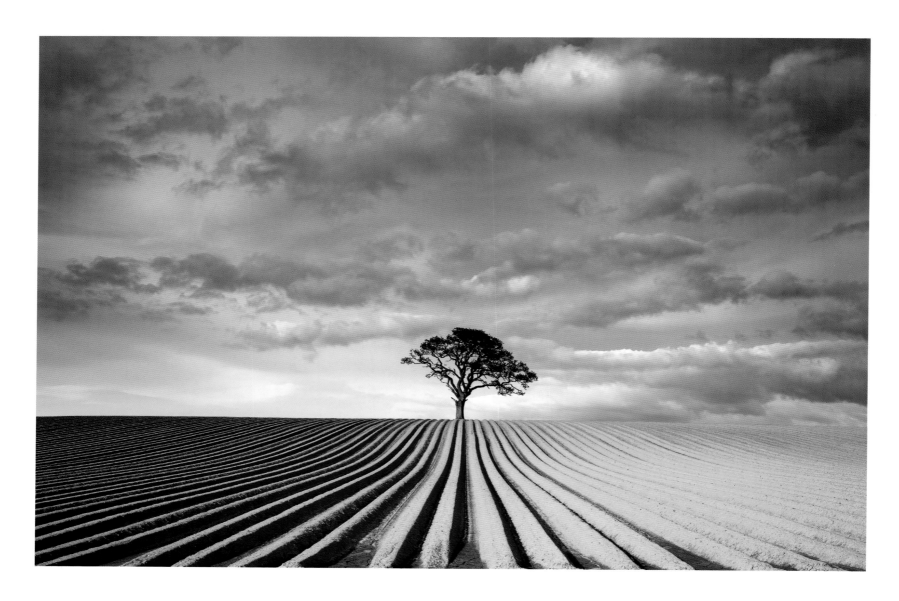

JOHN HODDINOTT

Oak Tree and Potato Field
Cronkhill, Shropshire, England

I found this field several weeks earlier. Having travelled hundreds of miles over three previous visits, I was desperate for the weather to produce something other than dense cloud and torrential rain. I hoped to convey the sense of isolation I felt for this lonely tree and knew it would only be a short time before the potato plants emerged to transform the scene completely. I couldn't have been more thrilled when my perseverance was rewarded with a few brief moments of magical light before the sun, once again, disappeared behind heavy cloud, something we had become accustomed to this springtime.

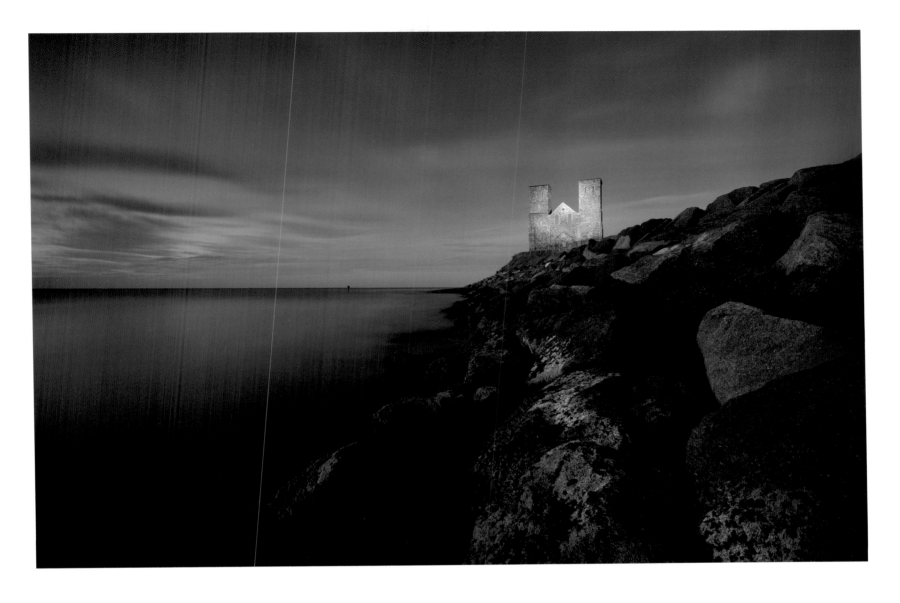

✝ **MIREK GALAGUS**

Reculver
Kent, England

This shot was unexpected, as I was heading back to my car after sunset. I had been trying to photograph from the other side of the towers and it was not good at all. I had decided to pack up my camera later, so was carrying it on my shoulder attached to a tripod. One more turn back to say goodbye to Reculver and that was it...the lovely soft light of twilight. I jumped over the stones, quickly found my place and took this photo.

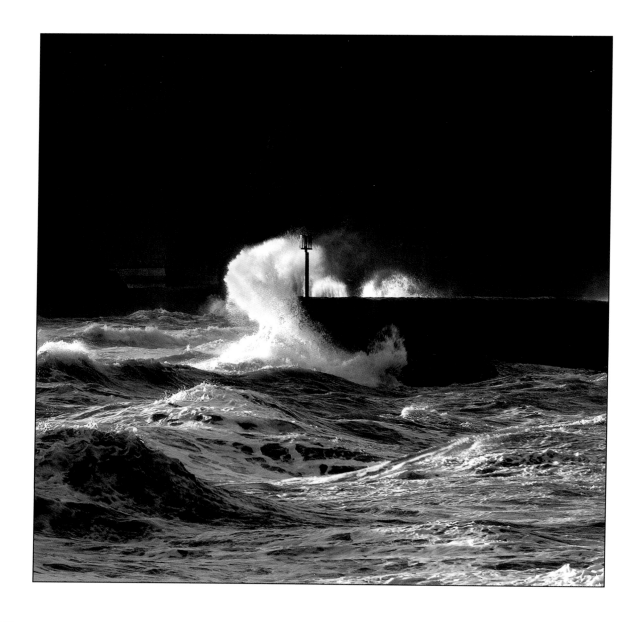

SUSAN BROWN

Sunrise on Wave
Dawlish, Devon, England

The day before this photograph was taken, my elder daughter had emigrated to Australia. I could not sleep, so decided to get up and go to Dawlish for the dawn. I was expecting a calm misty morning, which would have been therapeutic. Instead, the seas were wild and treacherous and the wind had increased to gale force. As the sun rose, I noticed the waves were catching the light as they hit the wall around the beacon. I set the tripod up and waited for the right wave that curled around. I exposed for the highlights so I had detail in the water and minimal detail in the cliffs behind so as not to distract from the wave.

DUDLEY WILLIAMS ⋯⋗

The North Harris Hills
Outer Hebrides, Scotland

Fifty-three seconds squeezed into a single frame on a beach in the Outer Hebrides. I used heavy neutral filtration to achieve a long exposure, enabling me to record a passage of time in one image. The aim was to create an abstract of the moving elements, the sky and the water. A solid tripod has kept the hills sharp. I love this beach for its remoteness and tranquillity. I spend hours watching the light change, sometimes sleeping in the dunes.

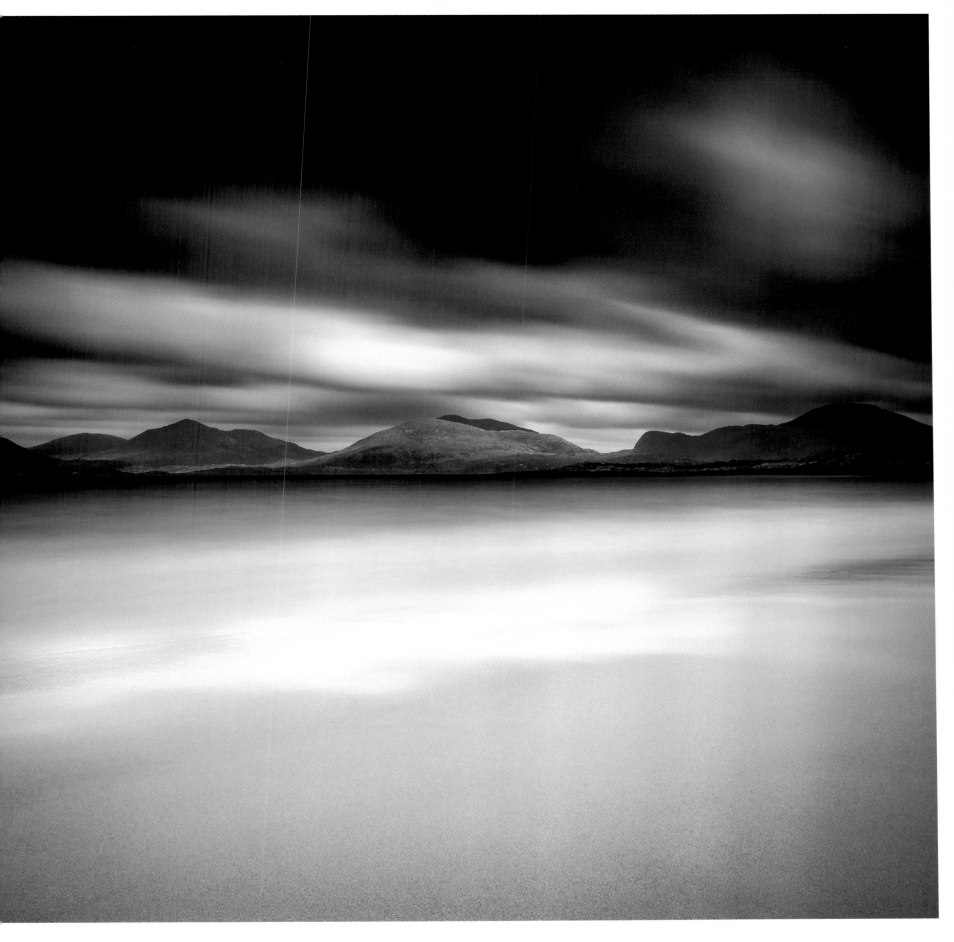

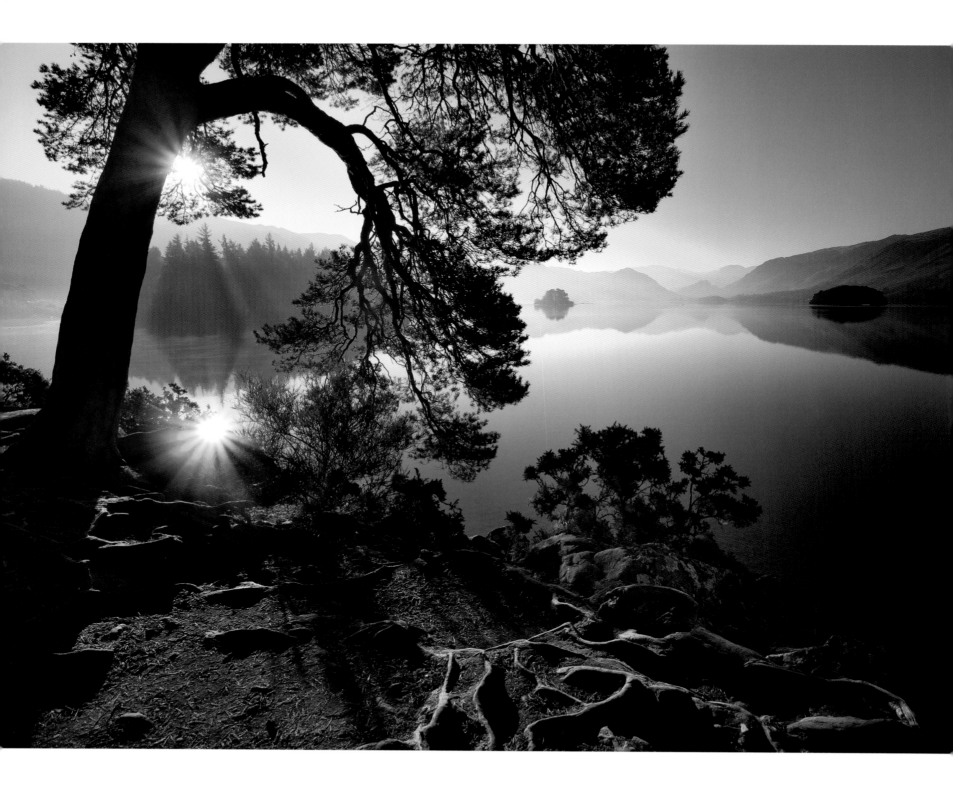

Derwentwater
Cumbria, England

This image shows Derwentwater, taken from near Keswick, in late January. Lack of cloud on this fine winter's day made composing images difficult; however, the delightful mist rising off the lake provided plenty of inspiration. Once the sun rose above the fell tops the mist cleared quickly, but not before creating some fine rays around the woods. I decided to make use of a lakeside pine tree to help control the sun and its reflections, whilst adding some interest to the top of the image and making the most of those wonderful well-lit, weathered roots.

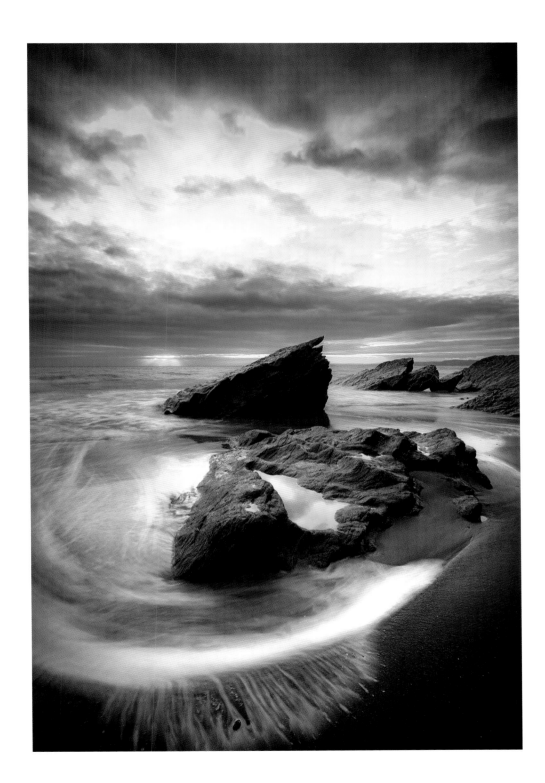

PAUL MORGAN ···►

Saline Sweep
Whitsand Bay, Cornwall, England

The dramatic sweep of the tide contrasts with the stillness of the pool in the rock formations, creating an almost gyroscopic lead through the image to the trio of light rays on the horizon.

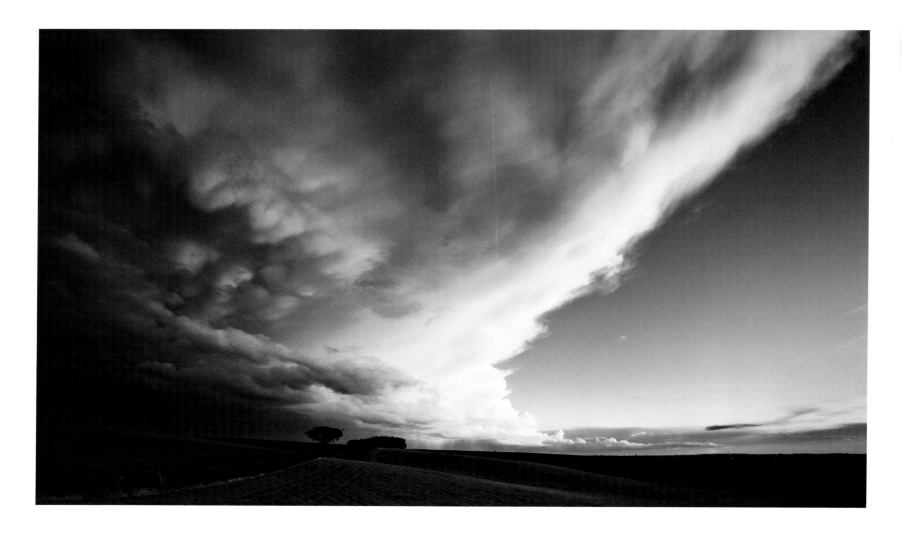

COLIN MILL

Sunset Stormclouds
Chichley Hill, Bedfordshire, England

This lone tree stands between two fields on Chichley Hill in Bedfordshire. It is a bit of an icon for local photographers, but with the changeability of the British weather you never get the same image twice. Taken one weekend in September, following an afternoon spent chasing light and dodging storms, this is of the stormcloud that had covered Milton Keynes for most of the afternoon as it made its way eastwards. The sun was setting in the west and lit the cloud beautifully.

DAVID ROE

Dawn near Malham in the Yorkshire Dales
Yorkshire, England

This tree is around 15 miles from where I live in Burnley. It was on a return journey from Malham that I first saw it. I was driving along and thought WOW! I pulled over immediately and took a few snaps. They were pretty uninspiring shots as it was midday but I knew I could create a great image given the right conditions. Knowing that the sun rose in the perfect position behind the tree with the hills in the distance, I embarked on a year-long quest to get the shot, visiting the location numerous times. It wasn't until late September at 7.30am when all the right conditions came together; the beautiful sunrise, the mist and the correct amount of foliage on the tree to allow just the right amount of sun to crack through...perfect!

JOHN FANNING ···⟩

Moonlit Bill
Portland Bill, Dorset, England

This image is one I needed perseverance to capture. The conditions were often not quite right until this one particular night. The wind concerned me, as I knew that I would be exposing the sensor for a long time and hence any movement would render the shot un-sharp, so I weighted my tripod from the centre stem with my camera bag. I particularly like the starburst effect from the surrounding lights and the lighthouse lamp itself.

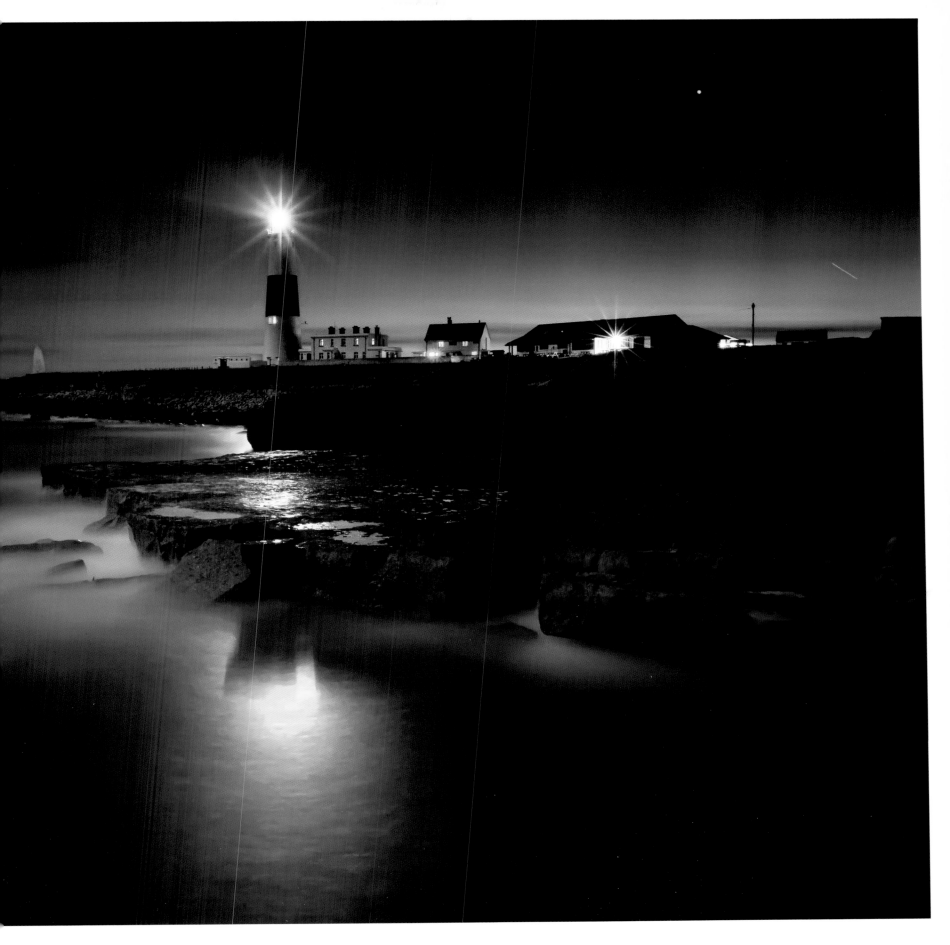

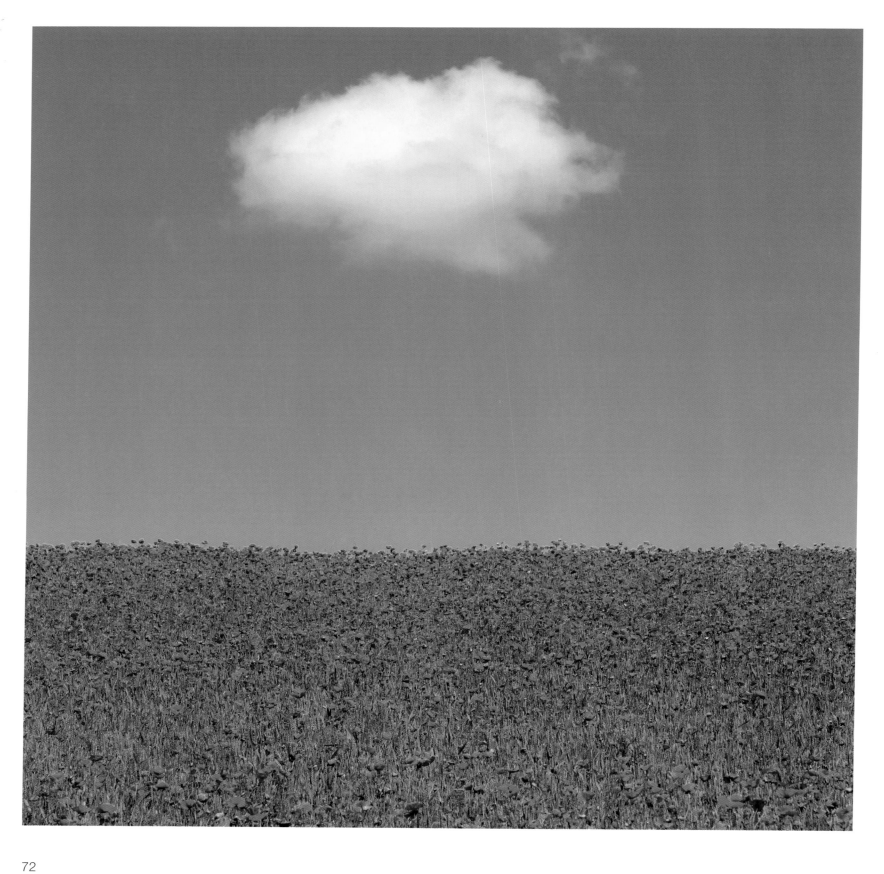

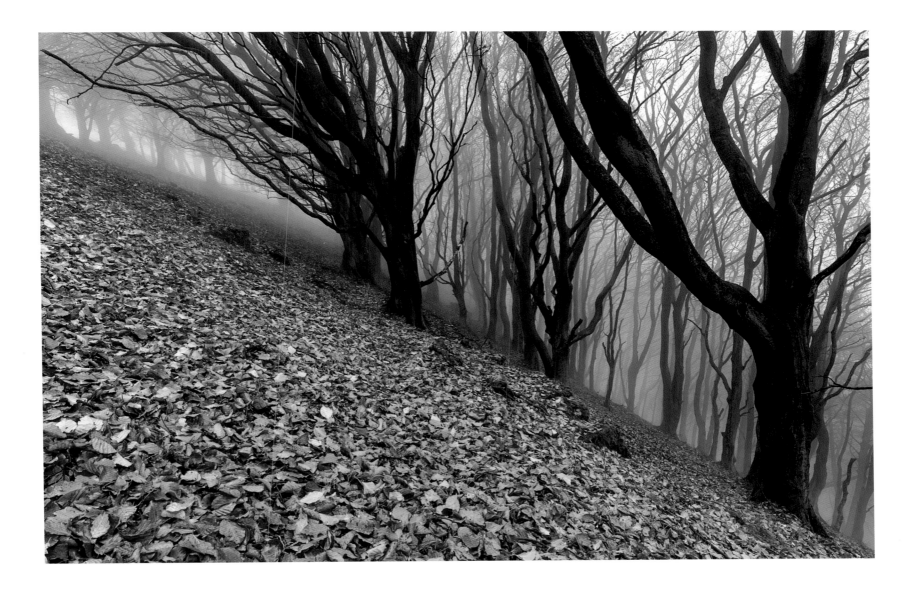

RICHARD THOMAS

Poppies and White Cloud
Alresford, Hampshire, England

One day in early June I noticed this field full of poppies in the distance whilst I was coming down the 18th fairway of Alresford Golf Club. Excuse the pun, but it stuck out like a red flag. The week after, we had a fantastic sunny day with blue sky and white fluffy clouds, so I did a number of shots including this one. I originally took the photo in portrait orientation but, during the editing process, cropping the image to a square format worked better for me in terms of composition. I went back a week later to do some sunset shots but most of the poppies had lost their petals.

JOHN FINNEY

Vertigo
Woodland near Castleton, Derbyshire, England

It was a perfect misty morning in the Peak District. I had the option of watching the sun rise over the mist from Mam Tor but instead I headed into the mist, looking for an opportunity to shoot some autumn woodland in the atmospheric fog. I found this steep woodland near Castleton with a fresh carpet of fallen leaves; the conditions were just what I was looking for. It was difficult working on such a steep hillside, being careful not to disturb the leaves for my next shot.

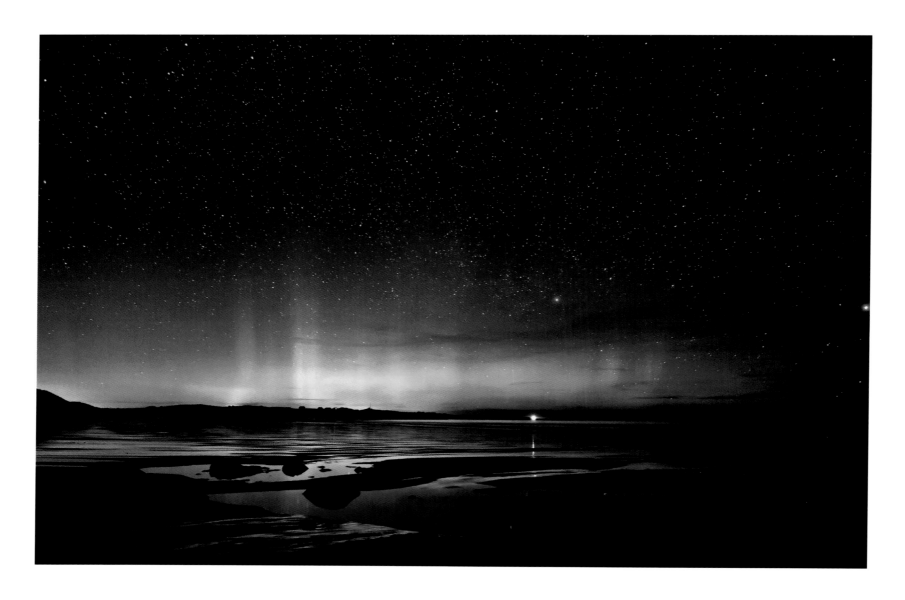

DAVID WATERHOUSE

Embleton Rays
Northumberland, England

I've heard you should never try too hard to seek the northern lights, they will find you. Nights spent chasing them around Scotland had yielded nothing but now, here I was on Embleton beach, heading for the castle to catch the moonrise, stopping every now and again to admire the stars. I looked out to sea, and noticed a bright glow in the distance, then the delicate fingers of light shining down from the sky. The show lasted about 15 minutes. On returning to the car, I bumped into two local photographers also seeking the lights, but the show had now ended. Incredible that I had driven over four hours to find myself, inadvertently, in the right place at the right time. The lights had found me.

STUART LOW

After the Rain
Path of Condie, Perth & Kinross, Scotland

One positive result of all the rain this summer has been some amazing rich greens across the landscape where I live. On this particular evening, there was a slow-moving rain shower with small breaks in the cloud that were lighting fields every now and again. I saw that the cloud was moving in the direction of this field, which had a lone tree at the top, so I walked up in the hope that the sun would illuminate the tree at some point. Eventually, and after an hour of waiting, my patience was rewarded.

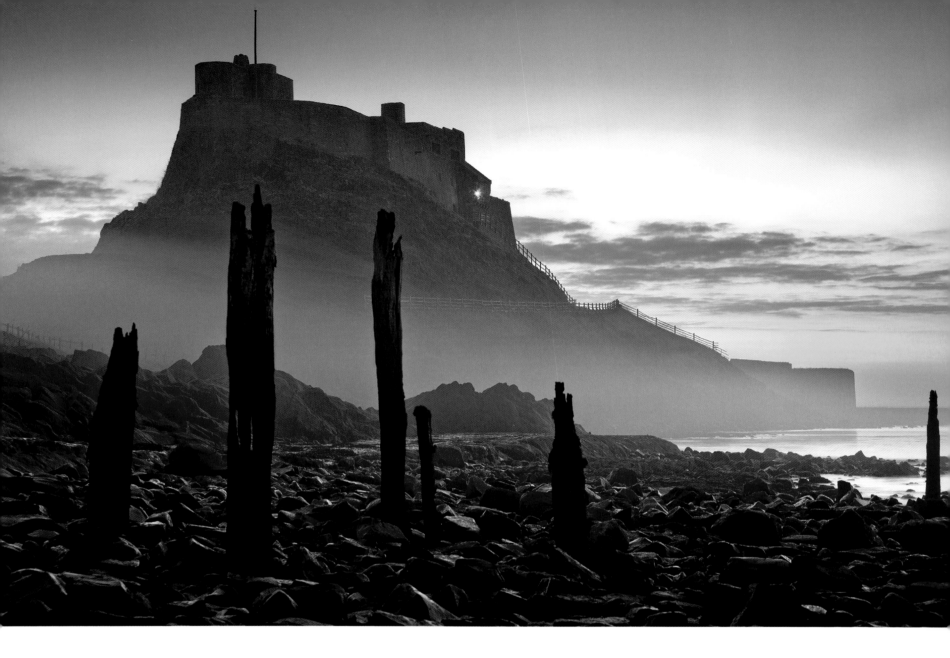

✝ **GARY WAIDSON**

Lindisfarne
Northumberland, England

It is rare to get such a calm morning on Lindisfarne that a mist really lingers. I had walked to the harbour well before dawn and, as I approached the castle, this mist was creating ever-changing scenes of pastel colours. The tide was low but rising and the posts of the old pier seemed to echo the outline of the fortress. I had on a pair of wellington boots and I was very grateful for them. The water seemed to rise much faster than the sun and I had to wait for the light to lift the dark rocks in the foreground. By the time the light was right and the mist just so, the water was scarcely an inch from the tops of my boots.

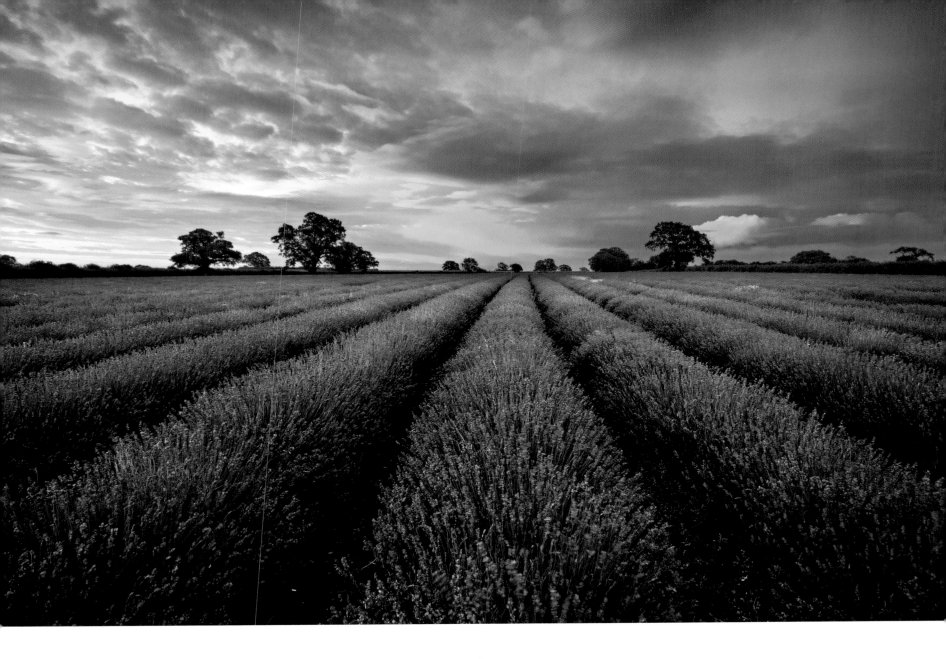

GRAHAM McPHERSON

Lavender at Faulkland
Somerset, England

For this image, I got up an hour and a half before the July dawn and drove for 40 minutes. Despite the pelting rain making it hard to see through my windscreen at times, I had a feeling that the lavender field would yield something good. Sure enough there was a gap in the clouds. An hour after this image was taken heavy rain set in again for the rest of the day. It was a great window of opportunity that surpassed my expectation and I was glad I went with my heart instead of my head on this one.

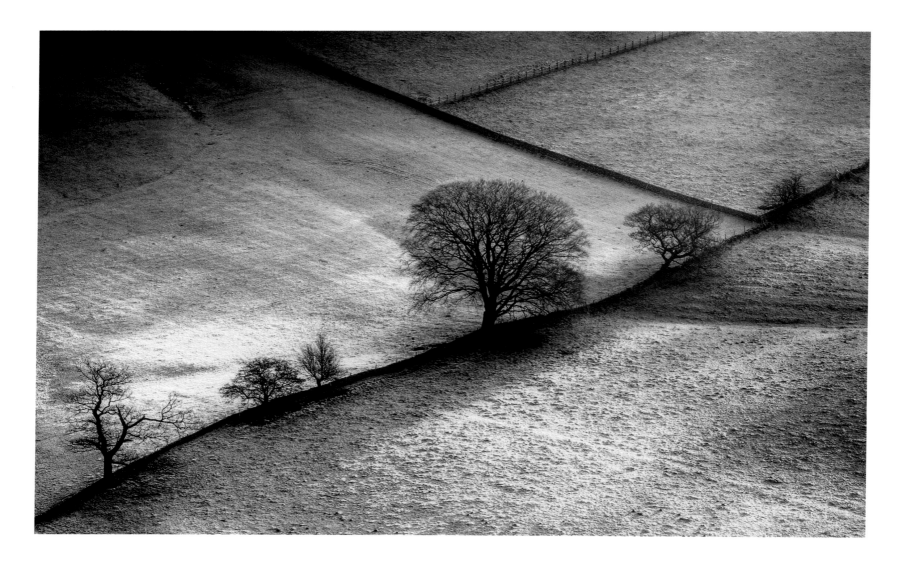

COLIN BELL

Light and Land from Tegg's Nose
Cheshire, England

An image made at dawn. The contours of the frosted land made for a wonderful show of shadow and light. In particular, I loved the way the height of the tree caught the highlights.

ADAM BURTON ···⟩

Merlin's Well
St Nectan's Glen, Cornwall, England

Regarded as a place of spiritual significance, this unusual waterfall is a truly magical location where you can almost believe you have been transported to a fairytale world. Being so close to Tintagel, for me this waterfall evokes legends of King Arthur and especially Merlin. For those more grounded in the real world, the hole in the rock also bears an uncanny resemblance to Alfred Hitchcock!

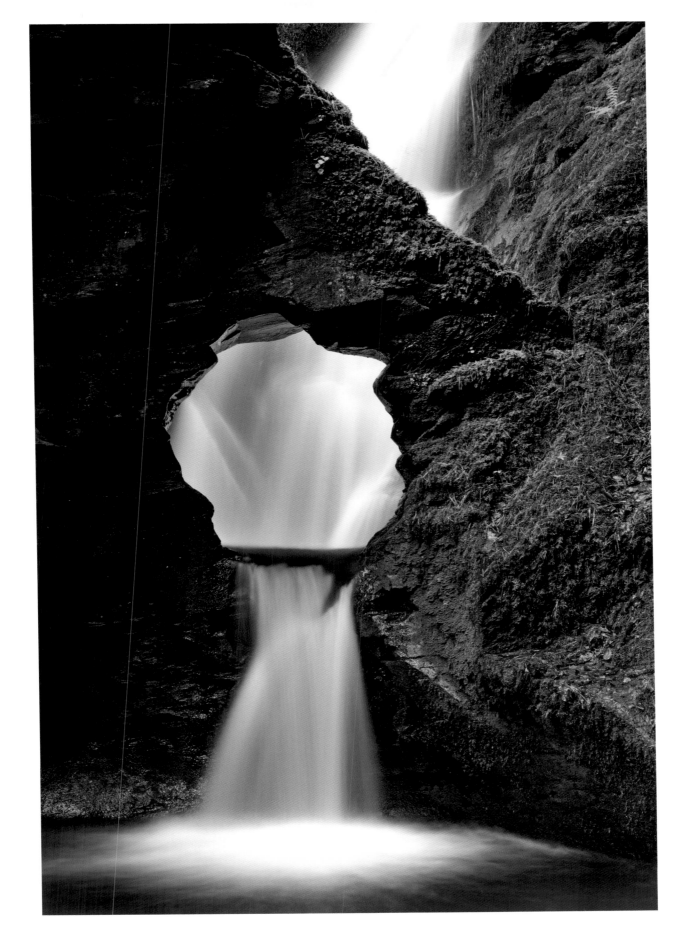

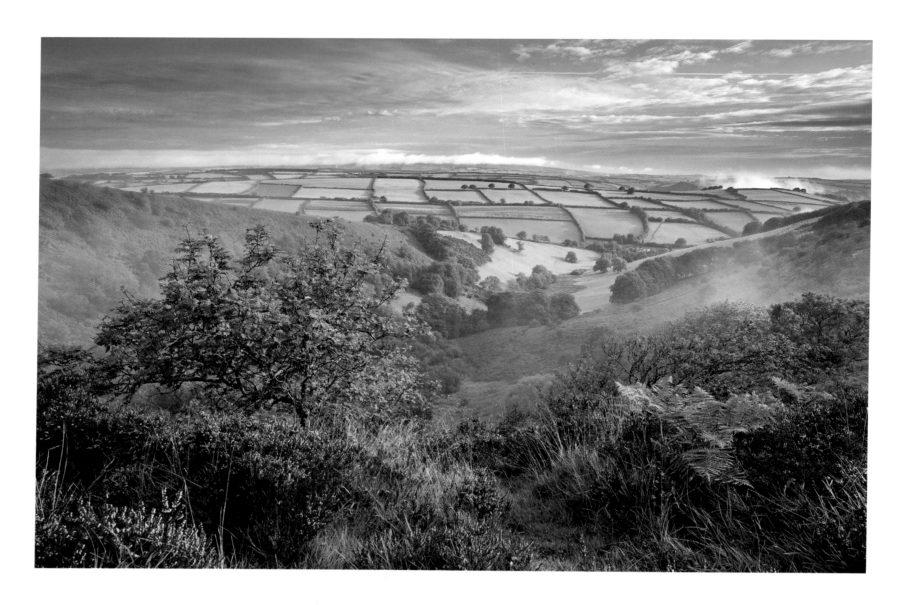

ANDREW WHEATLEY

The Punch Bowl
Somerset, England

The Punch Bowl is a natural basin in the heart of Exmoor. This view is from edge of the bowl on Winsford Hill. This was my second attempt in two days at getting this image. When I arrived at the location, the whole of this part of the moor was shrouded in fog but, as it is an 80-mile round trip, I decided to stick around and see how the morning was going to develop. As the mist began to clear and the view over the bowl was revealed, I knew I had made the right decision. I took three or four images as the light changed and the mist lifted. I felt this image portrayed the scene and the mood of the morning the best.

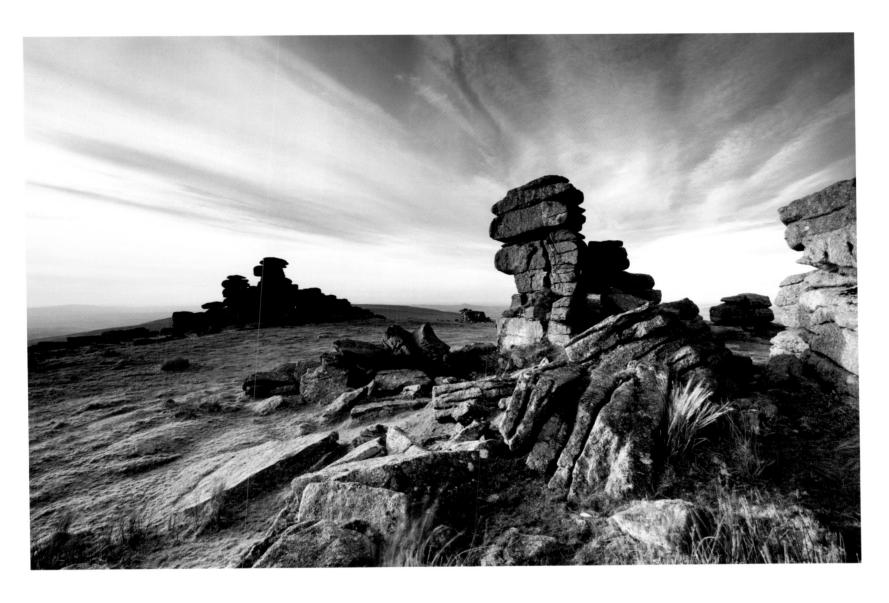

MATT WHORLOW

Staple Tor
Dartmoor, Devon, England

Great Staple Tor on a very, very windy evening. Fortunately, I was able to shelter out of the wind to get this shot. I loved the way the clouds are all leading in towards the main tower of rocks.

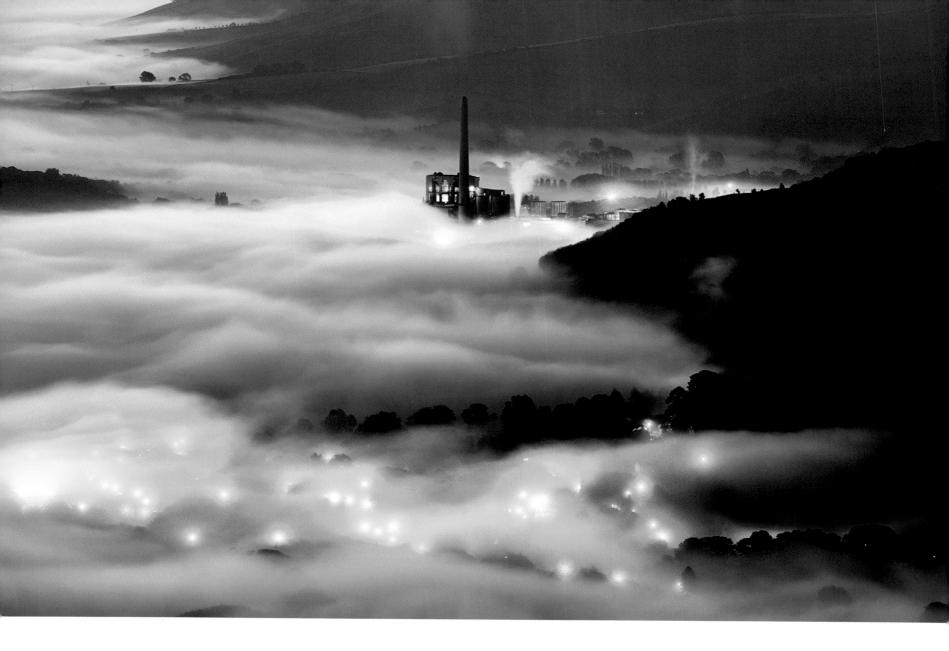

ALAN NOVELLI

The Cement Works and Castleton
Derbyshire, England

Two years of planning and a 3am start enabled me to capture this pre-dawn image of the Hope Valley in Derbyshire. A cold, calm and clear night, following heavy downpours of rain the day before, provided an excellent chance of fog forming in the valley overnight. Planning to be there 45 minutes before sunrise allowed me to carefully set up and fine-tune the composition. Then it was just a matter of waiting for pre-dawn light to work its magic upon the landscape and choosing my moment as the fog ebbed and flowed in the valley below.

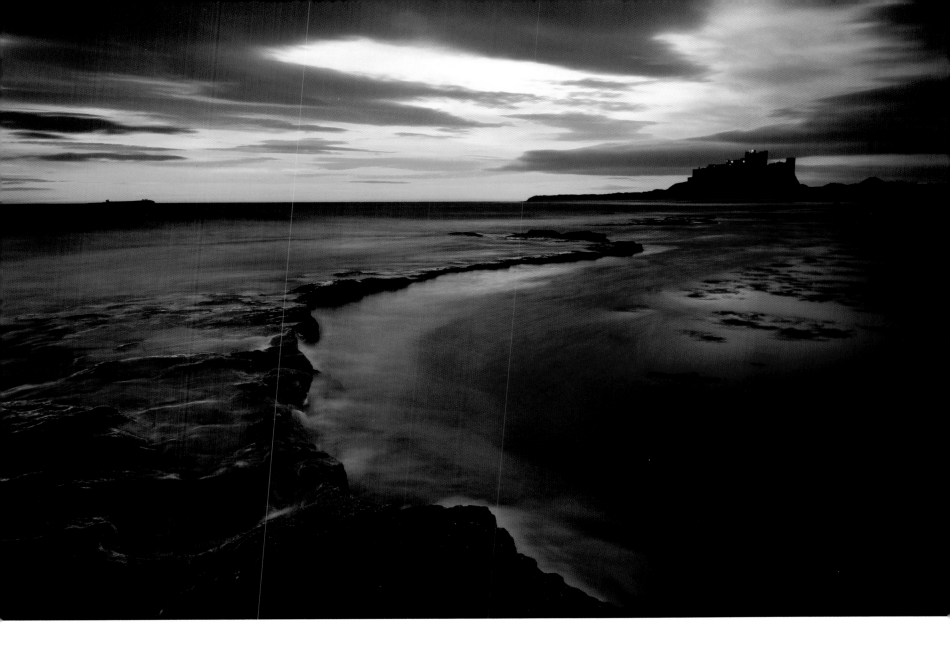

JOHN ROBINSON

Ledges
Bamburgh Castle, Northumberland, England

A rare moment in which timing of the encroaching tide and sunrise came together wonderfully, producing a stunning combination of colour and reflected light. Gently crashing waves surged over the sweeping basalt ledge, which naturally leads the eye to Bamburgh Castle. Timing and exposure length were critical to ensure that just the right amount of the movement of each crashing wave was recorded. While I managed to take a few exposures, it wasn't long before the incoming tide forced me to retreat further up the beach before making my two-hour journey back home to view the images.

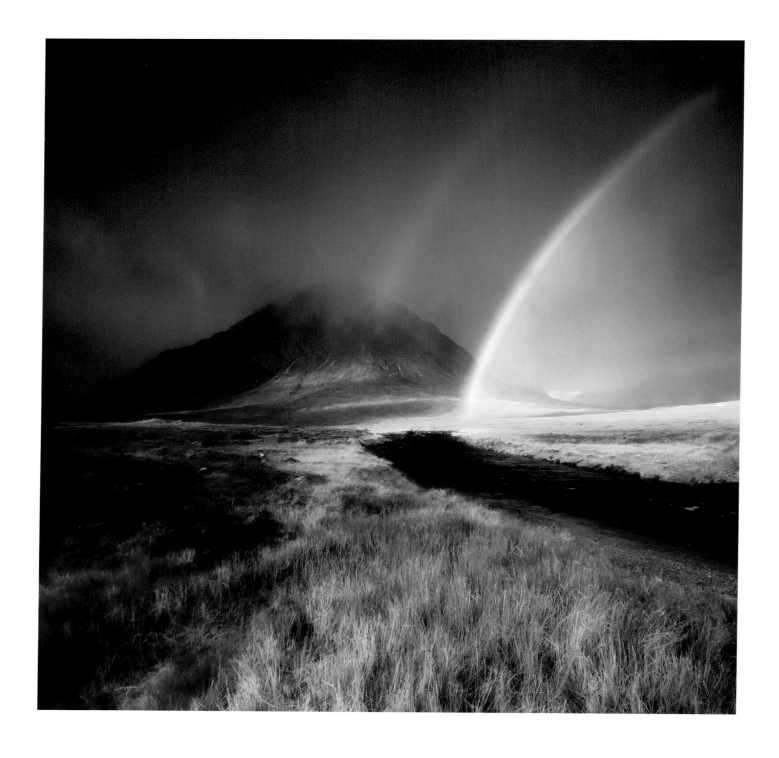

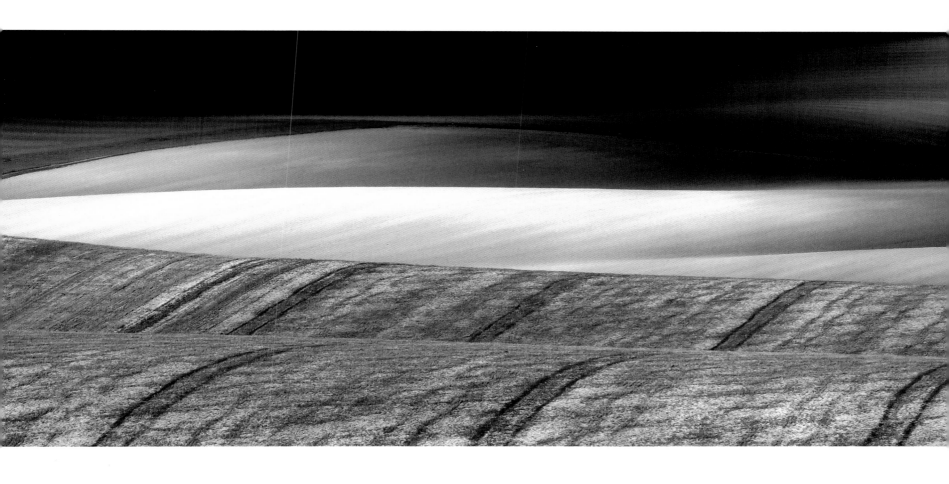

DAVID MOULD

Rainbow
Rannoch Moor, Argyll, Scotland

Having visited Rannoch Moor on many occasions, I knew that there was never a day that didn't throw up an opportunity to make a shot, although this one was close, until I looked in my rear-view mirror and saw this scene. Abandoning my car on the verge and quickly positioning myself beside the old metal bridge over the river, there was only a minute or so to battle the rain on the lens and get the filter positioned to fire off a few shots before a flash of lightning reminded me that standing this close to the largest metal structure on the moor was probably not the best idea. A minute or so later the scene appeared once again...in my rear-view mirror!

GREG COVINGTON

Autumn Fields from Coombe Road
Therfield, Hertfordshire, England

The rolling farmland in this area of Hertfordshire is well known to many photographers. It is always worth a visit as the landscape is changing constantly depending on the time of year, time of day, type of crop and weather conditions. My preference is autumn when there is not too much green in the fields. I like to concentrate on the shapes in the landscape, aiming for almost abstract images. This image was taken in September just after some of the fields had been cultivated to reveal the stark white chalky soil. Light and shadow were chasing across the landscape in the late afternoon. I waited for the sun to illuminate a particular area, giving, in my opinion, the most pleasing effect.

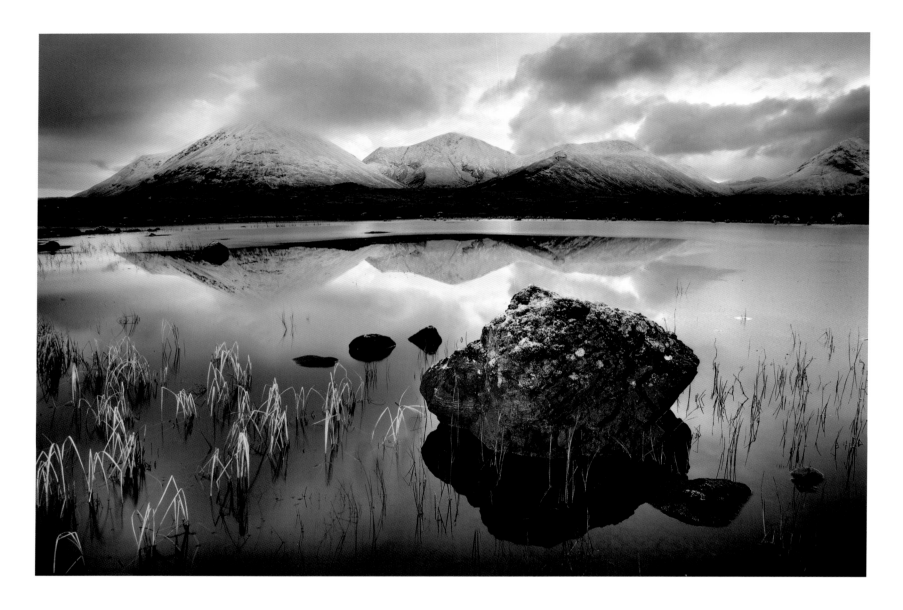

ALASTAIR SWAN

The Red Cuillin
Isle of Skye, Scotland

Early morning November light combined with the very first fall of winter snow creates
stunning reflections of the Red Cuillin mountain range on the charismatic Isle of Skye
off the west coast of Scotland.

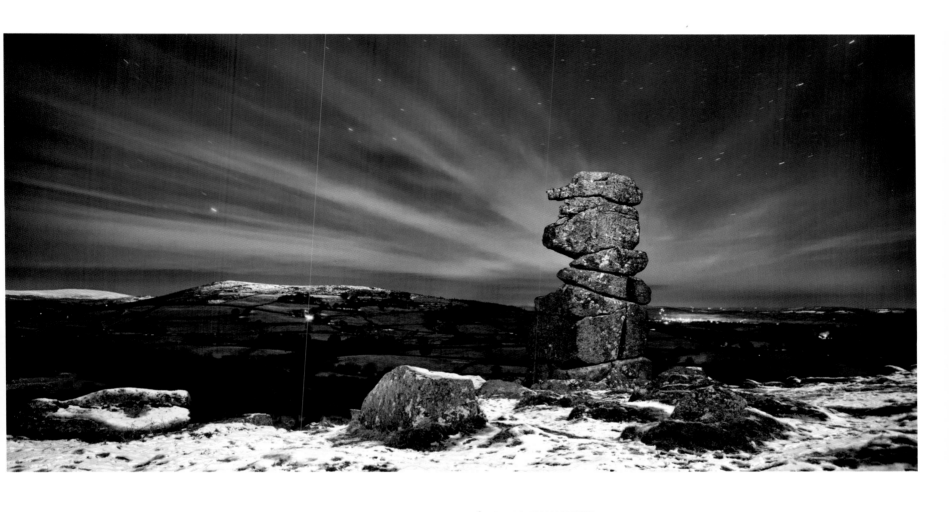

✝ DAVID DUMMETT

Under the Stars
Bowerman's Nose, Dartmoor, Devon, England

During a period of cold weather in February, I decided to go up onto Dartmoor one evening with the idea of capturing a nice sunset. This proved unsuccessful, so I moved on to a well-known Dartmoor landmark, Bowerman's Nose. By this time, the temperature had dropped dramatically. Dressed in several layers of clothes, I climbed the hill to the rock formation. The sun had now dropped below the horizon, but the landscape was illuminated by bright moonlight in the clear sky. I tried many compositions, exposures and extra illumination by the use of a torch and flash. Two hours after sunset my fingers were starting to get numb to the point where it was difficult to press the shutter release. This was one of my last images with a two-minute exposure that captured movement in the light cloud that had formed.

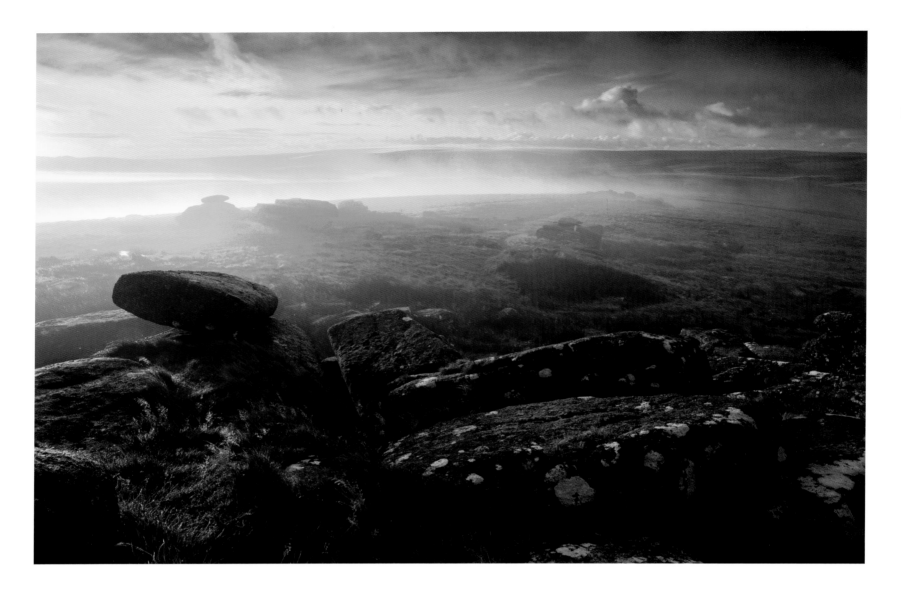

🏕 ADAM BURTON

Morning Has Broken
Dartmoor, Devon, England

Magical moments like this are rare and impossible to predict, so you need to be flexible and work quickly. On this morning I was initially heading to another tor for sunrise, but on noticing the mist choking the valley at Two Bridges, I changed plans and instead walked towards Wistman's Wood to capture the trees in misty conditions. Upon arriving at the wood, I was disappointed to find that the trees were quite clear of mist, so with time running out before sunrise I changed plans again and quickly made for Littaford Tor above the woods. Here, the rocks were choked with thick mist but, as the sun broke through, the mist cleared in seconds, changing the atmosphere completely. Fortunately I had already set the camera up and managed to capture this image, and I'm very glad I did, too!

PAUL NEWCOMBE ⋯⟩

Square of Gold
Win Hill, Derbyshire, England

I'd found this composition the previous morning after an unsuccessful sunrise shoot on the top of Win Hill in the Peak District. I thought it might make a good sunset location and, after checking the sun alignment, I knew it would be perfect. I returned with a friend the following evening. After taking a longer but more gentle route up, we arrived just in time. The light started to illuminate the landscape perfectly. We had to work quickly, knowing these moments can be brief, and sure enough, within minutes the moment had passed. The remainder of the afternoon was spent chatting and enjoying being out in this fantastic National Park, happy that we'd got a shot to take home. I cropped to a square image to strengthen the composition.

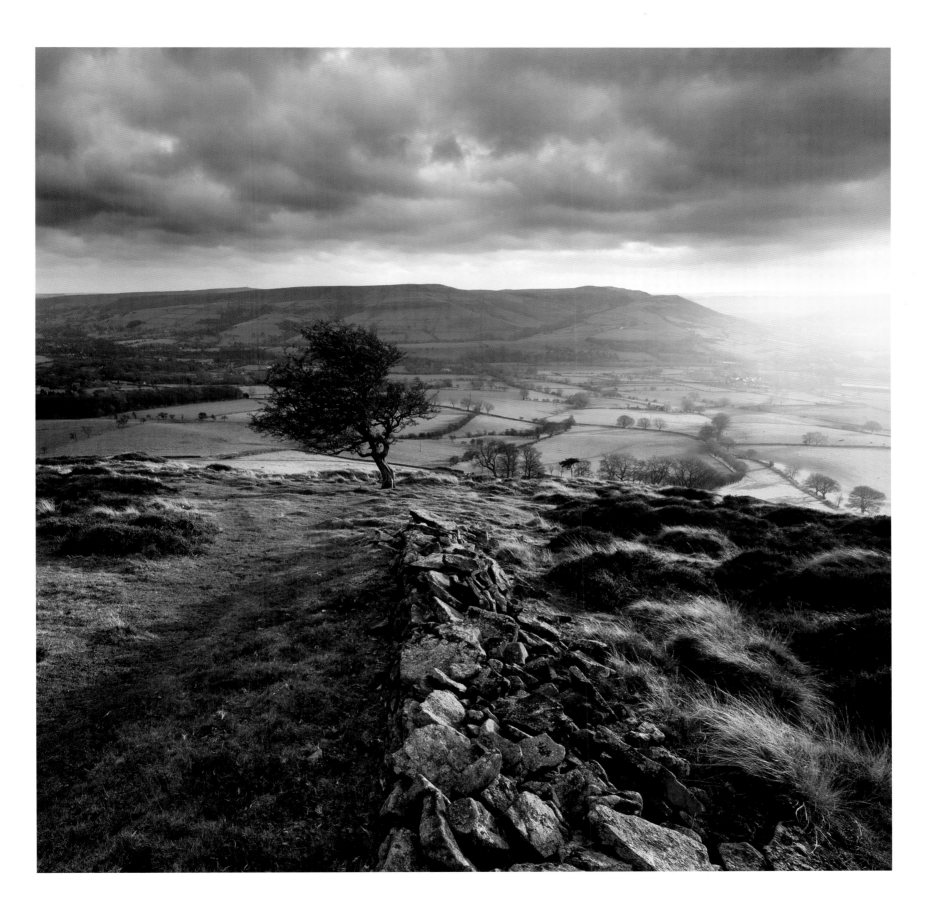

CLASSIC VIEW
youth class

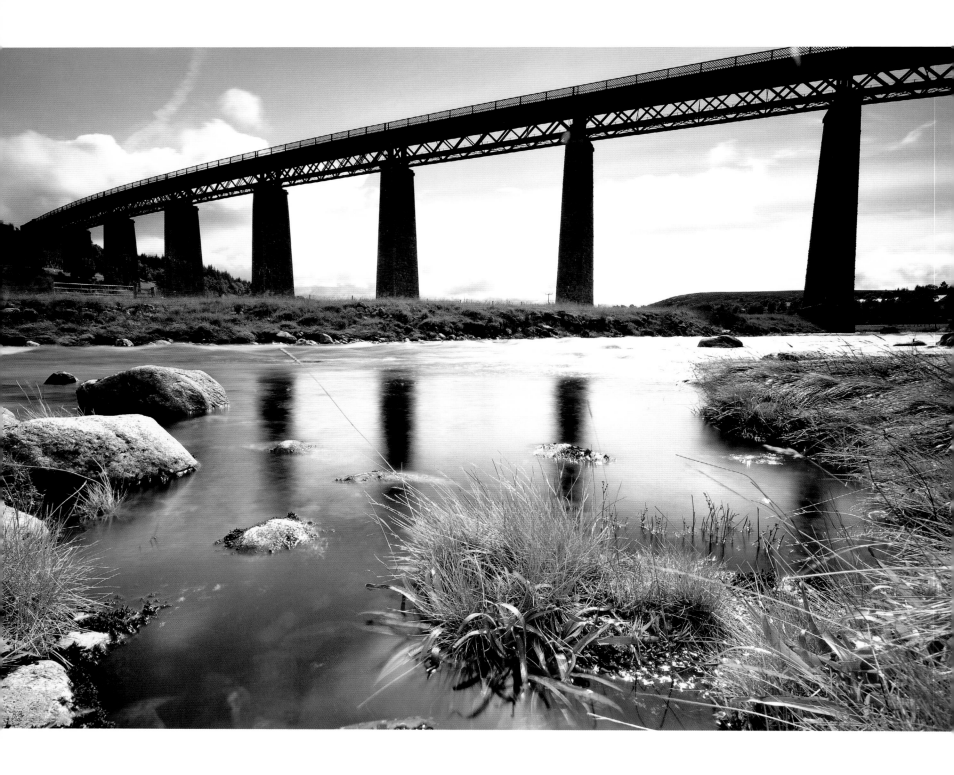

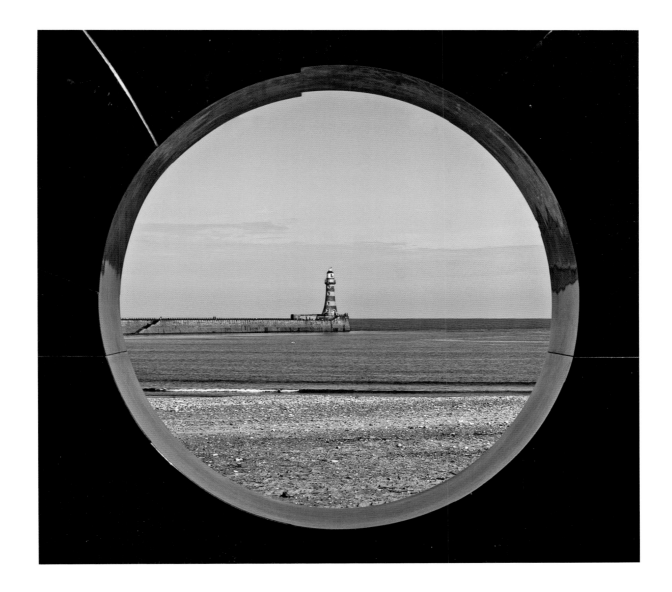

CLASSIC VIEW YOUTH CLASS WINNER

SAMUEL BAYLIS

Findhorn Viaduct
Near Tomatin, Scotland

This viaduct conveys the main Perth to Inverness railway line. It is 49 metres high and 400 metres long with nine spans of lattice-steel structure on stonework piers. It is a very impressive piece of architecture and makes a great image with the River Findhorn flowing underneath it.

EMMA HOLLINGS

The End of the C2C Cycle
Sunderland, Tyne & Wear, England

This photo was taken after cycling the 152-mile Coast to Coast route from Whitehaven to Sunderland. I chose to frame this shot through the finishing circle of the C2C. The effect is like a camera shutter, as though you are looking through the lens. The calmness of this photo is portrayed though the horizontal lines, along with the symmetry of the lighthouse. This was a great contrast to the hard work of cycling 50 miles a day for three days.

LIVING THE VIEW
adult class

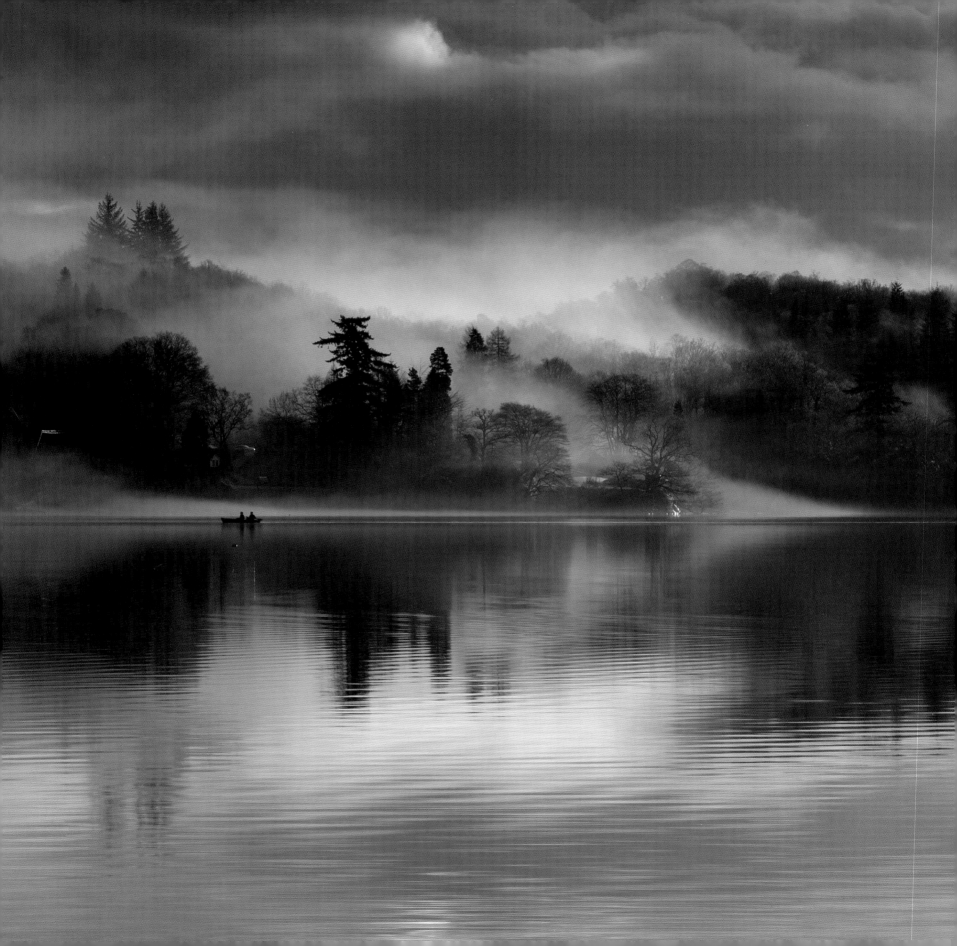

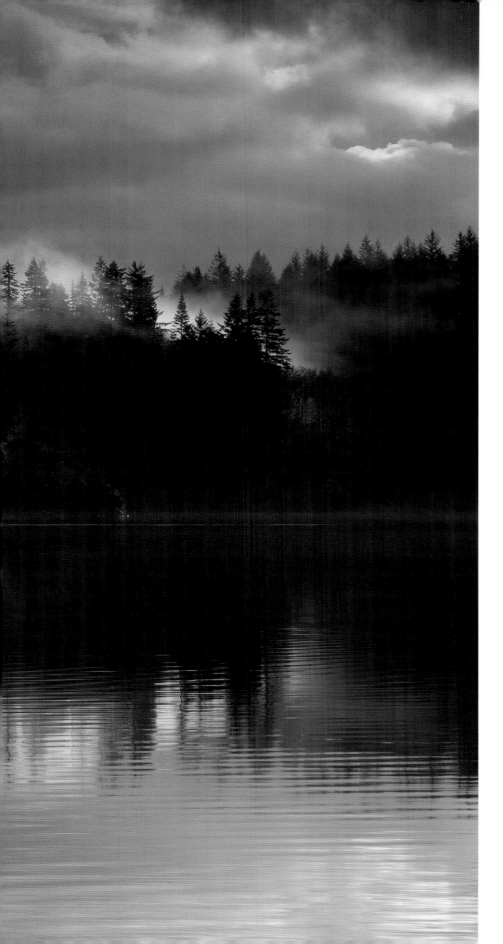

LIVING THE VIEW ADULT CLASS WINNER

←··· PAUL BUNDLE

Fishermen on Loch Ard
Trossachs, Scotland

Dawn in March and it was raining at Loch Ard, but there was broken cloud appearing in the west. Gradually the sky cleared and the water surface calmed, but mist started enveloping parts of the Loch. For over an hour, the scene kept changing from clear views to quite dense mist. It was fascinating to see the trees appearing and disappearing with mist clinging to the contours. I had just taken a clear sunlit reflection shot towards the western end of the Loch when at the opposite end the mist was lifting and the clouds were breaking, revealing an almost monochromatic mixture of light, shadow and reflection. The boat and two fishermen completed the scene. I hope their fishing was as enjoyable as the photography.

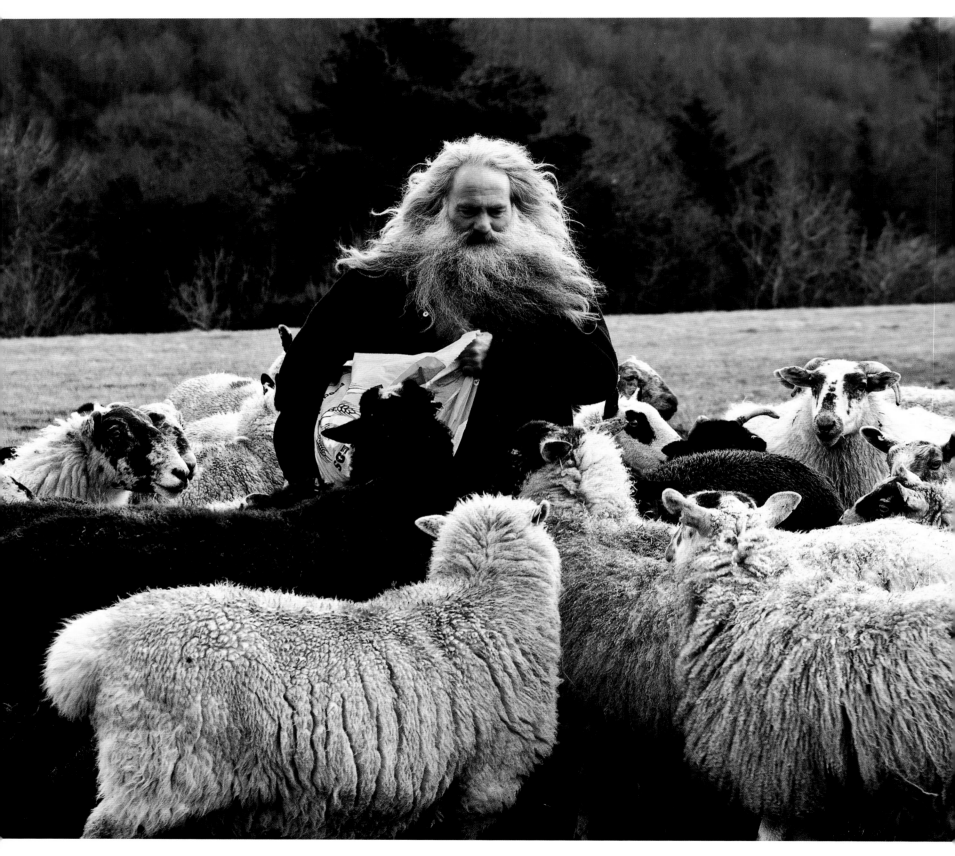

Winter Evening Walk
Near Kilmacolm, Inverclyde, Scotland

This image only came about because it was exceptionally cold (−15°C). As we walked along the cycle path near our home, we saw the dog walker ahead of us and he turned off the path and headed down towards Auchenbothie Mains House near Kilmacolm and into the most amazing light! The truly great pictures, I believe, are the ones taken on the camera and not assembled from many sources to make up one that never existed. I've been capturing images since I was a teenager. My interest in photographing 'almost anything' has created a fascinating record of ordinary scenes that many would walk by without a second glance. I'm a self-taught photographer and find that our Scottish landscape and seascapes provide ample opportunities to capture our distinctive light throughout the various seasons. Many of my most successful images are of my local area.

NICK LIVESEY ···>

Castles in the Sky
The Aonach Eagach, Glen Coe, Scotland

Towering above Glen Coe, the Aonach Eagach ridge is one of the most revered mountaineering challenges in Britain and a career highlight for many hill-goers. New Year's Eve saw me and a good friend making a 5am start in order to arrive on the ridge at sunrise. That we did, but what we didn't expect was a wonderful temperature inversion, which lasted until sunset and our descent in darkness. This shot was particularly hard won, as the ridge was coated in a treacherous veneer of verglas but, that morning, everything came together and I was treated to a photographic bonanza. Of the many days in the mountains I've enjoyed since, the hours we spent on the Aonach Eagach remain some of the finest of my entire life.

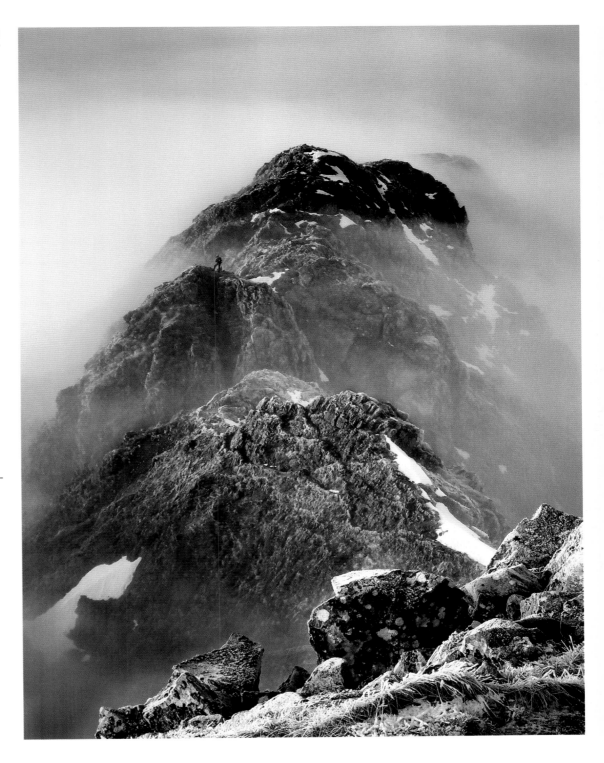

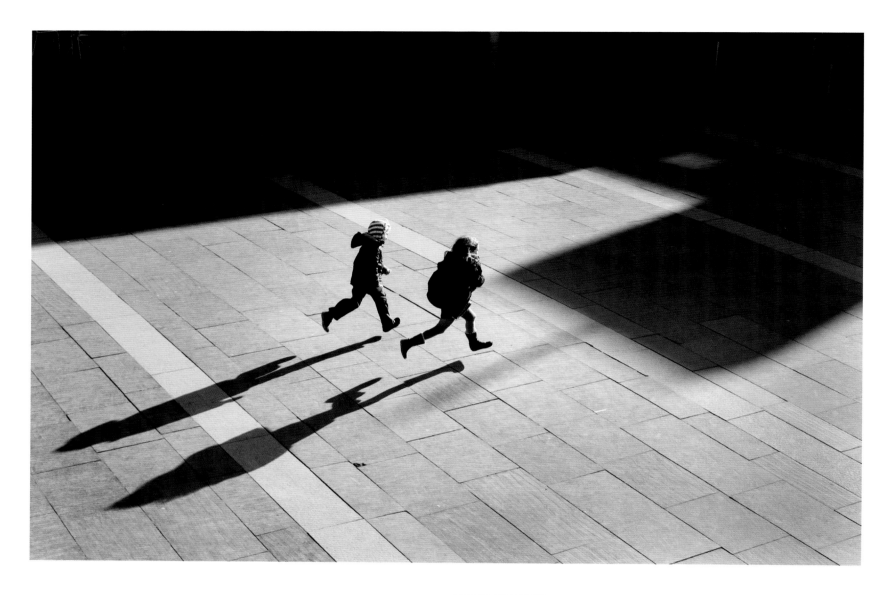

⚑ TATIANA ZIGAR

Weightlessness
South Bank, London, England

This was taken in front of the National Theatre on the closing day of the Landscape Photographer of the Year 2011 exhibition. It was a nice sunny winter's day and, after I had visited the exhibition, I decided to hang around in front of the theatre to watch people, enjoy the sun and look for shots. My camera was at hand as usual. I went up the stairs (one of my favourite positions is to shoot from above), which were just near the entrance and noticed a nice frame on the ground made by shadows. When I saw the kids running I composed the shot and waited for the 'decisive moment' to take the image.

KAYODE OKEYODE ⤏

London When it Snows: Big Ben and Lovers
London, England

This image was taken on Westminster Bridge. It was a planned visit and I'd known for a while that it was going to snow on that night. I was on the bridge for 30 minutes looking for pictures. I was rewarded with this couple and I was happy to see the girl raise her left leg because I thought it expressed just how she felt at that moment. The bus coming into view was great timing, but I have to admit that I was praying for it!

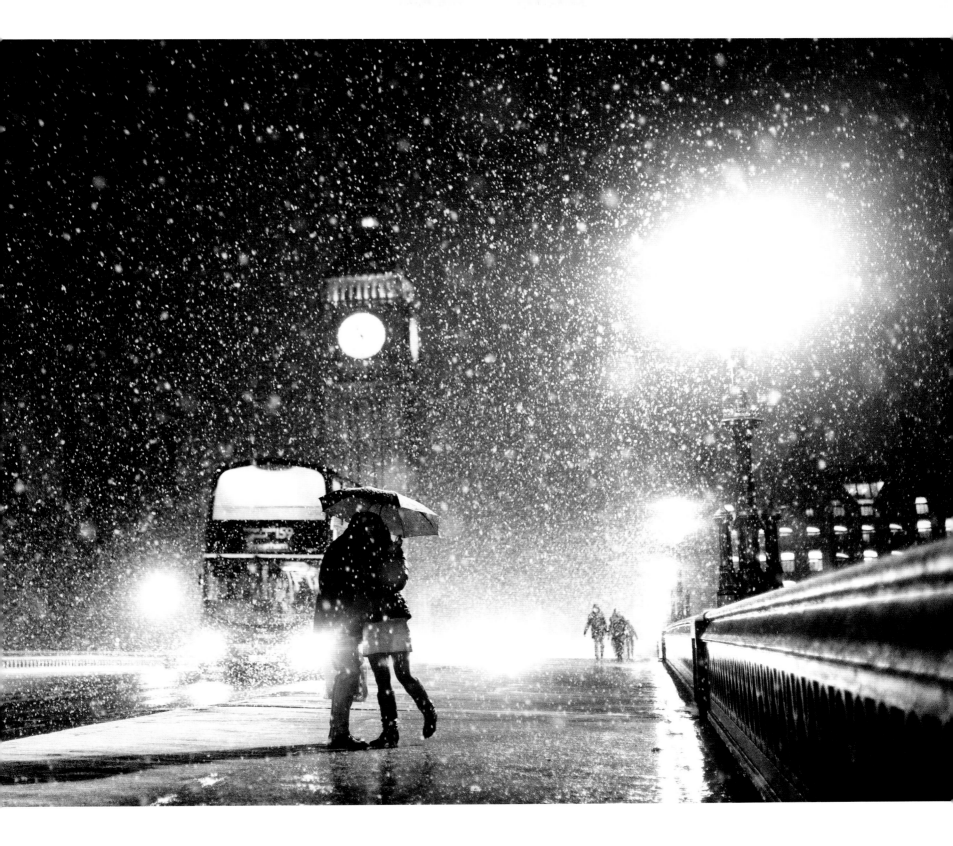

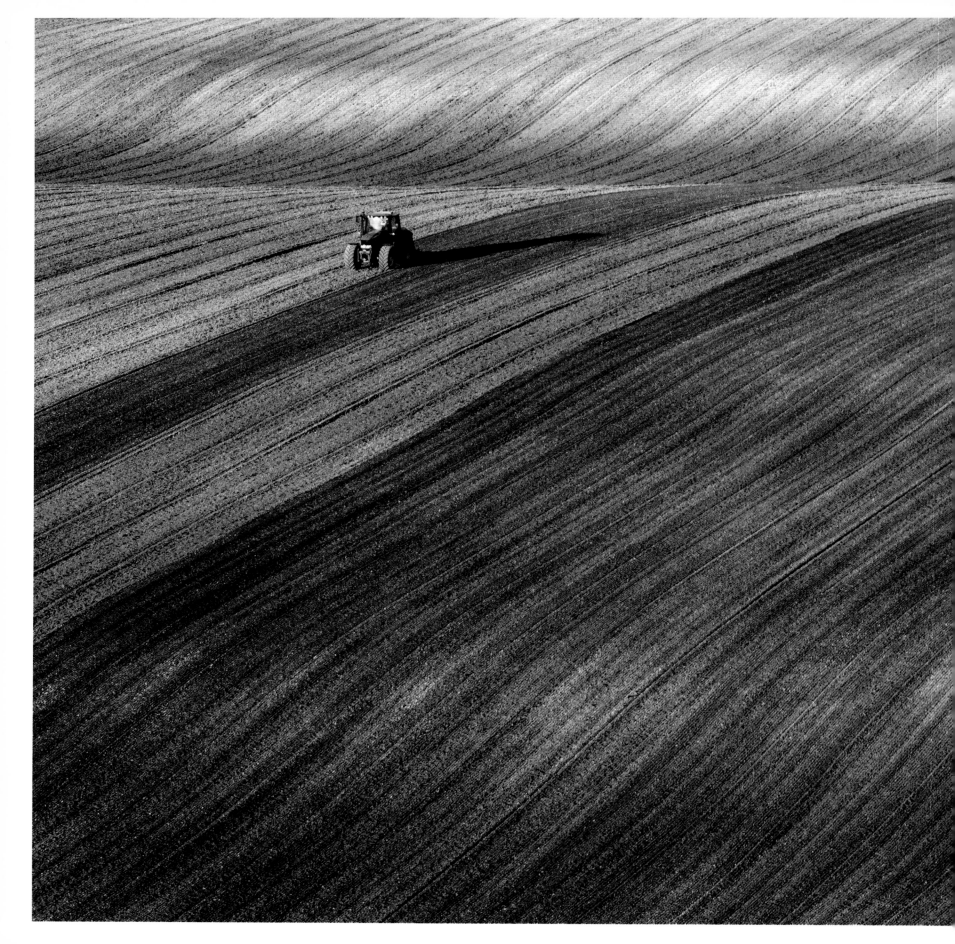

⋖··· ROGER VOLLER

Accomplish
South Downs National Park, Hampshire, England

I enjoy exploring my local area to find any unique compositions, so decided to let my feet follow a wild footpath across an overgrown rapeseed field as, in the distance, I could see some open landscape views. When I made it out of the overgrowth, I didn't expect to immediately stumble across this stunning view. Then I just waited patiently for the tractor to be in a good position to finalise my composition.

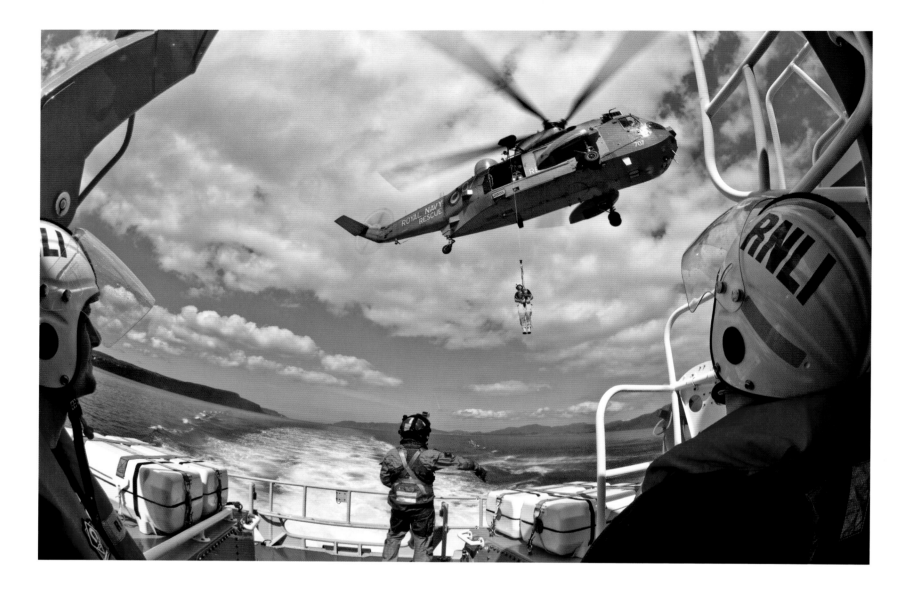

SAMANTHA JONES

Tobermory Lifeboat on Exercise with Rescue 177
Sound of Mull, Scotland

As a photographer and member of the Tobermory RNLI lifeboat crew, I am in the privileged position of being able to photograph training and 'shouts' from the very heart of the action. This image was taken during an exercise in the Sound of Mull with the Royal Navy's search and rescue helicopter, call sign Rescue 177. I thought that the fisheye lens might work well in the confined space of the aft deck, with a slow shutter speed to blur the helicopter rotors. First, I had to be winched into the helicopter. After an exhilarating few minutes, I was winched back onto the lifeboat, grabbed my camera and took this shot of our mechanic, Jock Anderson. For once, my pre-visualisation worked.

NICK SHEPHERD ···→

On Top
Slapton Sands, Devon, England

This image was taken at Slapton Sands in south Devon. The aim was to convey the intricate beauty and power of a single wave. The low viewpoint and inclusion of a passing yacht were chosen to add contrast and scale.

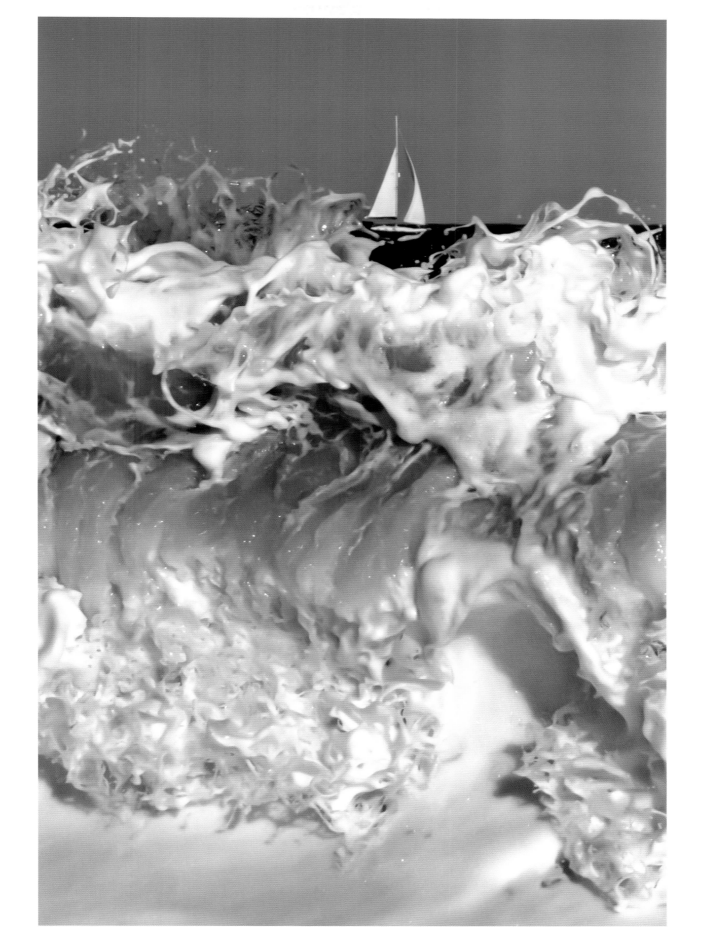

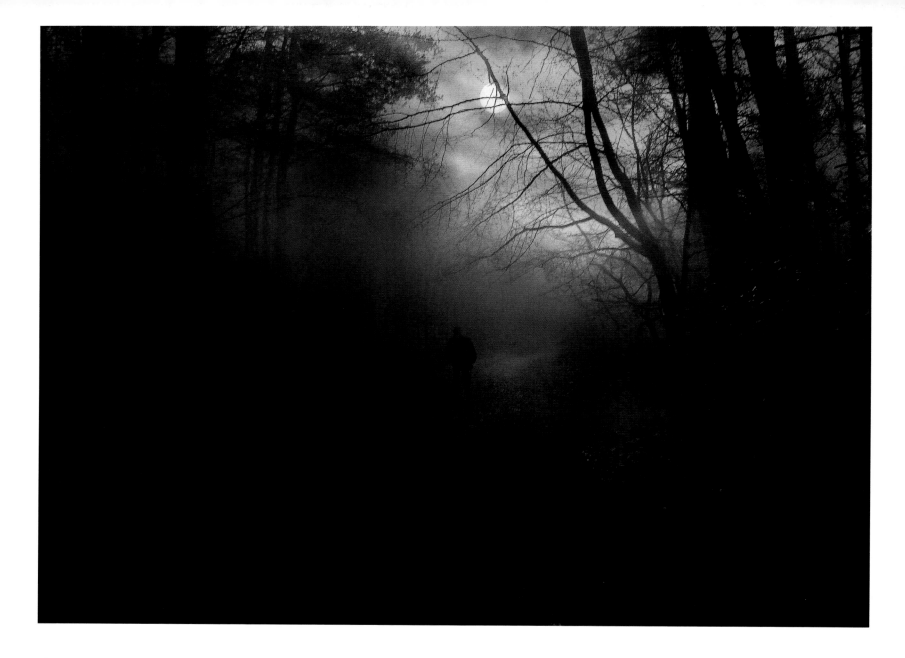

⁙ RAY BEER

Dark Forest
Near Chideock, Dorset, England

Langdon Hill Woods are above Chideock in west Dorset. As I live nearby, I visit them
often to exercise my dog. Having regular access to these woods, I have the privilege
of witnessing the ever-changing seasons, whose mood is heightened by the sea mists
that regularly hang over the woods. On one such occasion, I was lucky to be at the right
place at the right time.

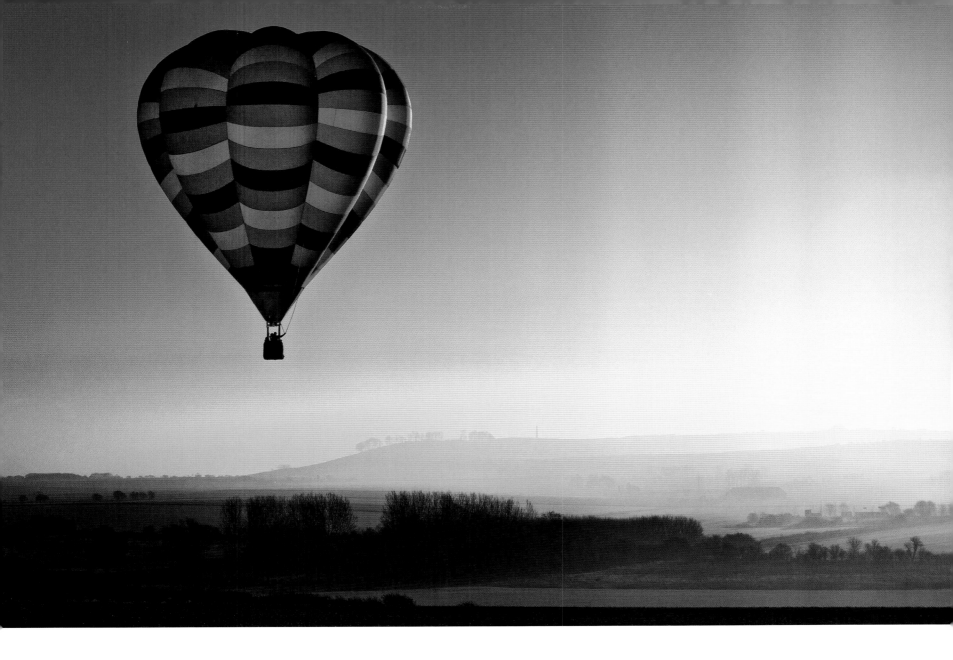

ANNA STOWE

An Evening Flight over the Wiltshire Downs looking to Cherhill
Wiltshire, England

I had been standing by the tripod hoping for a dramatic sunset when suddenly the balloon drifted into view. I waited until it had floated into just the right position before clicking the shutter. The warm light of the setting sun gave a lovely glow to the balloon's envelope.

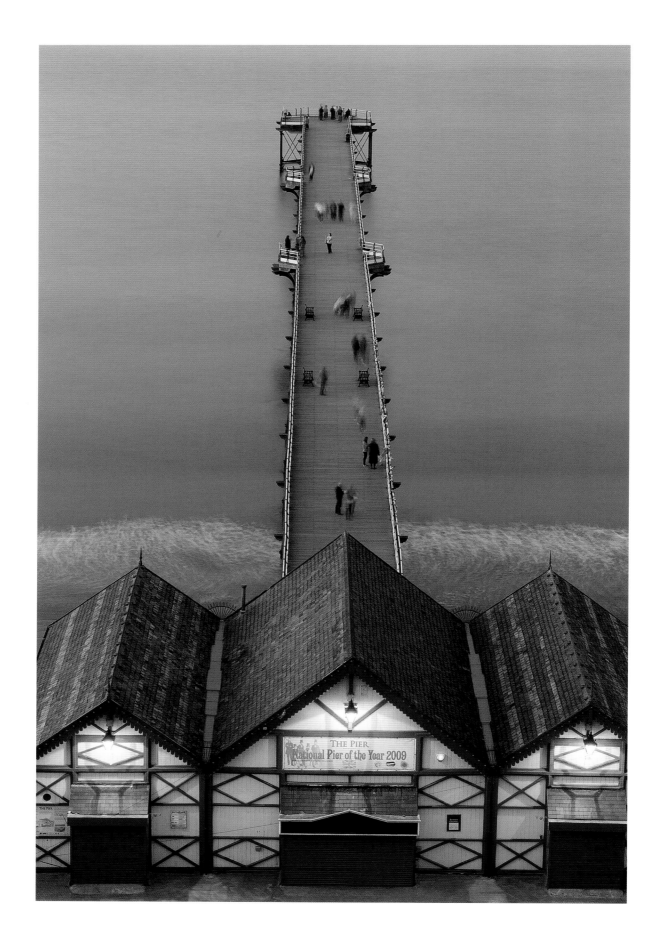

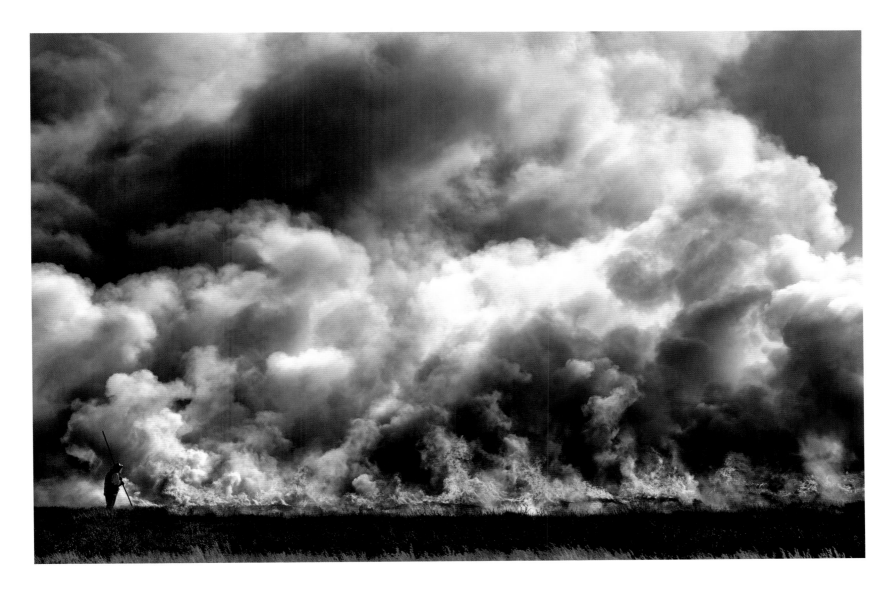

◄··· IAN LAMOND

Evening Walk along the Pier
Saltburn-by-the-Sea, North Yorkshire, England

After an evening photographing Saltburn, I reached the top of the cliff as the pier lights were switched on, creating a lovely mix of cool and warm light. I will forever thank the lady who stood still in the centre of the pier as everyone else became blurred.

⫮ PAUL WILSON

Heather Management
North Yorkshire Moors, England

I was travelling along the A171 between Whitby and Middlesbrough when I saw huge plumes of smoke billowing into the air from the North Yorkshire Moors. On investigation, I found it was controlled heather burning. This process is carried out between April and October, stimulating new growth, and provides good grazing for sheep and an ideal habitat for wild birds. I approached (with caution), taking a few shots at varying focal lengths with the sun partially backlighting the smoke and creating a shadow over the flames, making them stand out against the dark background. I framed the shot with emphasis on the smoke, placing the 'beater' in the bottom corner to provide scale and show the enormity of the scene.

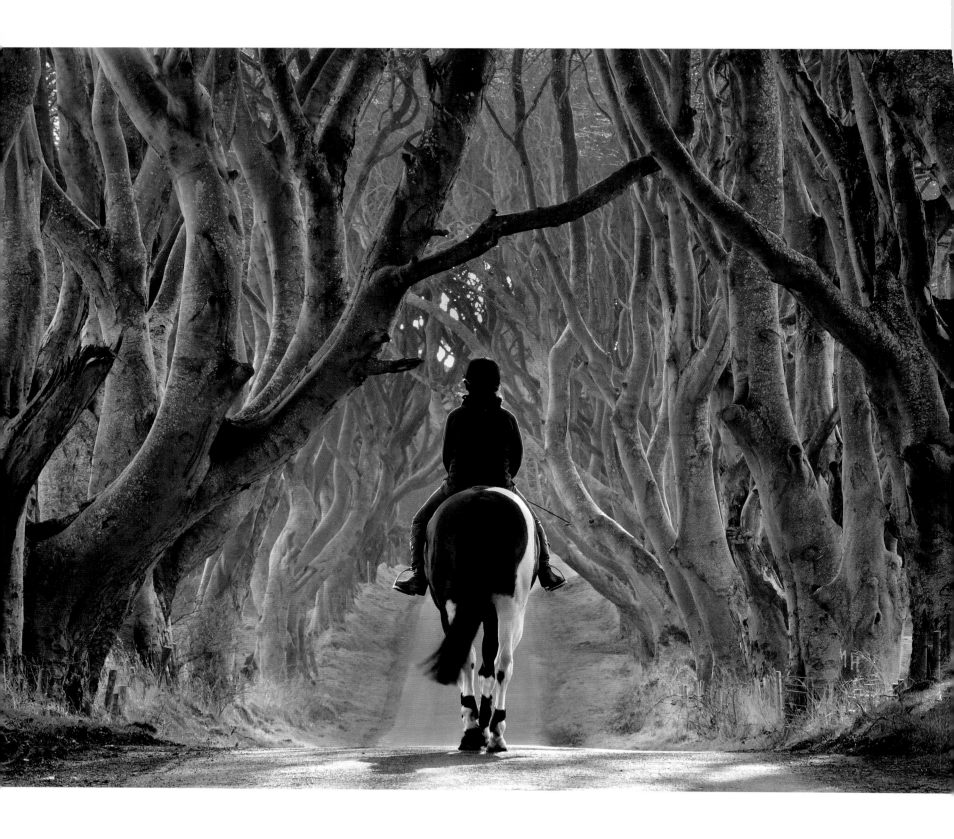

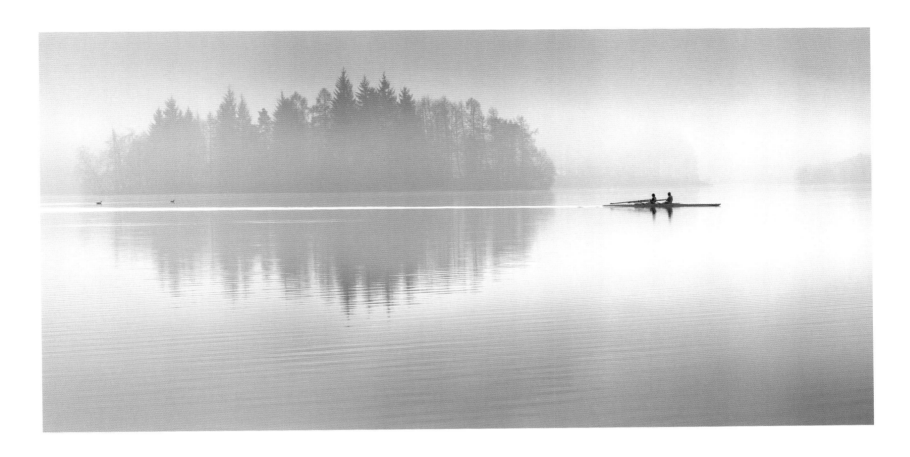

BOB McCALLION

Riding Out, the Dark Hedges
County Antrim, Northern Ireland

These 300-year-old beech trees are nearing the end of their natural lifespan and have become world renowned for their beauty and majesty, forming an entwined arch over the road below. It was here on a quiet Sunday morning in March that I had a chance encounter with Melanie and her horse, Rocky. From a series of shots, this one seemed to stand out because of the 'swish' of the horse's tail. It was early spring and the soft light and lack of greenery convinced me that the final image would look best in black and white.

OMER AHMED

Scull Boat on Loch Ard
Trossachs, Scotland

The sheltered position of Loch Ard (the High Loch) in the Trossachs National Park allowed a dense morning fog to linger. The isolated forms of tree-covered headlands started to appear and the silence was broken only by the splash of the blades.

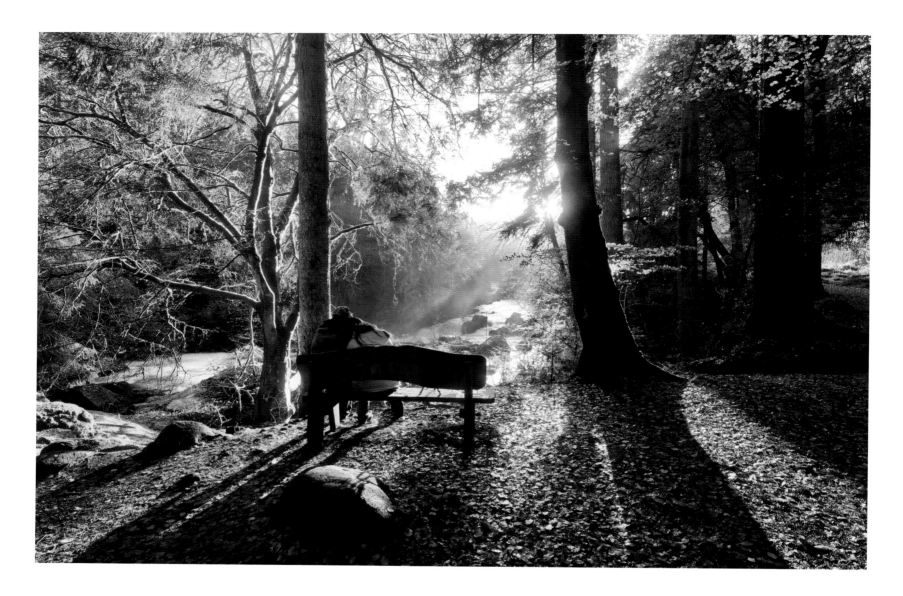

PHILIP STEWART

Autumn Retreat at the Hermitage
Dunkeld, Perth and Kinross, Scotland

The Hermitage is a fantastic location, full of history. It was home to the tallest tree in Britain for some time. I have paid many visits here in all seasons, but it is autumn when the Craigvinean Forest comes alive with colours. I wandered around the forest for hours, and lost track of time, taking in the surroundings. As the sun dipped lower in the sky, the light became more intense and the long shadows grew along the ground. I came across a couple taking in the view on a bench looking up the River Braan, which really completed the composition and overall feel of the image for me.

PETER LAURENCE DOBSON ···>

A Winter Walk
Lytham Green, Lancashire, England

A big freeze had frozen moist sea air onto the trees surrounding the iconic summer house on Lytham Green. A couple of dog walkers complemented the winter wonderland scene.

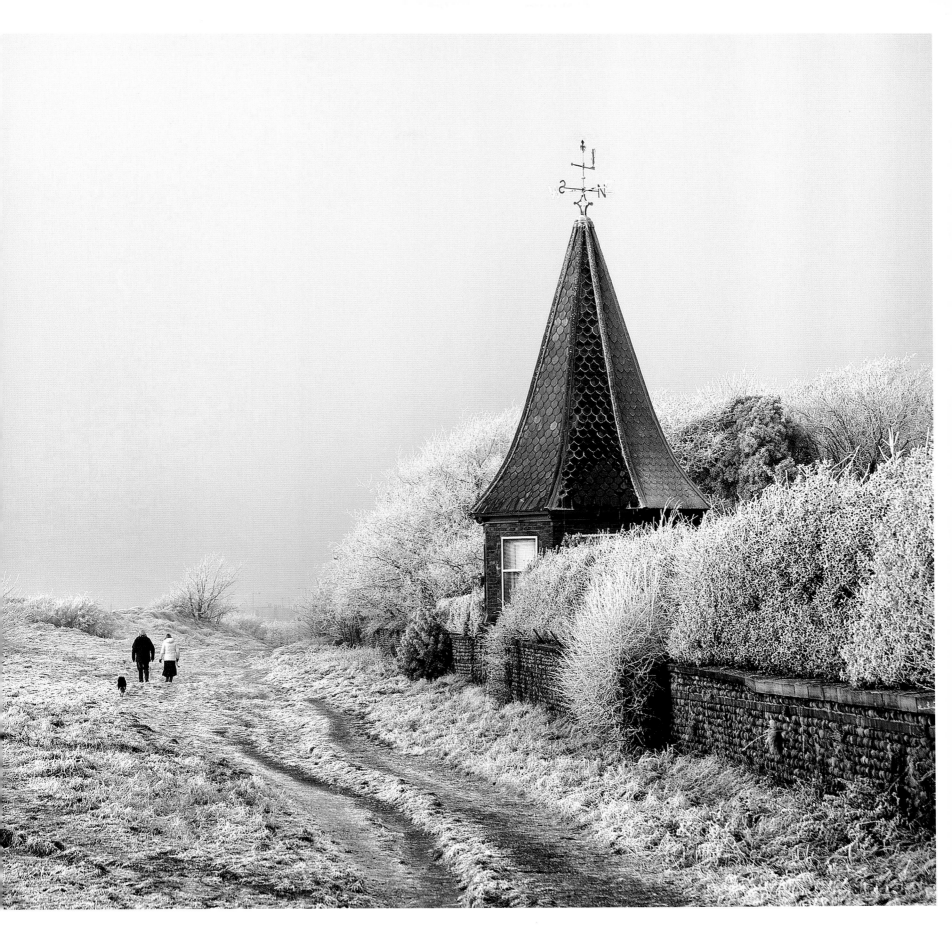

URBAN VIEW
adult class

URBAN VIEW ADULT CLASS WINNER

SIMON BUTTERWORTH ⋯⟩

Condemned
Port Glasgow, Inverclyde, Scotland

An imposing row of traditional Scottish tenement buildings. The opposite side of the street was demolished by German bombing in World War II.

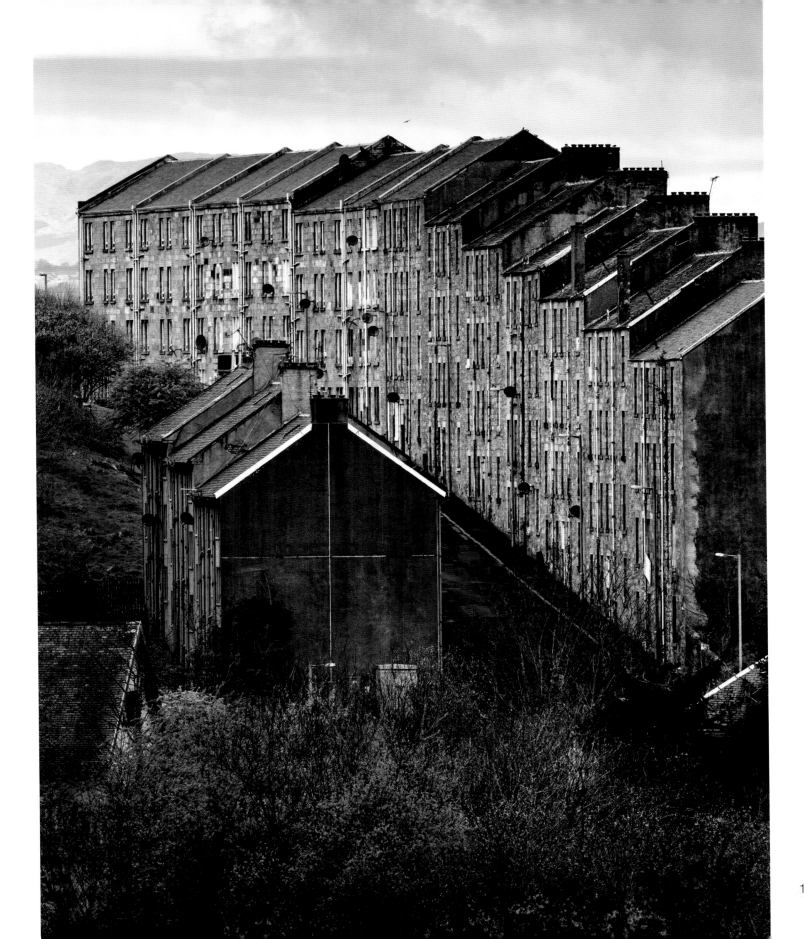

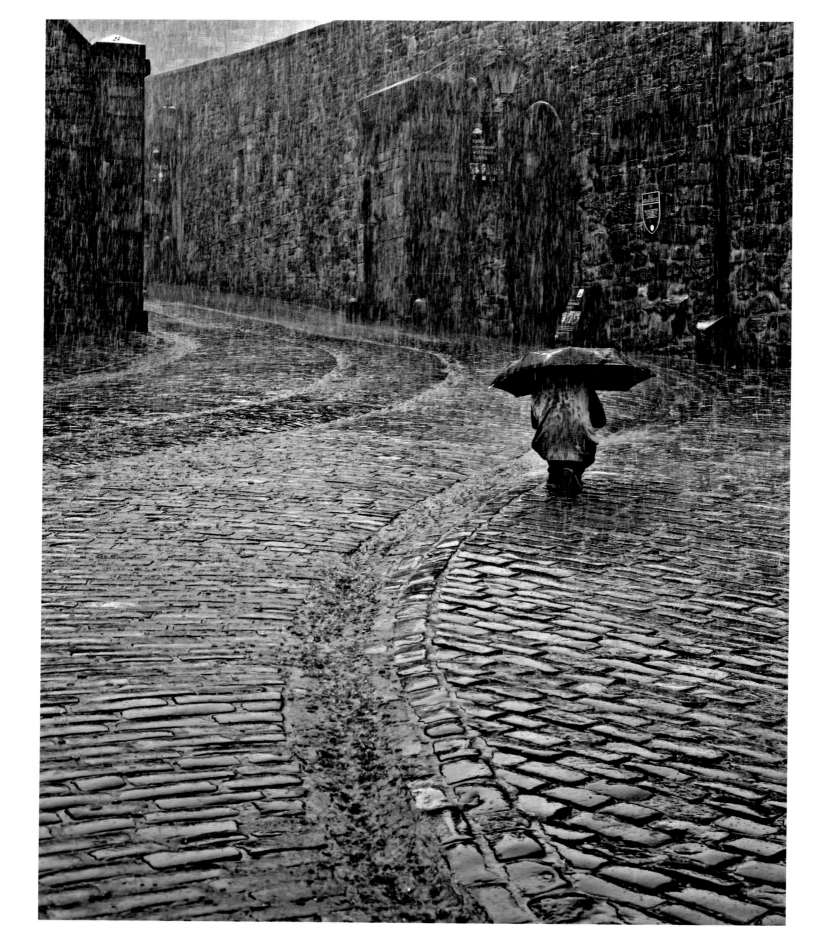

URBAN VIEW ADULT CLASS RUNNER-UP

←··· **BILL TERRANCE**

Light Rain in Edinburgh
Edinburgh, Scotland

The picture was taken at Edinburgh Castle. During our visit, there was a thunderstorm
and most people took shelter in the castle entry gate. All except for this hardy soul who
preferred to wait it out in the open.

Judge's Choice David Watchus

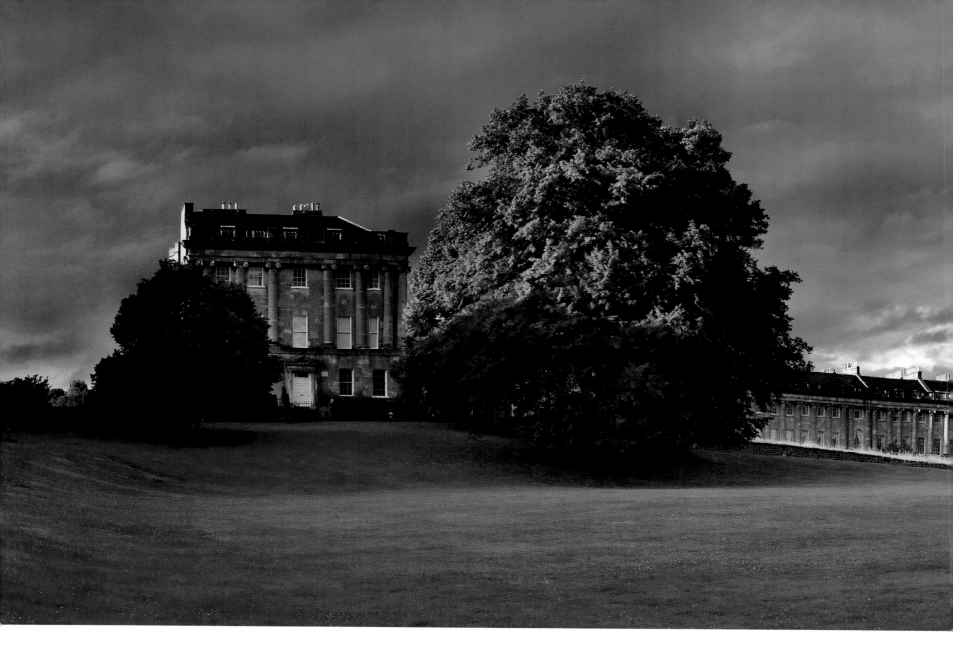

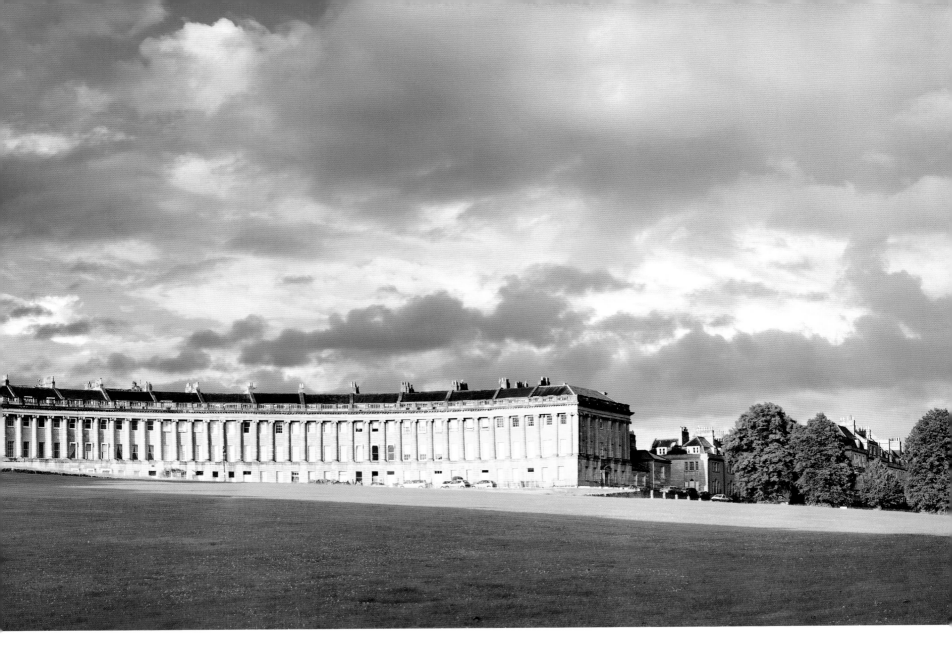

ALEX HARE

The Royal Crescent
Bath, England

During a visit to Bath, the persistent rain and stiff breeze persuaded me to have a go at this location. I set up my tripod in the rain, covered myself and my camera in a waterproof and waited. I just felt that the sky might open up, however briefly, and let some low late afternoon light in. This shaft of light only lasted a couple of minutes, but it was enough to take this shot because I was all primed and ready.

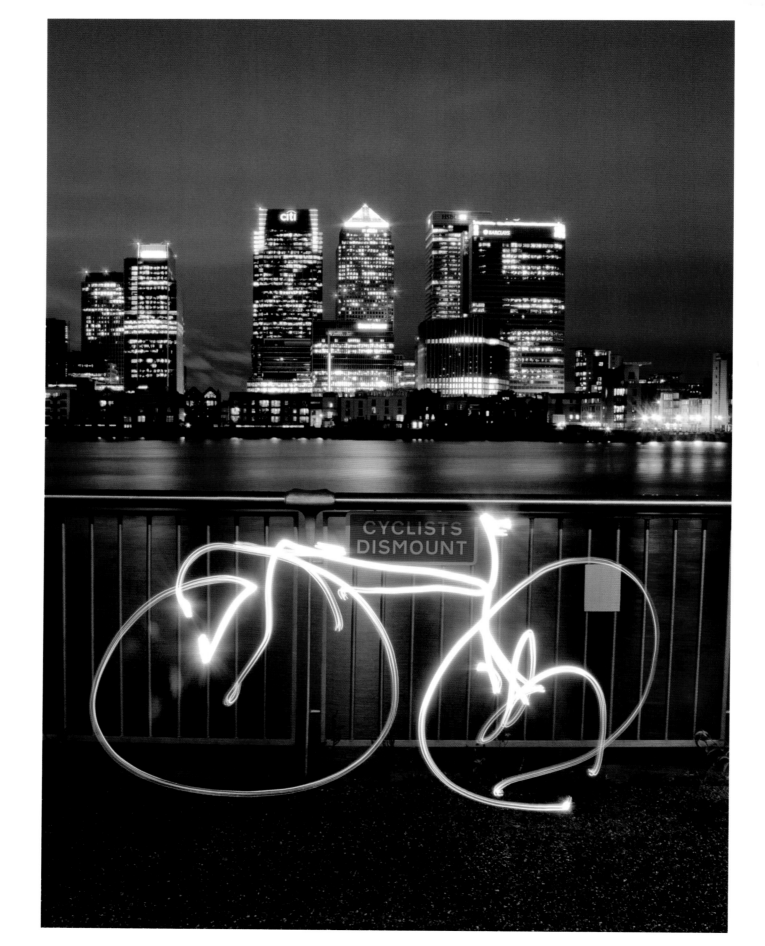

Cyclists Dismount
London, England

This image was taken near the O2 centre in North Greenwich on a summer's evening. The aim was to capture photos of London's iconic Canary Wharf skyline on the opposite bank of the River Thames. After taking several images at various locations and from various perspectives, I came across the sign 'Cyclists Dismount'. Since there were no cyclists at that time of night, here was an opportunity to show that photography really does mean 'painting with light', as I decided to add my own bicycle to the urban scene in front of me. After a couple of mental rehearsals, I pointed a small torch at the camera and, with the shutter open for several seconds, drew a parked bicycle. Amazingly, it worked first time.

GILES McGARRY ···> HIGHLY COMMENDED

Inauguration
The Shard, London, England

This is a shot from the Shard inauguration evening, where a spectacular laser show was taking place. Whilst the show was certainly colourful, I'd always planned on a mono version with the lasers contrasting against the dark night sky.

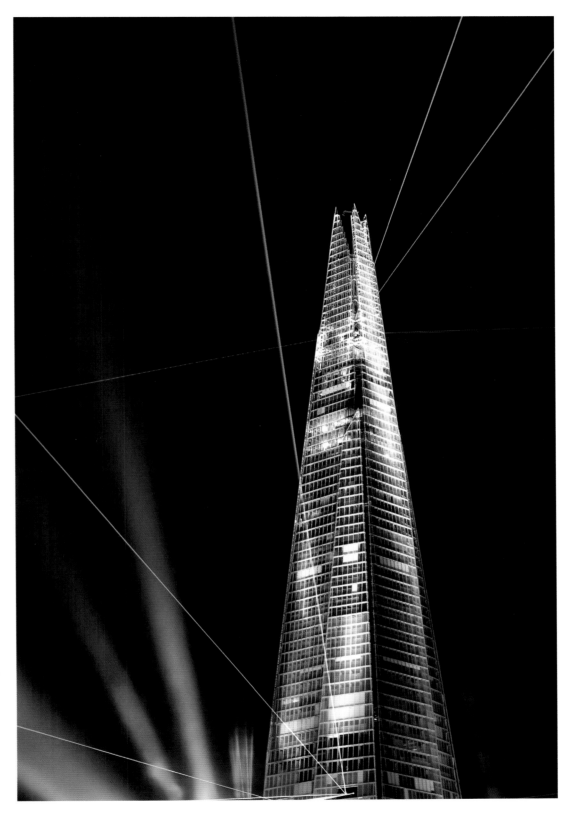

133

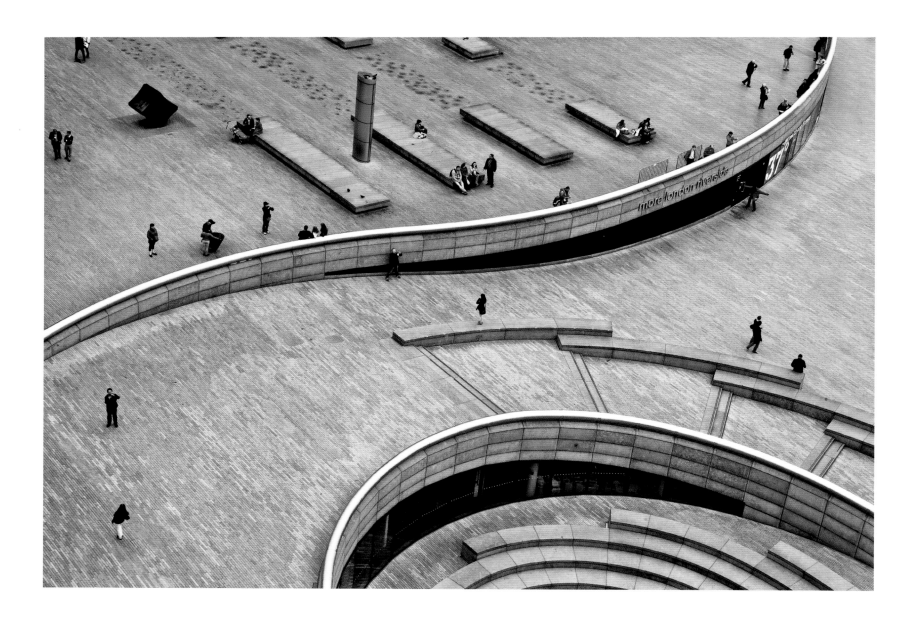

✝ **ROSALIND FURLONG**

More London from City Hall
London, England

More London is one of the most photogenic parts of the capital, with its spectacular modern architecture and vistas along the Thames. I was there with some fellow students to photograph the architecture inside City Hall. Our first stop was outside on the viewing deck, but the steely grey sky was not doing any favours to my shots of Tower Bridge. Deciding to look for something else, I walked to the other side and noticed that the walls around the Scoop, the sunken amphitheatre in the pedestrian plaza next to the river, made an interesting pattern when seen from above, punctuated by little groups of tourists.

134

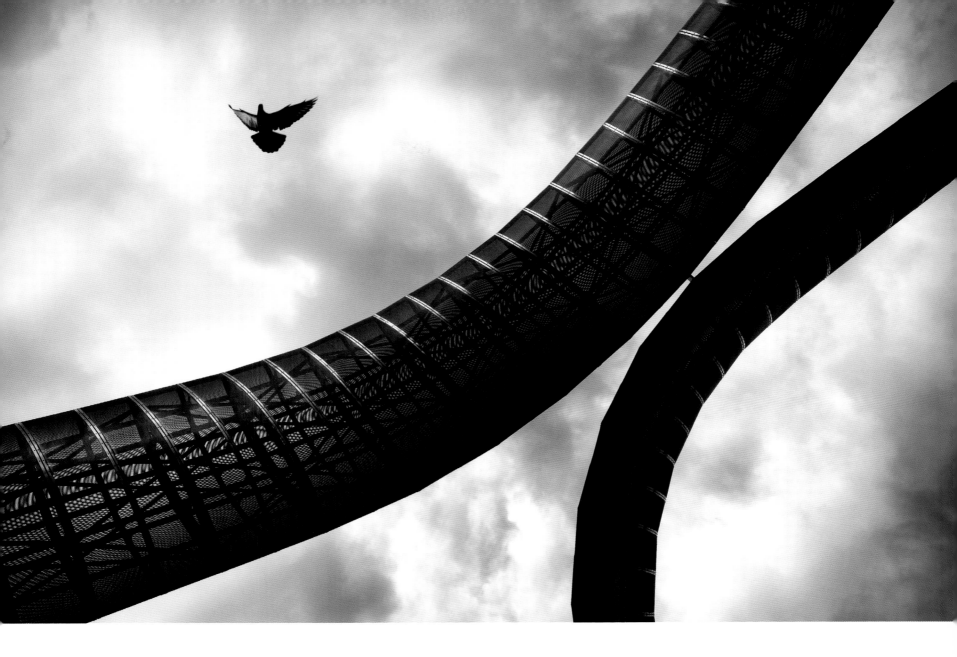

✝ RUSS BARNES

Departure
Coventry, England

This image, from Coventry city centre, was about capturing the juxtaposition of natural flight against an abstract of these man-made 'wings'. This is fitting, as the urban architecture on show here is a permanent tribute to Coventry-born Sir Frank Whittle, who is accredited as the inventor of the jet engine and enabler of modern flight. It's a favourite resting place for the acrobatic city pigeons, so it was just a matter of timing, patience, angle and some great side light that eventually presented the right moment as a lone bird launched itself from this imaginative structure.

135

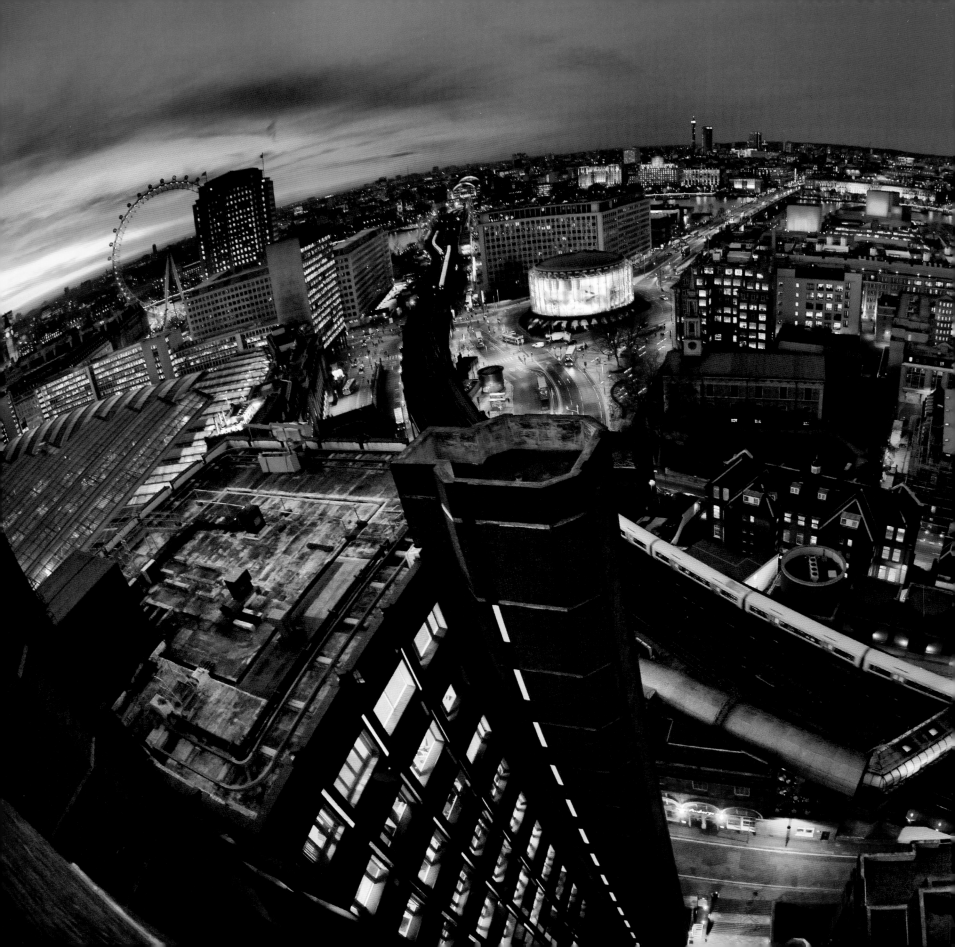

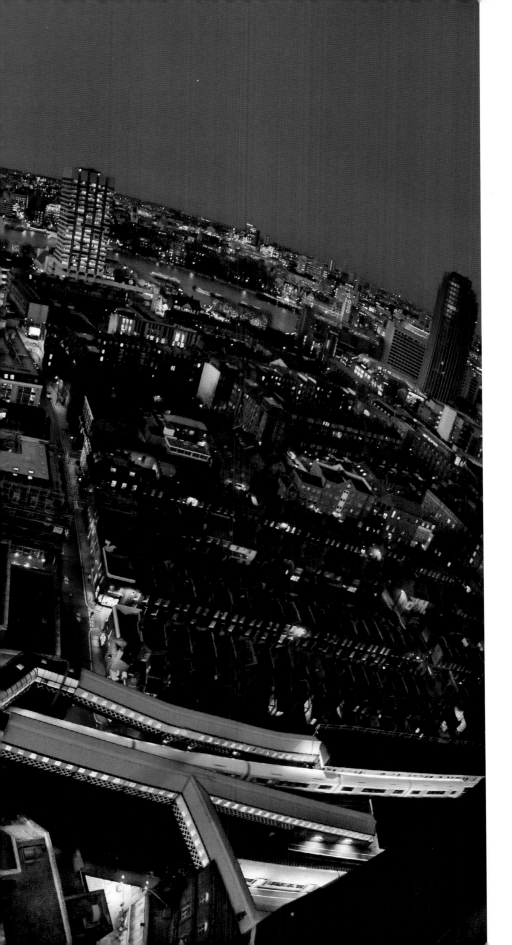

⟨··· ION PACIU

Sunset from a Rooftop
London, England

I teach photography and I was running a one-to-one on a beautiful spring afternoon when suddenly I noticed the wind was getting really strong and the colour of the sky had a lot of potential.
I told my student, 'Let's go up, this is going to be a really nice evening!' In a few minutes we were on the roof of the Union Jack Club building near Waterloo Station. The building has 24 floors and offers an amazing view across central London. My student was bored while I was trying to explain that patience is one of the most important skills in photography. After about an hour of 'boredom', the sky started to change and he rushed to the camera but I said, 'Let's wait, we need more time.' A little later, we started to prepare for the shoot. We were both pleased with the results in the end.

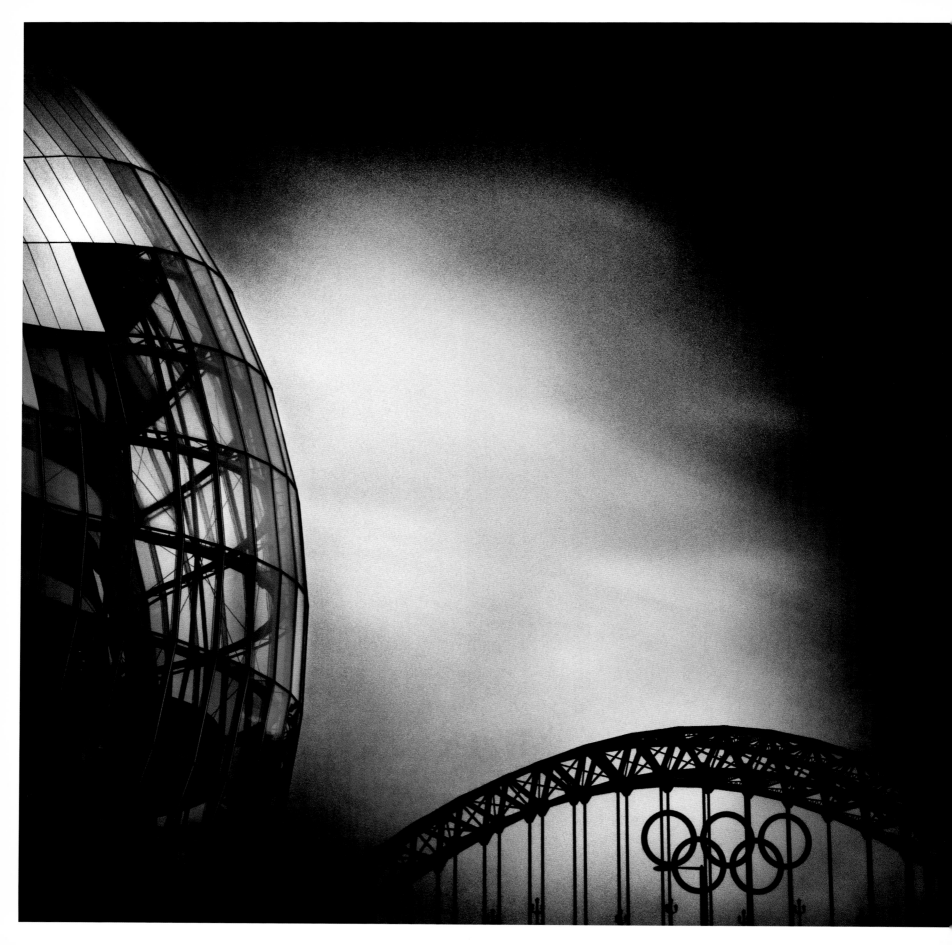

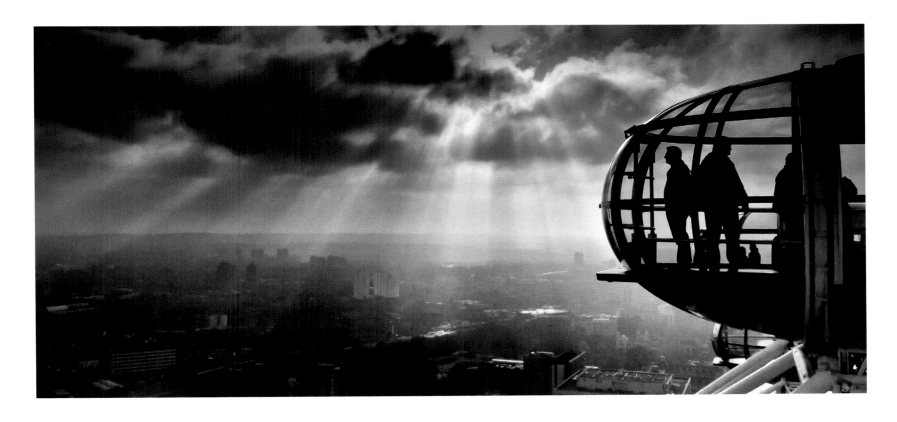

KAREN ATKINSON

The Sage Gateshead and the Tyne Bridge
Newcastle upon Tyne, England

At 3:45am I arrived at Gateshead Quays ready for Plan A: a sunrise spotlighting the Tyne Bridge and its newly installed giant colourful Olympic rings, on the day that the Olympic Torch Relay would be welcomed 12 hours later and a celebrity was to zip slide from the bridge along the Quayside, holding the Olympic Torch. After an hour drenched in drizzle and no sun, I moved on to Plan B. By setting up on the verge below the glass frontage of The Sage, it was possible to marry its curves to the arch of the Tyne Bridge, while underlining the theme with the inclusion of the circular shapes of the Olympic rings. The two iconic landmarks come together in the image, reflecting the spirit of Newcastle and Gateshead united in celebration of forthcoming events.

MIK DOGHERTY

Admiring the View
London, England

This image was taken while on a day trip to London last November. At the time I only had my trusty DMC FZ38 crossover camera with me, as it was just a family day out and I only intended taking happy snaps, but the photographer in me always seems to take over. A man appeared to be talking to the person next to him, then he moved away, leaving this guy on his own just looking out and admiring the view across the London skyline. I couldn't resist. Then the sun burst through the clouds and completed the shot.

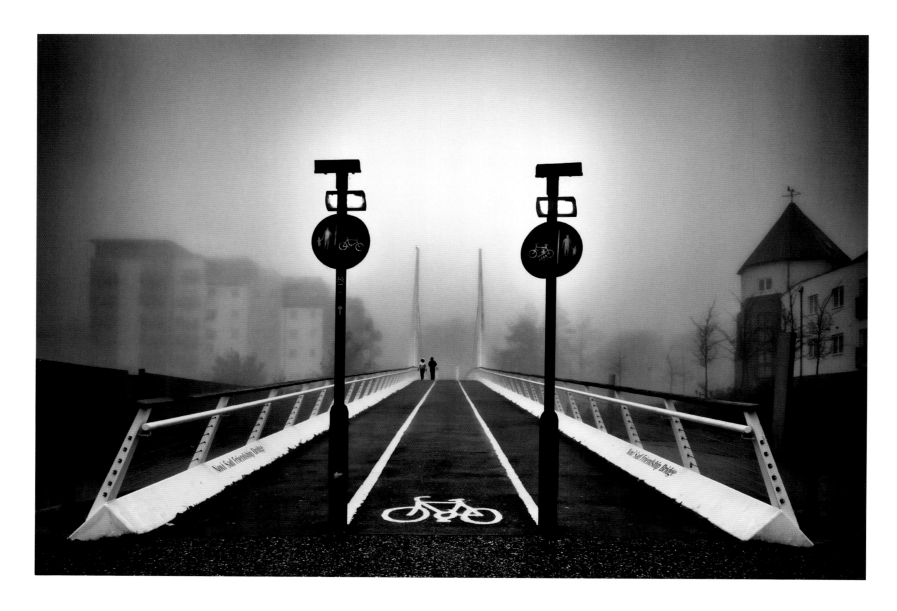

KATE BARCLAY

Dawn Walk
Norwich, Norfolk, England

This is an image I have been wanting to capture for several years, but the conditions never seemed right – I knew I wanted a heavy mist to give it the mood I was after. A heavy mist was forecast one weekend, so I got up pre-dawn hoping to capture the bridge before the mist disappeared. It turned out to be a fantastic day for me as the mist lasted all day. For this composition, I needed to sit in the middle of a road. Luckily no one was around except for a group of workmen who were very amused; they couldn't understand why I wanted to photograph a boring old bridge in a grey mist. I was happy, as it was just what I was after.

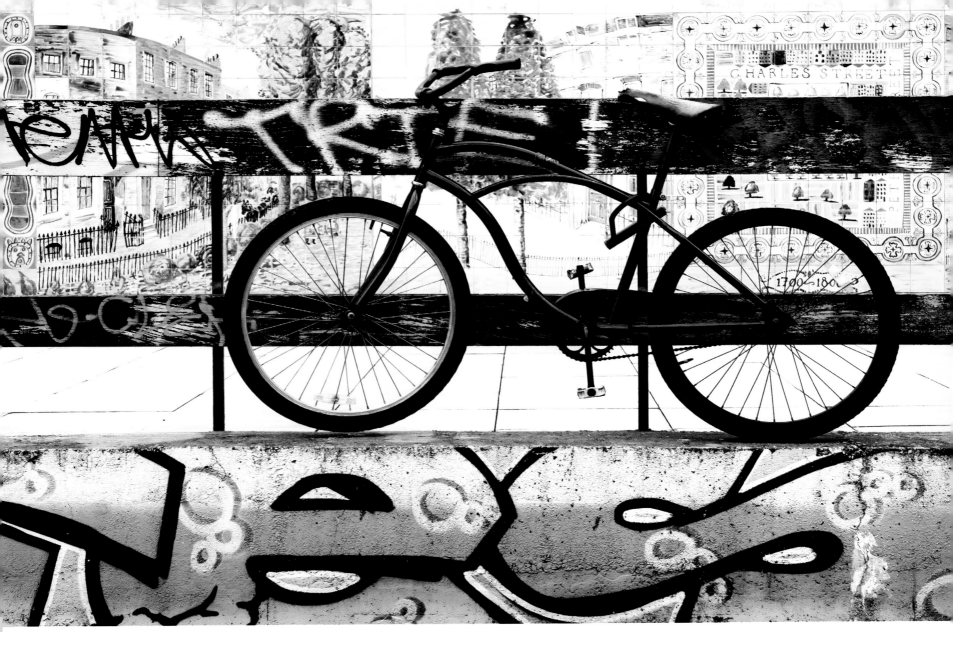

RADEK VIK

Near Old Street
London, England

This is probably the most beautiful bike I have ever photographed. It felt like it was there waiting to be photographed. East London is beautiful.

SLAWEK KOZDRAS ···>

XXIst-century Factory
London, England

An office building in central London. It reminded me of the old photos with rows of people working with sewing machines in a huge space. These days we do the same, but in office buildings like this one.

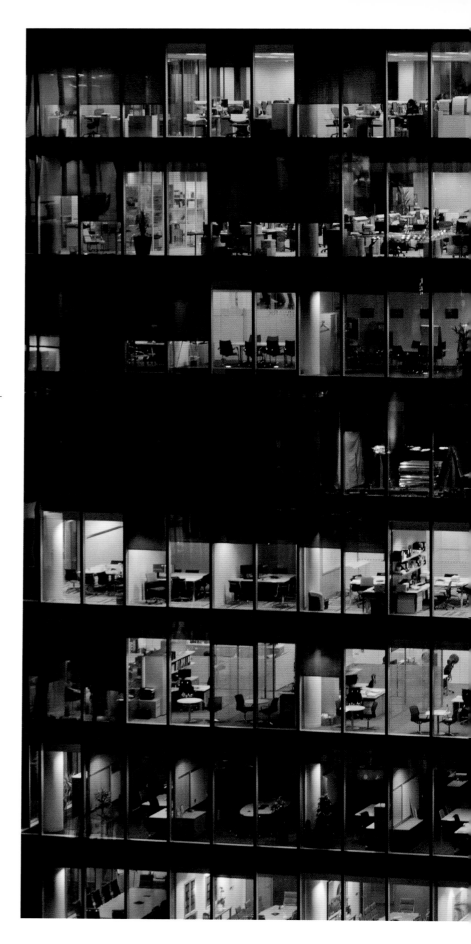

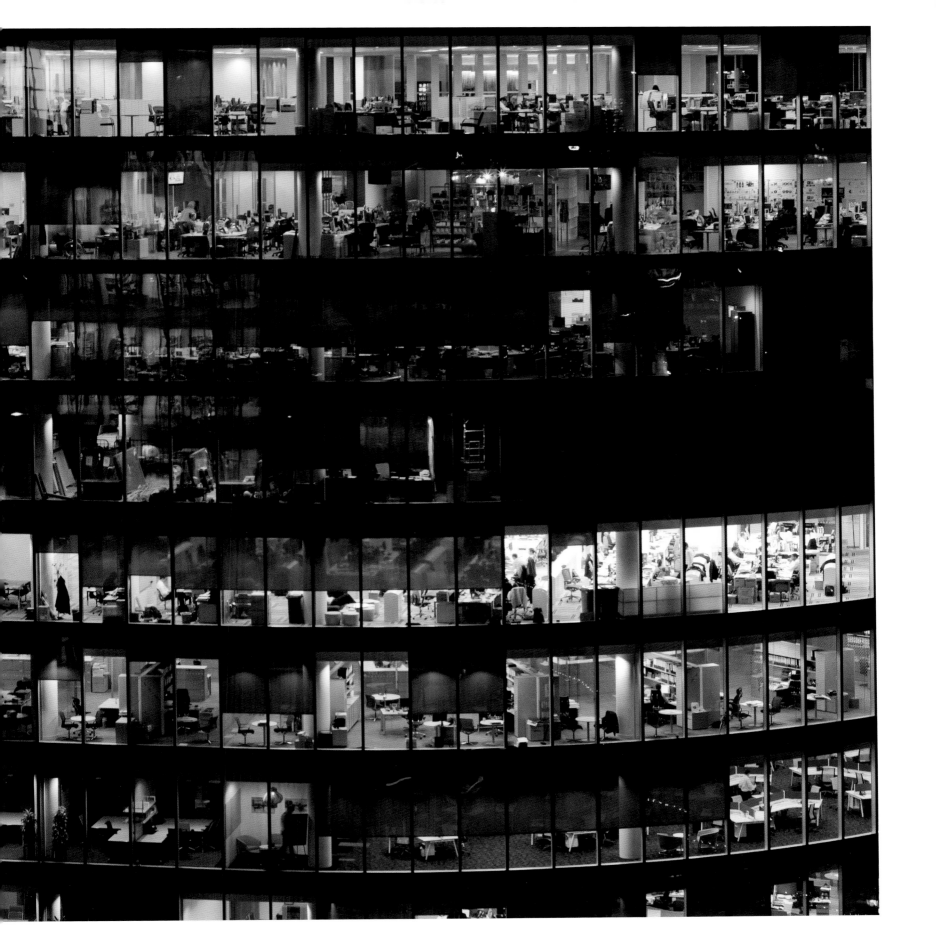

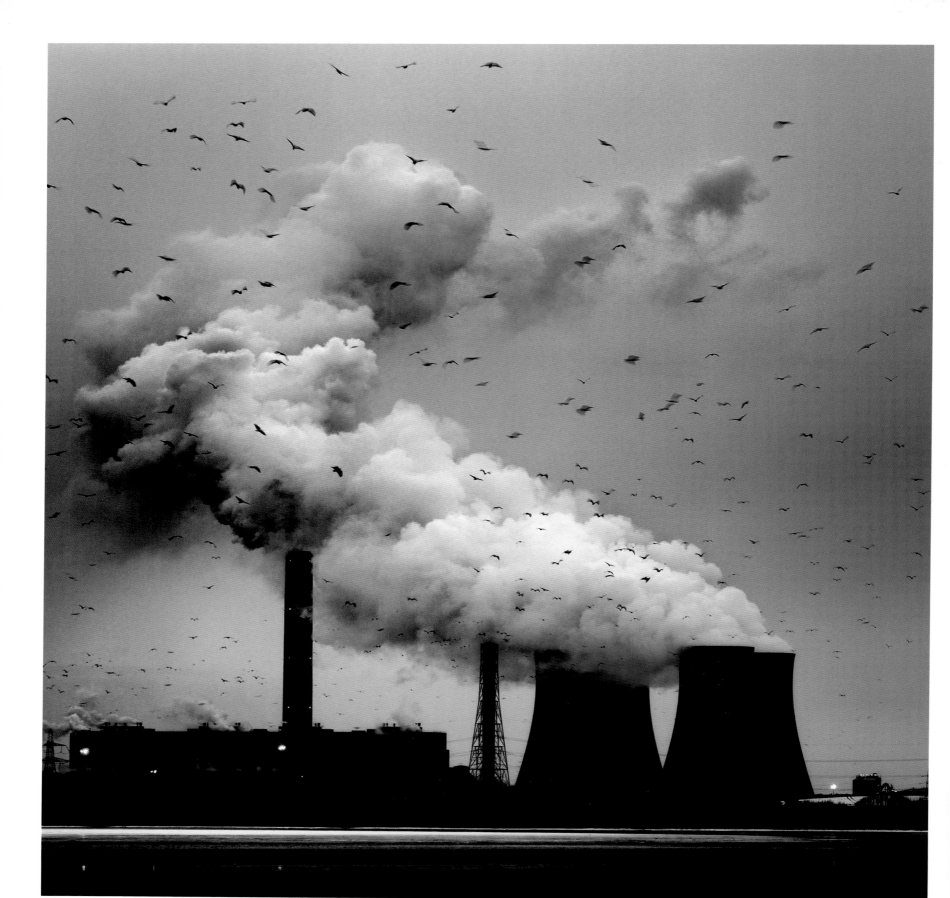

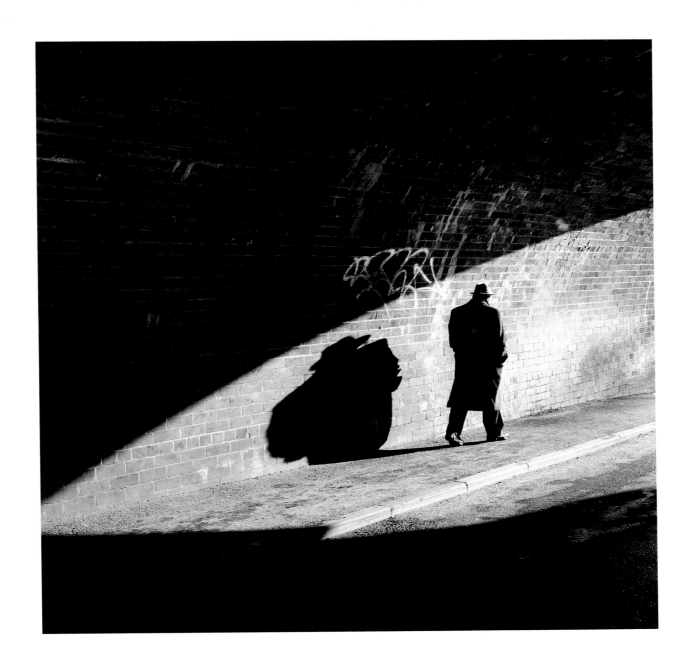

◀····· IAN BRAMHAM

Dusk at the Power Station
Cheshire, England

Fiddlers Ferry coal-fired power station is located on the banks of the River Mersey near Widnes in northwest England. The power station is not far from the sea and often, at dusk, the sky can be filled with birds as well as with the smoke and steam emanating from the power station's huge concrete cooling towers and boiler chimney.

⬆ STU MEECH

Man Walking through Tunnel
Bath Spa, England

On my way to work one day, I walked through the tunnel under Bath Spa station as I always did at this time. The low sunlight, in combination with the snow on the road outside, lit up the tunnel with this shaft of light. So I decided to stop, set a manual exposure on my camera, and waited to see what subjects I might find walking through the light...

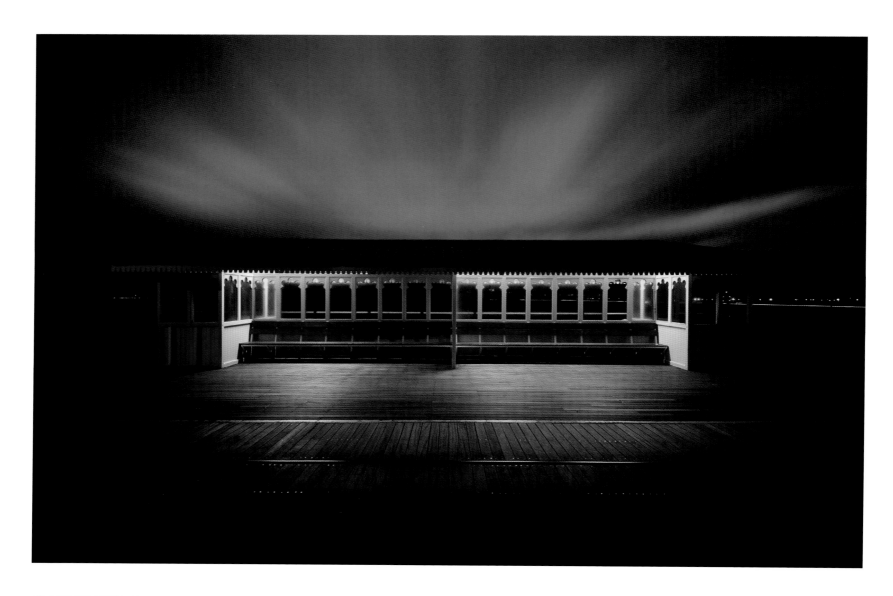

IAN BRAMHAM

Shelter on Southport Pier at Night
Merseyside, England

Southport has a wonderful Grade II listed Victorian pier complete with ornate wooden shelters. I took this photo in winter during the hour after sunset. There was still some blue colour in the darkening night sky, which contrasted nicely with the yellow of the pier lights illuminating the shelter. I also really liked the way the wooden decking and the metal tram lines caught the light.

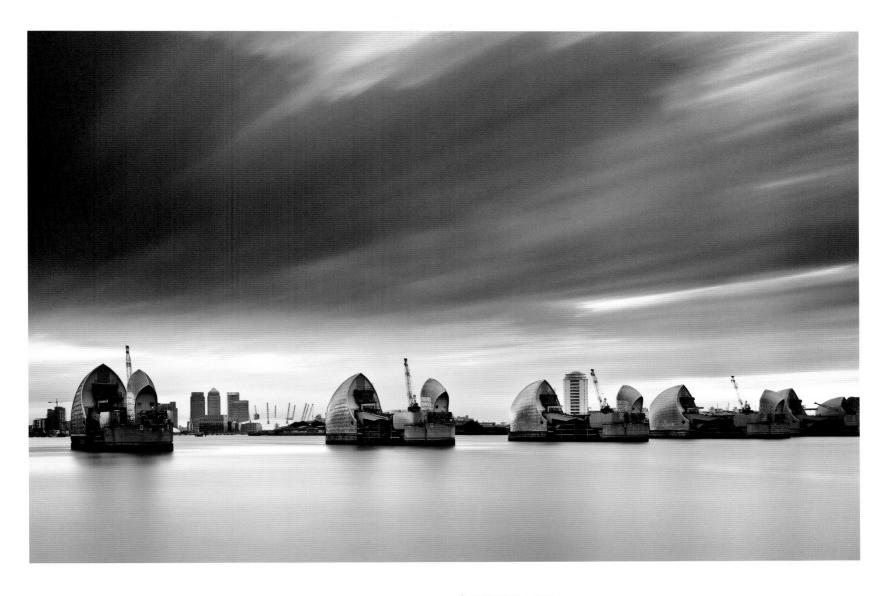

DAVID BAKER

The Thames Barrier
London, England

I wanted to capture the Thames Barrier with the O2 arena and the city in the background, but I wanted to make an image that was different to the norm. The clouds were heavy in the sky and there were small breaks of light leaking through, so I opted for an exposure of 16 minutes, to exaggerate the movement in the clouds and add some drama.

London City, looking West
London, England

I have a studio in Shoreditch and spend considerable time looking
for new vantage points in central London. I have to apply various
strategies to try and gain access, with security and a general
apathy as the obstacles. This access point was eventually secured
through a personal contact via my Financial Advisor, and took
several months to achieve. I was allowed just 15 minutes and,
of course, I was very lucky with the weather.

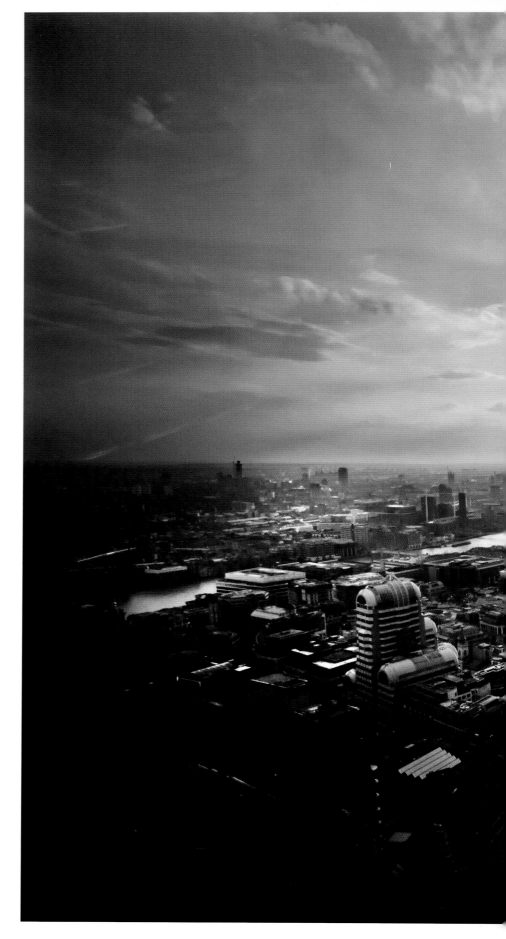

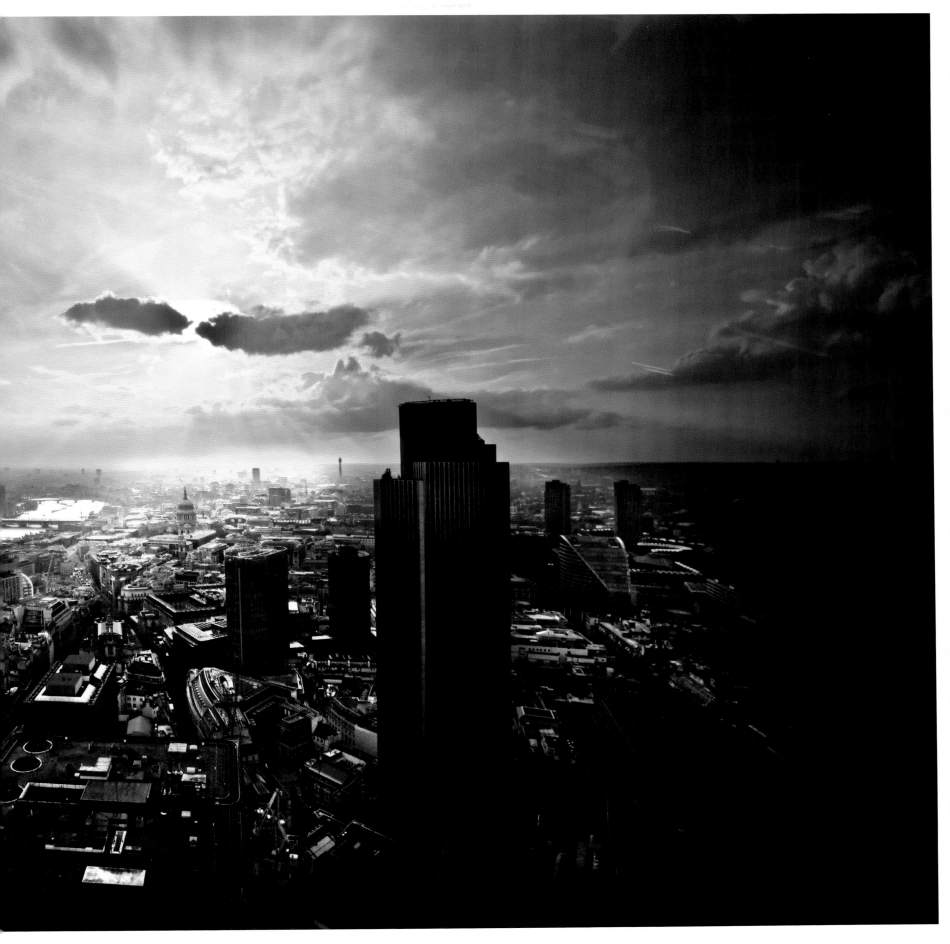

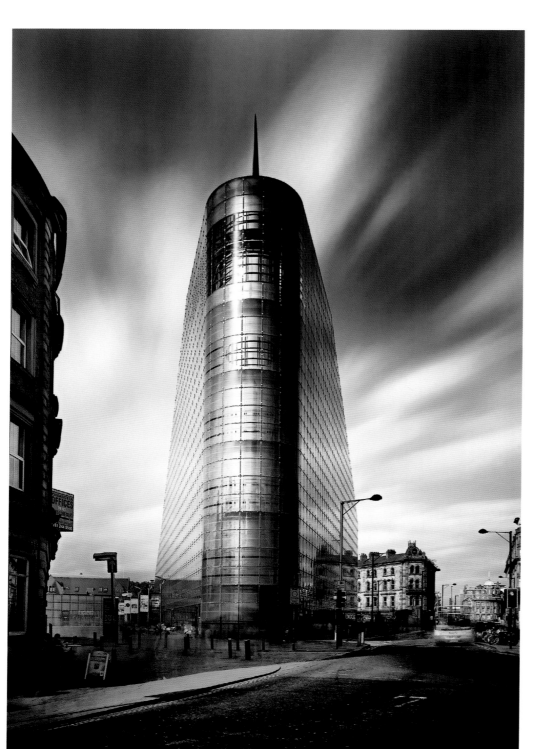

←··· **IAN BRAMHAM**

Manchester City Centre
Manchester, England

This is a long exposure photo of the modernist Urbis building in Manchester city centre. I love the contrast between the old and new architecture and also the way that the glass cladding of this stylish building reflects the light and the famous cloudy skies and changeable Manchester weather. The long exposure has blurred the movement of people and vehicles on the busy street and dramatised the movement of the clouds in the sky.

RICHARD FRASER ···→

24-hour Power
Yorkshire, England

Taken during a late-night journey from Cambridgeshire to Cumbria. This power station on the A1 has often caught my attention, so this time I pulled off at the next junction in search of the cooling towers. This is what I found.

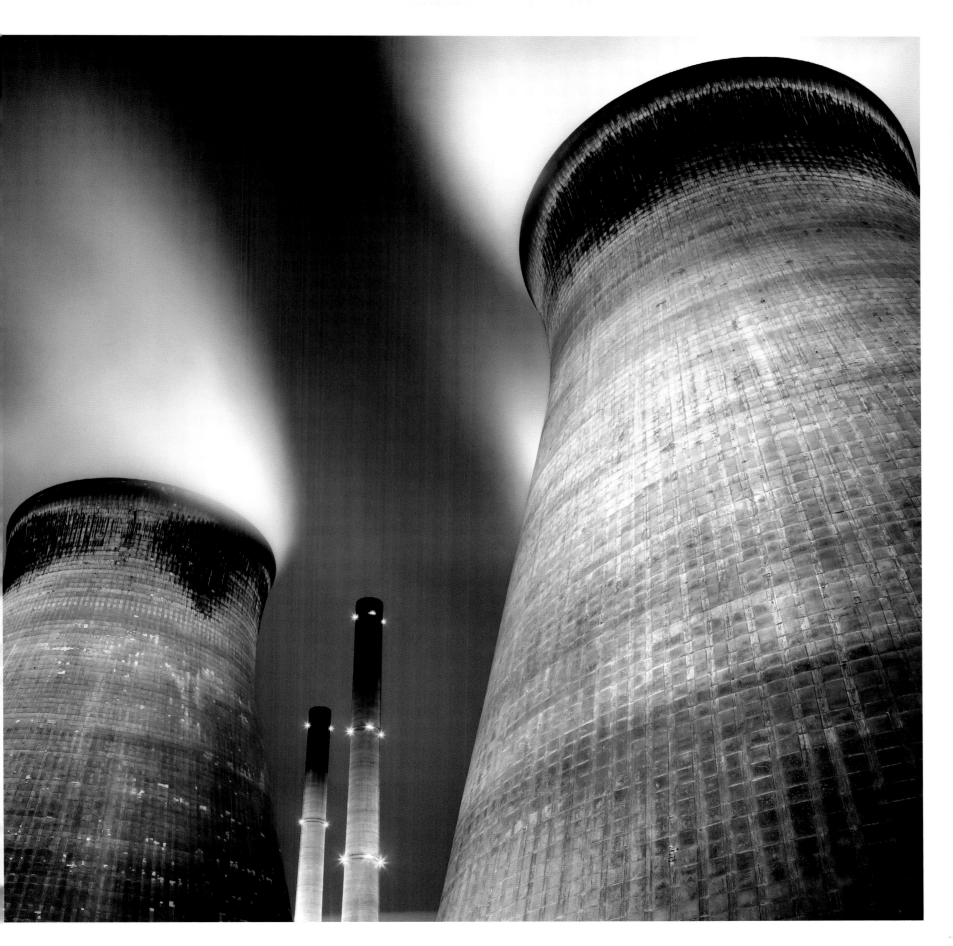

URBAN VIEW
youth class

URBAN VIEW YOUTH CLASS WINNER

GABRIEL DE SOUSA ⋯⋗

Intertwining Flumes
The Aquadrome, Basingstoke, Hampshire, England

These flumes form part of the water slides at my local swimming pool and extend out of the building, overlapping and intertwining with one another before returning to the pool. They create clear, sometimes simple and sometimes intricate forms that are entirely different from one perspective to another. I'd taken many photos of them before this one, but none had been entirely successful, the conditions never quite being right, until the day of this photo. A temporarily opened path made it possible to capture the flumes from a previously impossible perspective, and the strong light and clear sky made the shape created by the flumes stronger and more distinct from their surroundings. The light created deep, contrasting colours, which I liked a lot, but I ultimately decided to make the photo greyscale to give a more continuous, web-like impression of the flumes.

YOUR VIEW
adult class

YOUR VIEW ADULT CLASS WINNER

DAVID BAKER ⋯⋗

The New Forest
Hampshire, England

This image was taken in March and is part of a project involving a particular area of the New Forest that I am visiting at dawn, or a little after, on days when there is mist.

Judge's choice Damien Demolder

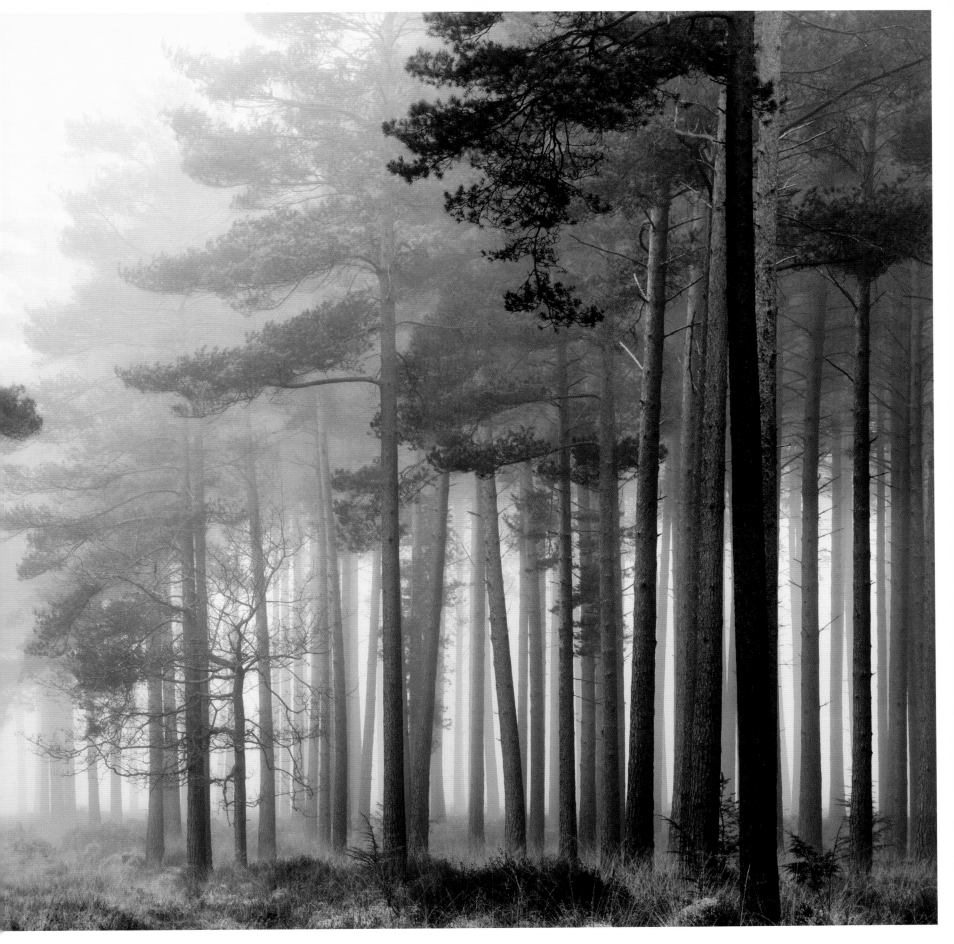

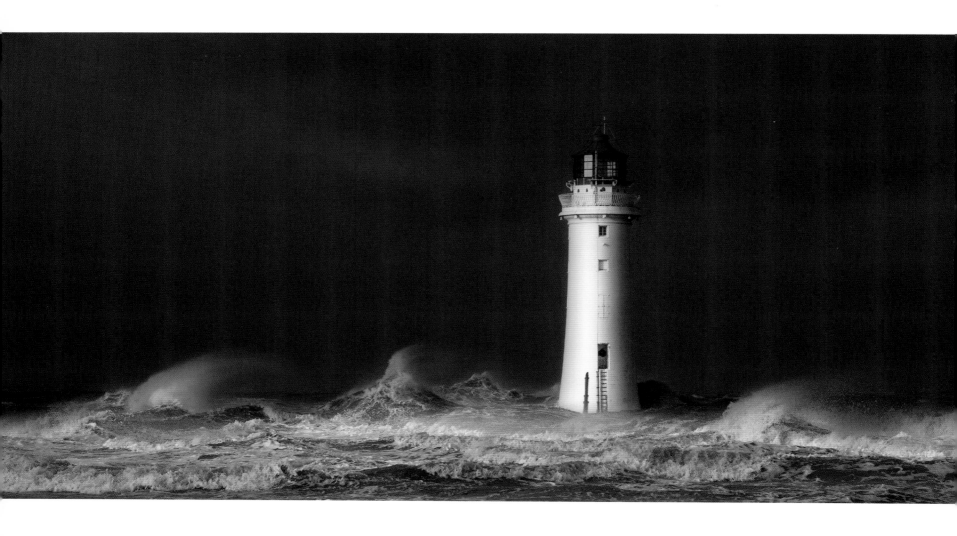

YOUR VIEW ADULT CLASS RUNNER-UP

☙ ROBIN HEPBURN-EVANS

New Brighton Storm
Wirral, England

On arrival at New Brighton lighthouse, I could see the waves lashing this monument. The gale-force winds were lifting the spray in great plumes of white. Armed with my tripod and camera, I waded into the sea in my wellies, which were soon engulfed by water. The bitterly cold wind whipped my favourite hat off my head and deposited it about 30ft out in the churning ocean before bizarrely returning it to me on an incoming wave. The sun, at that moment, was partially obscured with some very thin cloud, which gave a slightly more interesting light than the full-on version, so I took another shot. I had ended up thigh deep in the waves, hanging on to my camera, battling 60mph winds to get this shot and, with the composition, it is my favourite image of the day.

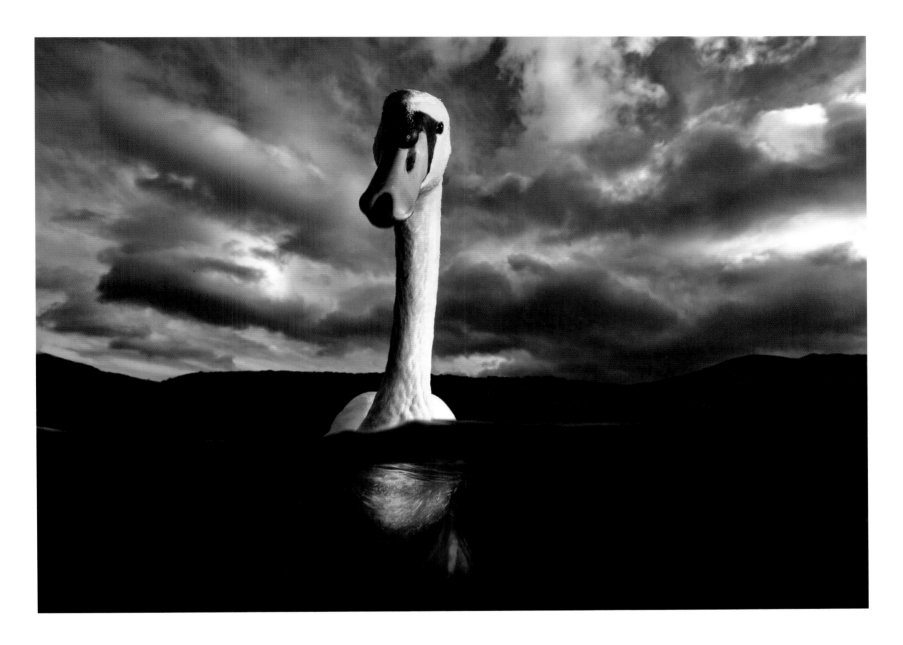

GRAHAM COLLING

Poppies in Barley Field
Near Cannock, Staffordshire, England

Having a mobile phone go off in the bedroom at 3:47am sometimes has its advantages. Why my wife's riding partner decided to text her at that time still escapes me, but it allowed me to be in the middle of this barley field as the sun rose and the wind blew, combining to help realise this image.

GRAHAM EATON

Swan Lake
Llyn Padarn, Llanberis, Wales

I wanted to capture an image of a swan from an alternative perspective, to look at the whole bird within its world and the landscape. I used a wide angle to place the bird within the context of the lake and the landscape and to exaggerate how its long neck reaches from the water to the sky.

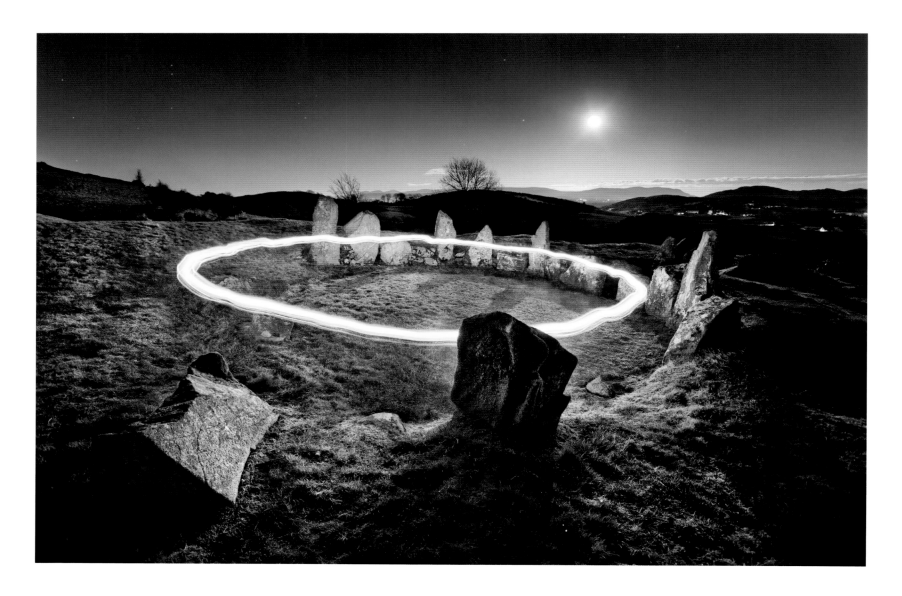

STEPHEN EMERSON

The Fairy Ring
Newry, Northern Ireland

This monument, lying on the slopes of Ballymacdermot Mountain, close to Newry, is an extremely well-preserved Neolithic burial site with three chambers. It can be dated between 4000 and 2500 BC. It is locally known as the Fairy Ring and is reputed to be haunted. I captured this image under the light of a full moon, which gives the scene an eerie but mystical mood. I like how the moon casts the shadows of the stones into the circle. For my first exposure, I had to try quite a few times to create a ring of fire by means of an oil lantern, not easy on the uneven ground. This is how I had envisioned the ancient site and I achieved it through an exact technique of three exposures.

KERSTEN HOWARD ⇢

Old Tree in Towy Valley
Carmarthenshire, Wales

After checking the weather forecast the night before, I took a gamble on the mist they promised being where they said it would be. It must have been one of the only weather forecasts they have got right in Wales in years, much to my delight. The rising sun was quickly burning through the mist so I positioned the tree between the sun and my camera and managed a few shots before it burnt through. Well worth the two-hour round trip.

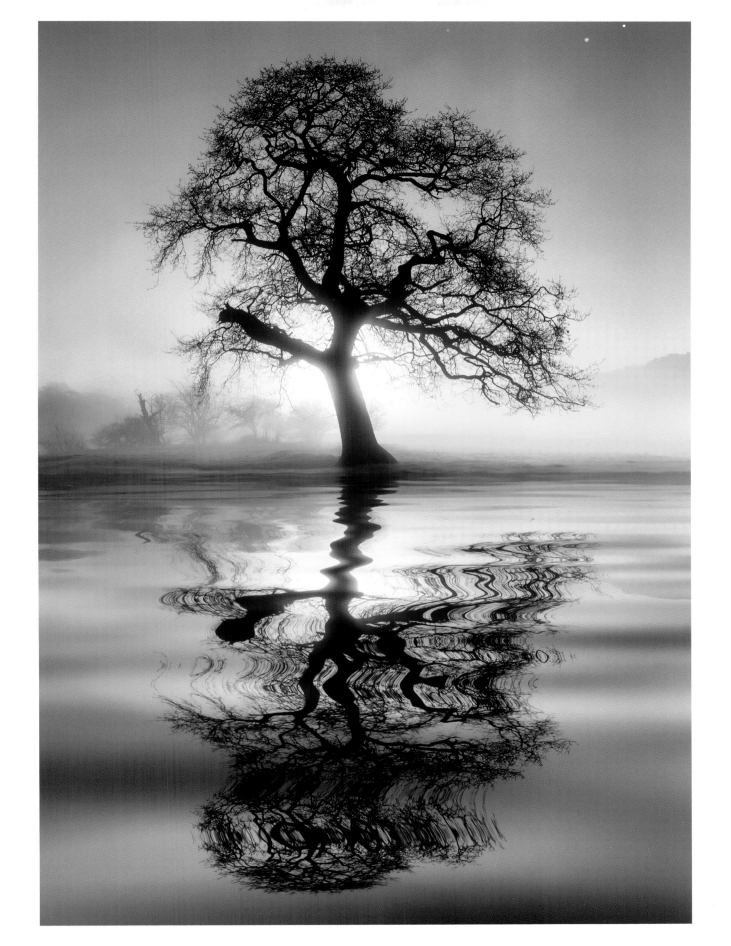

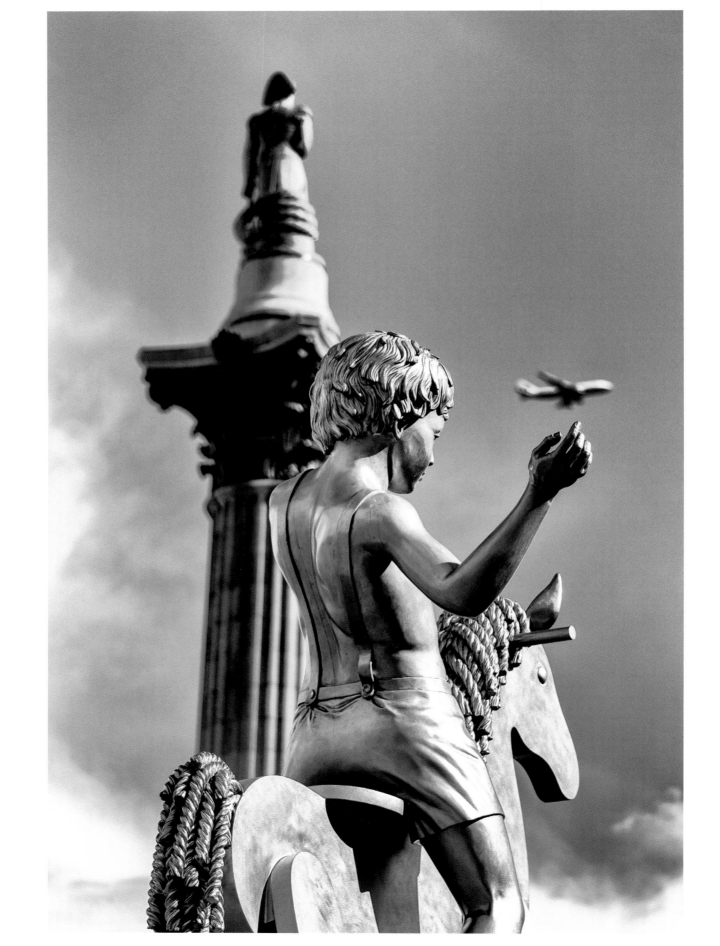

ANTHONY WORSDELL

The Fourth Plinth
Trafalgar Square, London, England

This is the equestrian statue occupying the fourth plinth in Trafalgar Square. Works are selected for the plinth on a rotating basis every 18 months. This one, a boy on a rocking horse, cast in bronze, is an ironic twist on the military equestrian statues on the other plinths in the square. It is by Michael Elmgreen and Ingar Dragset. The aeroplane really was there — no digital manipulation. Nelson's Column is in the background.

SUSAN BROWN

Steps to Shoalstone Pool
Brixham, Devon, England

I love this pool on the coast of Brixham. I try to visit when a spring tide coincides with sunset and watch the sea pouring over the walls and have been visiting here for three years now. Access can be difficult out of season as it is fenced off for safety. Recently, when the pool was threatened with closure, local passions ran high and at the moment it remains open and hopefully will stay so. A great place for a swim. How many places can you swim where the water is changed twice a day?

⟵ DAN SANTILLO

Icicles on Pen y Fan
Brecon Beacons, Wales

These icicles weren't very large, so I got very close and used the tilt-shift lens to make sure they were sharply in focus. It was a real privilege to be on the top of the Brecon Beacons that day with pure blue sky, ice and snow on the ground and a severe wind chill.

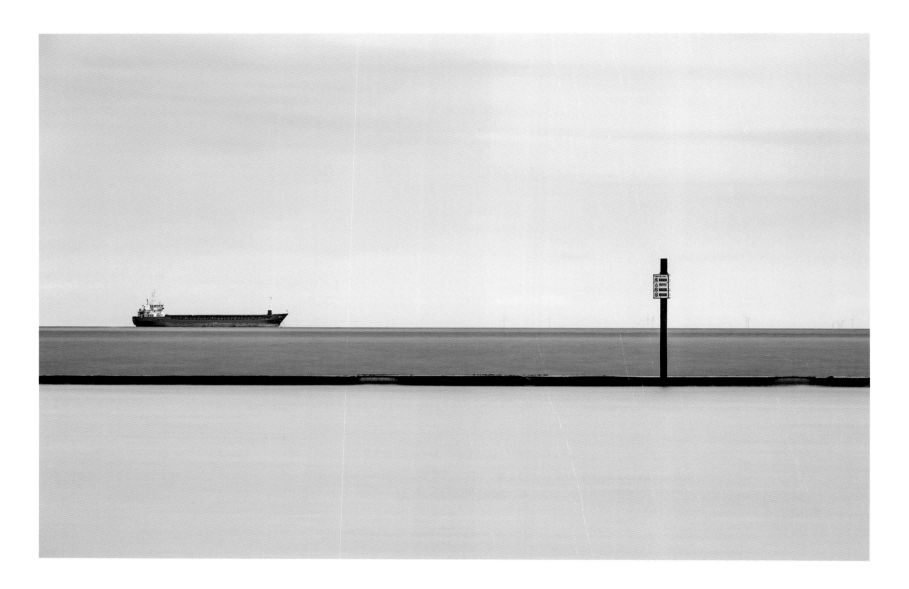

VALDA BAILEY

Gursky Goes to Margate
Kent, England

Not a conscious attempt to emulate Gursky's famous photo of the Rhine, but clearly influences trickle down. Don't suppose anyone is going to give me $4.3m for it any time soon, however.

TONY GILL ⸳⸳⸳⟩

Heaven's Hill
Symondsbury, West Dorset, England

This well-known Dorset landmark is often lapped by autumn mists, but they are rarely this dense. In my rush to a nearby vantage point to capture the pre-dawn scene, I promptly fell over, brand-new 5D MkII in hand. Thankfully I got up, composed myself and took the shot.

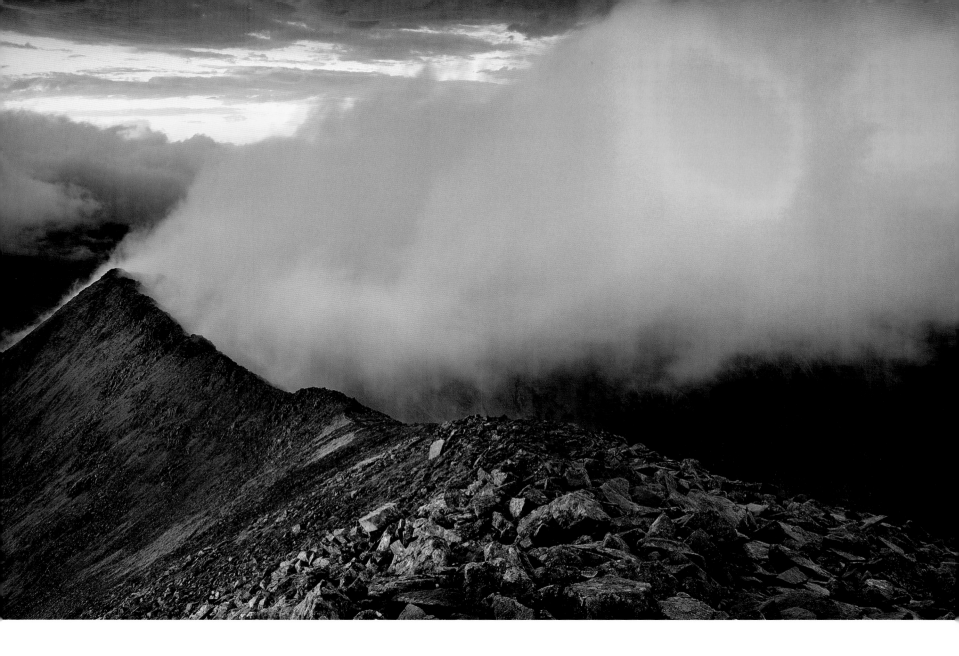

JOHN PARMINTER

Steamer
Carn Mor Dearg, near Fort William, Scotland

Sunrise on mountain summits can provide some memorable sights. I set off in the dark for a two-and-a-half hour climb to be on the summit for dawn, my intended shot being of Ben Nevis along the arête. Whilst climbing, the cloud was swirling around me and I didn't hold much hope of getting a view but, as I reached the top, the cloud lifted and the sun broke through to reveal the start of a fantastic day to be out on the hills.

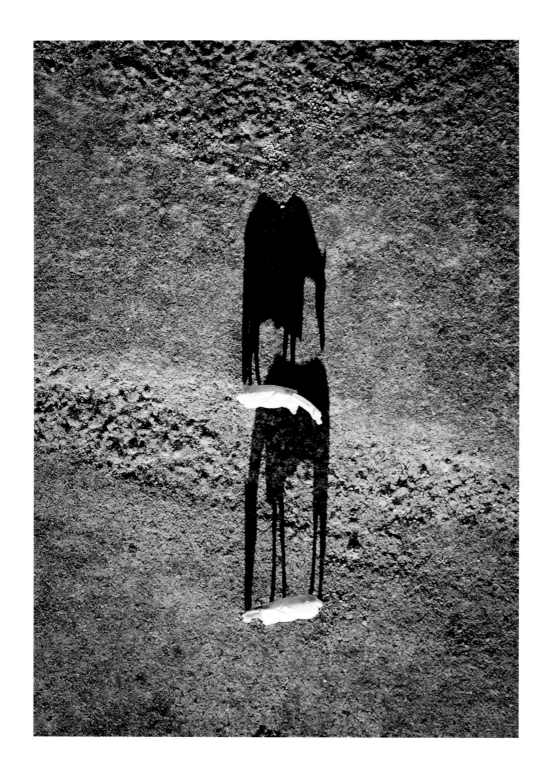

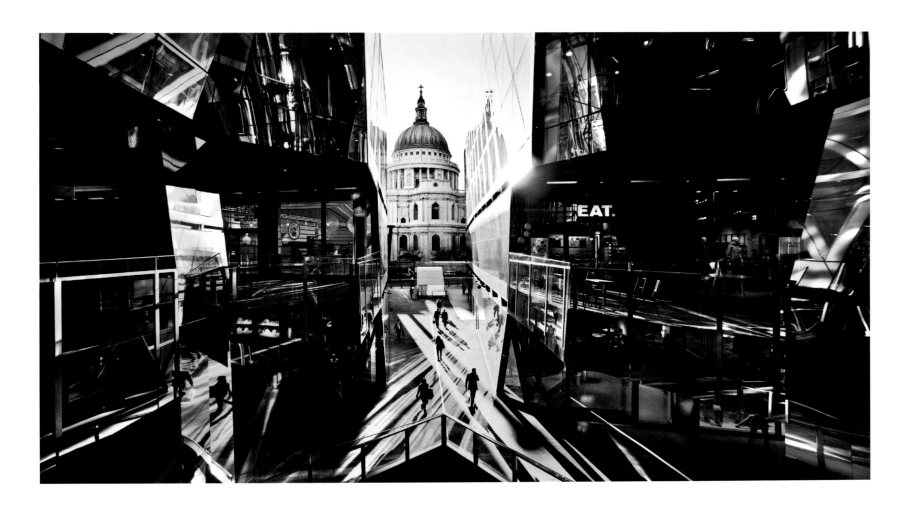

⬝⬝⬝ MARTIN CHAMBERLAIN

From a Hot Air Balloon
Near Edenbridge, Kent, England

This image was taken from a hot air balloon drifting directly above two horses grazing near Edenbridge in Kent. The long shadows of dawn created abstract images as we looked down on familiar objects from an unfamiliar angle.

⬝ HOWARD KINGSNORTH

St Paul's Cathedral and One New Change
London, England

I had earmarked this location a few years ago, when the shopping mall was first proposed. To get a new shot of an established landmark is always a challenge. This required a combination of the right time of day, a very wide lens, and a steady hand. I visited this site several times to establish all the factors that would eventually produce this image.

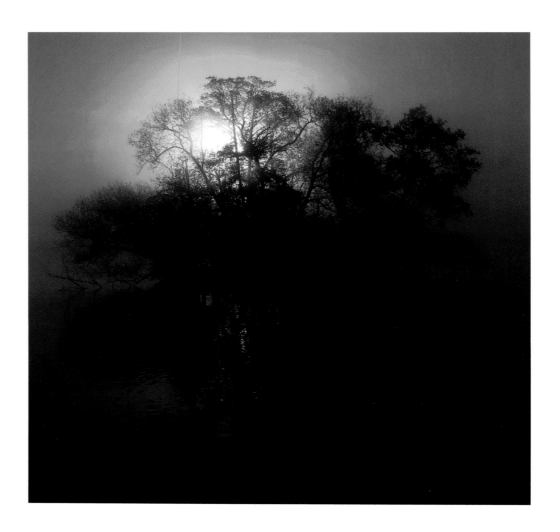

ERIC BALDAUF

Richmond Pond Island at Sunrise
London, England

This picture was taken on a misty November morning in Richmond Park, surrounded
by the surreal sound of rutting deer.

DAVID WATERHOUSE

Liquid Gold
Fleswick Bay, Cumbria, England

Taken at Fleswick Bay in Cumbria; a remote bay that requires some effort to get to.
On arriving, I noticed the sunlight catching the droplets of water which were falling
from the sandstone cliffs. The long exposure made it a little more dramatic.

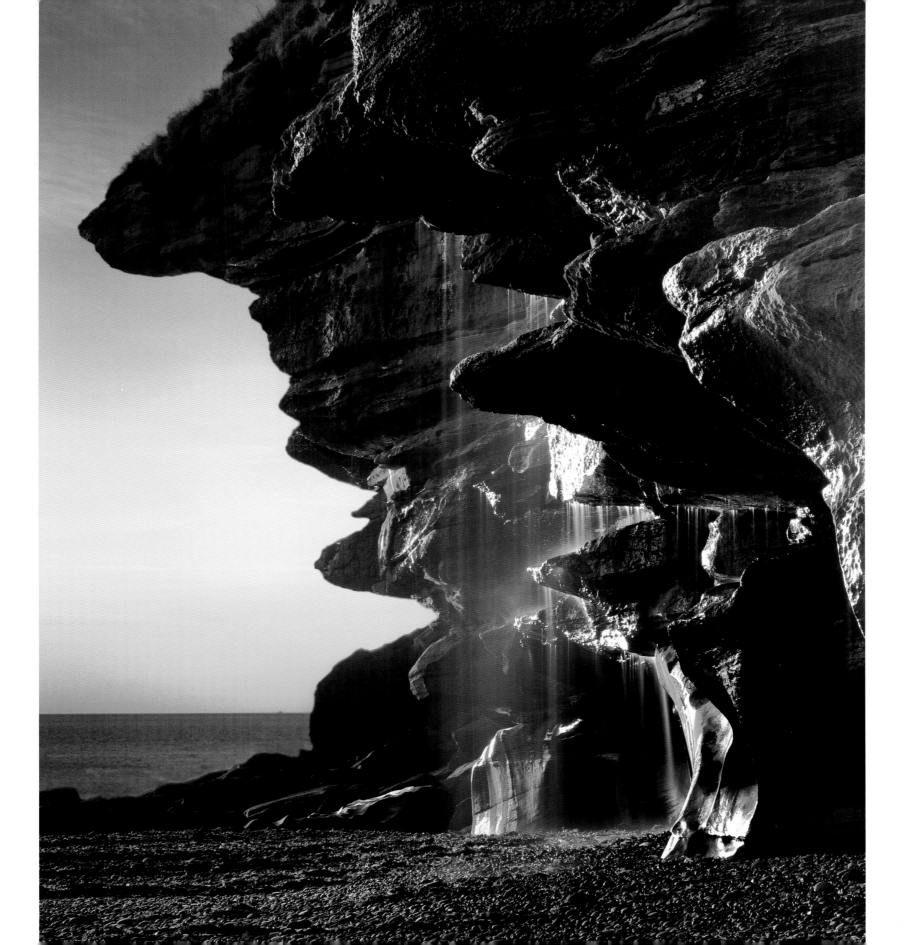

⬅ BARRY HUTTON

Dawn Display on Rydal Water
Cumbria, England

A beautiful misty morning in the Lake District and I headed to the little jewel that is Rydal Water. Almost totally enshrouded by the mist, I began composing, ready to catch the light as it managed to break through. A welcome bonus to the scene was a pair of swans. Whilst they were totally ignoring me, I began experimenting with using them as foreground interest. In this photograph, I realised that one was lifting in readiness to stretch its wings, so I timed the shutter release to capture the display. The slow shutter speed managed to capture a range of movement of the wings, which is nicely complimented by the clearing mist and breaking light brushing Nab Scar in the background.

⬆ JEAN BROOKS

Beach Huts at West Wittering
West Sussex, England

On a dull and drizzly day in October, the wind was gusting strongly. The sands had been blown into rippled dunes towards the beach huts and I used a low viewpoint and wide-angle lens to exaggerate their effect.

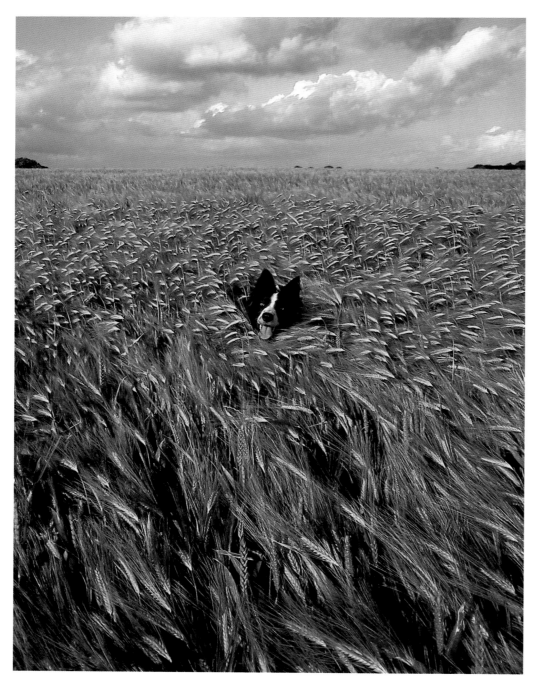

◀··· **LINDA OUSAID**

Bobbi's Paradise
Vale of Pewsey, Wiltshire, England

The Vale of Pewsey is a magical place to walk, full of surprising views and contrasts. This particular cornfield follows an exhilarating ascent up to Giant's Grave and is part of a rooftop stroll out to Martinsell Hill with a descent into Wooton Rivers, near Marlborough in Wiltshire.

SCOTT WILSON ···▶

Rojo
Near Mansfield, Nottinghamshire, England

One of a series of dramatic flowerscapes achieved by shooting nature with a grad filter and flash. The consequence of being a committed 'seascaper' who lives nowhere near the coast!

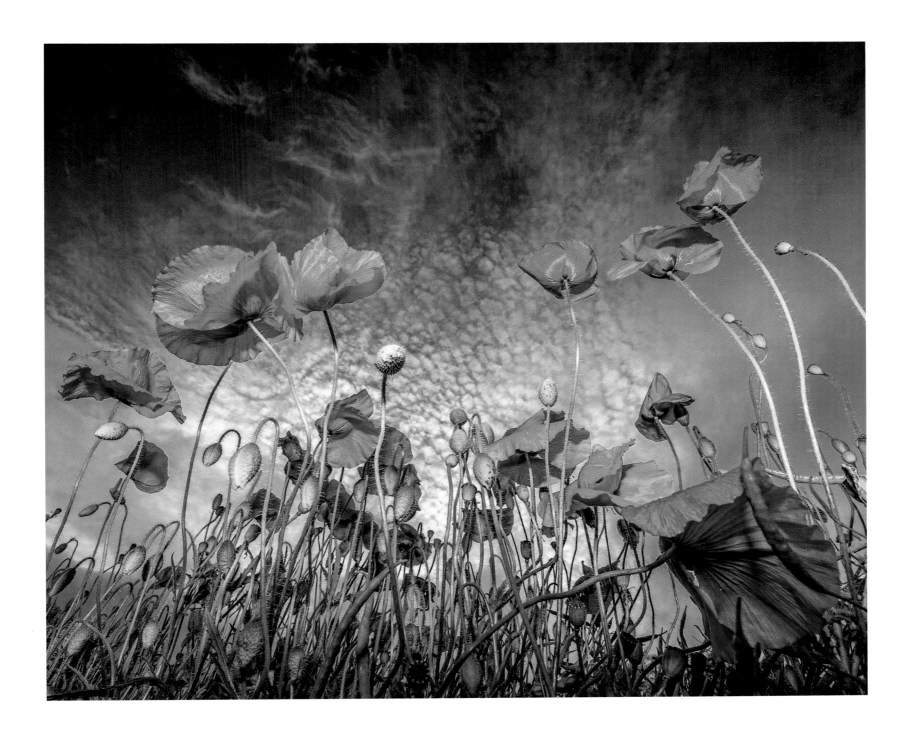

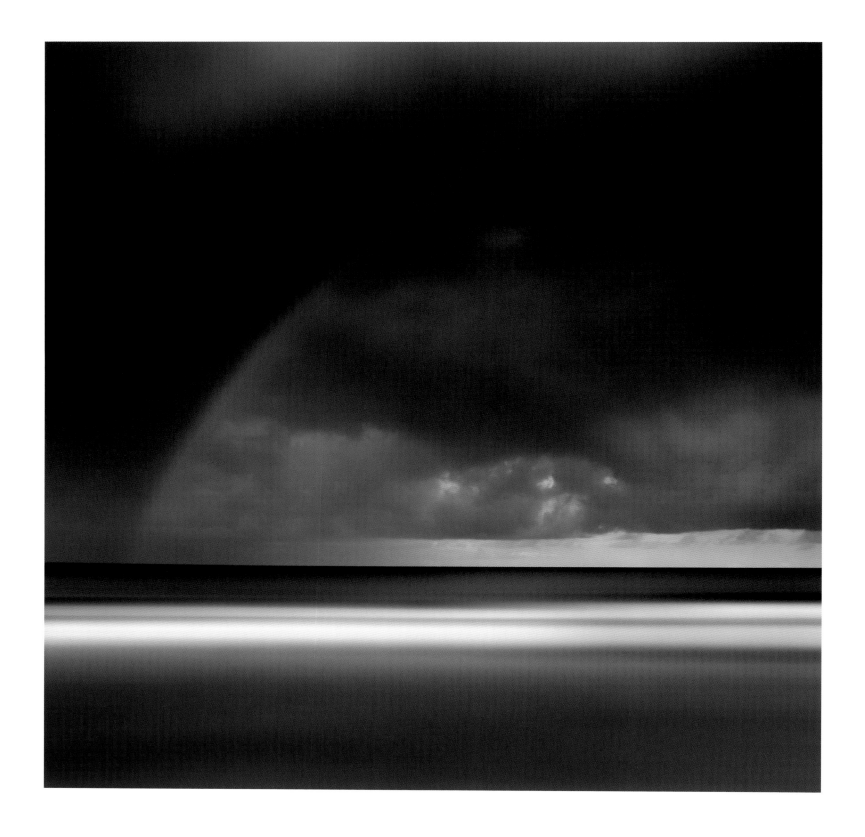

186

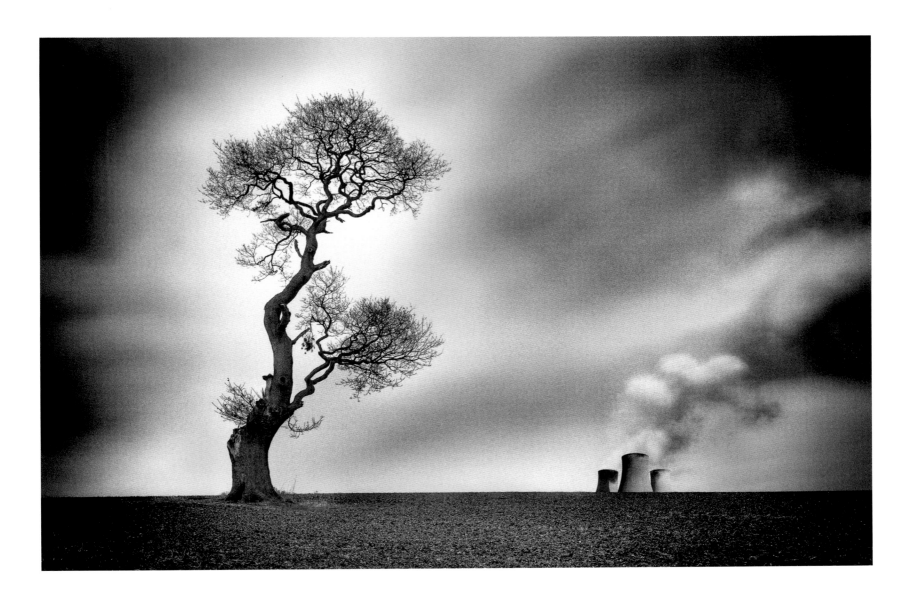

BRIAN McMEECHAN

Rainbow over Embo
Highland, Scotland

This was taken on a family holiday to a caravan site at Embo, just outside Dornoch in the Highlands. We had a pretty wet and horrible week and didn't get many photo opportunities. This shot nearly got binned until I started to muck about with it and gave it a square crop.

DAVID BYRNE

Maria's Tree in Rugeley
Staffordshire, England

There is a semi-famous tree in Rugeley, near where I live, called Maria's Tree. Nobody seems to know where it gained this name, or who Maria is, but it is a cracking tree to look at; most unusual. In the distance is Rugeley Power Station.

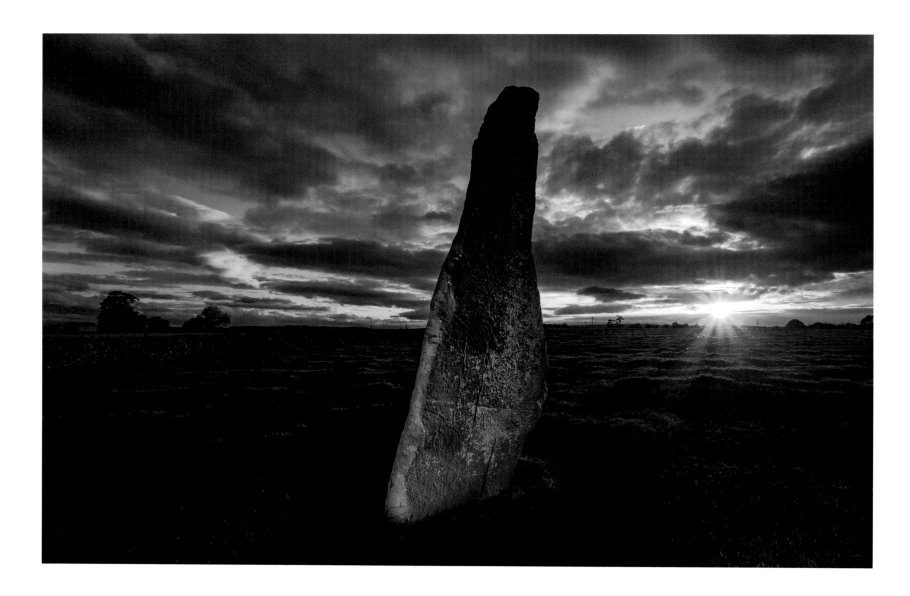

BRIAN KERR

DOMINIC LESTER ···>

Sunset at Long Meg
Cumbria, England

Wild Deer in Crop Field
Surrey, England

Sunset at Long Meg, a standing stone with prehistoric carvings, including a number of spirals, on one if its faces. The smaller nearby stones, known as Her Daughters, form a stone circle. This stone circle is the third-largest in Britain (after Avebury and Stanton Drew) and is considered to date from Neolithic to Early Bronze Age. It is part of a range of monuments that form a prehistoric landscape in the north of Cumbria.

This was taken very near to St Mary's church in West Horsley. No deer were visible when I first arrived but this one popped up, wondering what I was doing there...

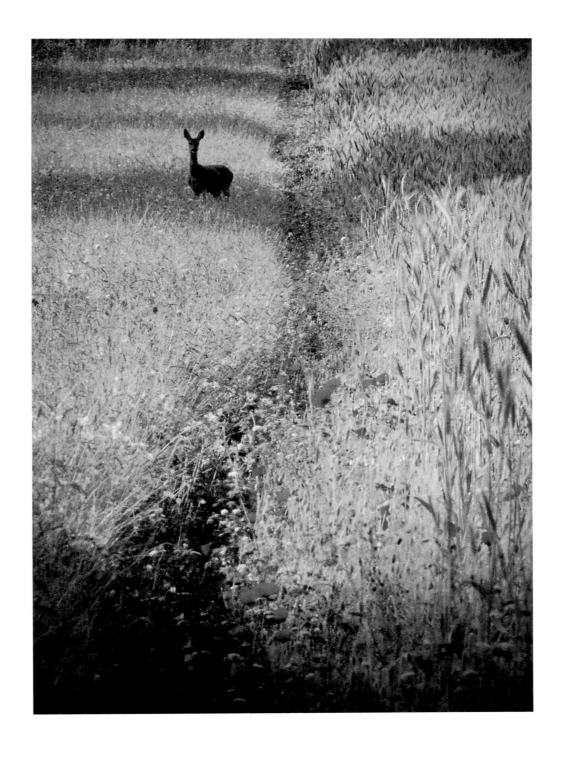

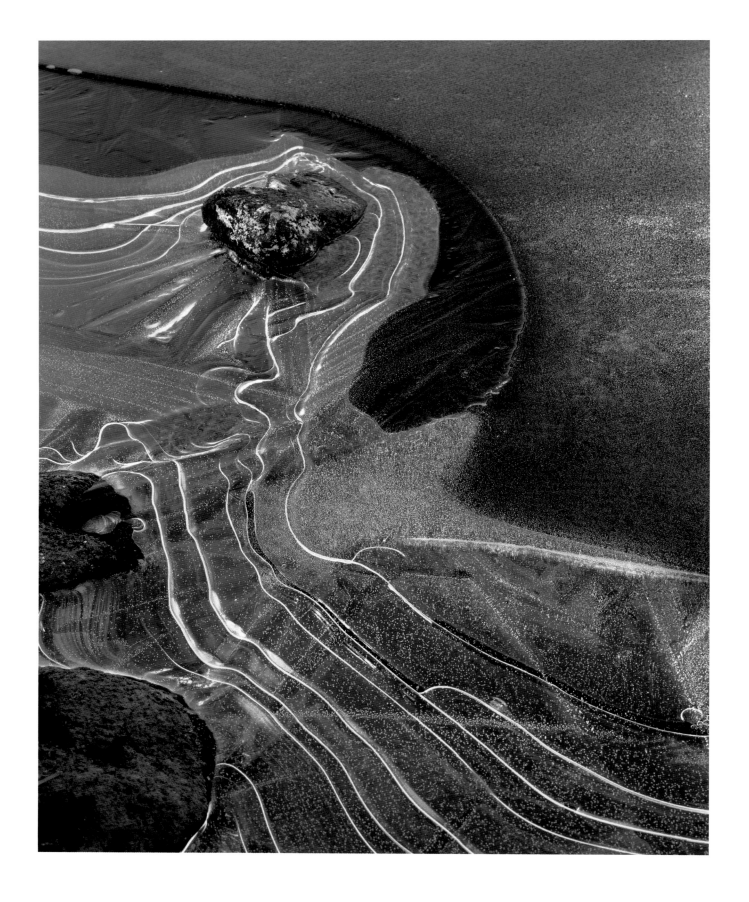

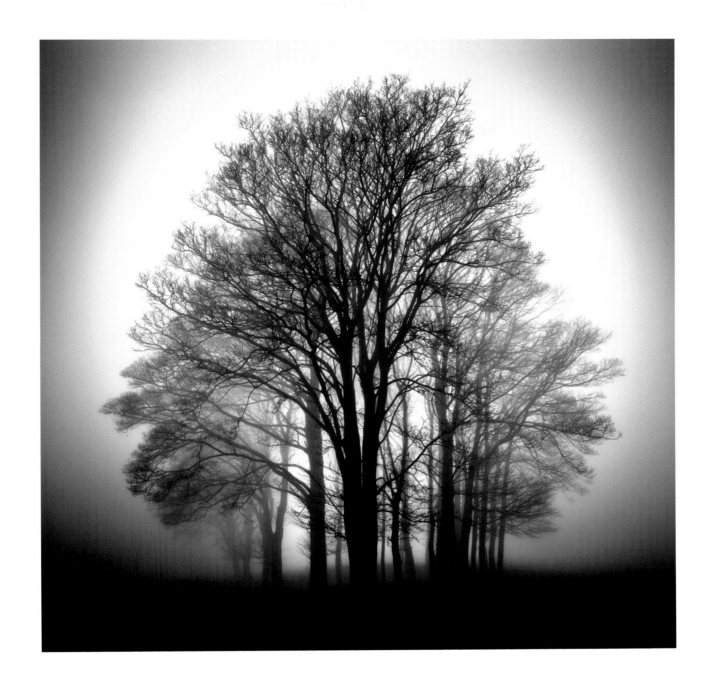

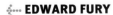 **EDWARD FURY**

Contours in Ice
Highland, Scotland

The River Ba in the Scottish Highlands had completely frozen. I was mesmerised by looking at the patterns formed during the gradual freeze. I loved how the lines ran from corner to corner in the frame. Just waiting for the sunlight to kiss the top of the stone was essential. The blue hue is given by an open blue sky above.

JASON THEAKER

Something a Bit More Melancholy
West Yorkshire, England

One morning in winter, the conditions were perfect for some moody shots and I headed to a spot close to my house to work with a coppice of trees that I had pencilled in for this type of moody 'coffee shop' shot.

SUSAN BROWN

Iced Fern
Lydford Gorge, Devon, England

It was −8°C when I took this picture. I was on my way to North Devon and stopped at the National Trust's Lydford Gorge for a walk on the way. As it is steep and damp, the light did not penetrate and the dripping water had frozen. I had my tripod and camera just in case I saw anything. I was delighted to come across this fern completely encased in clear ice, the weight of the ice bending the fern to give this lovely shape with the icicles falling.

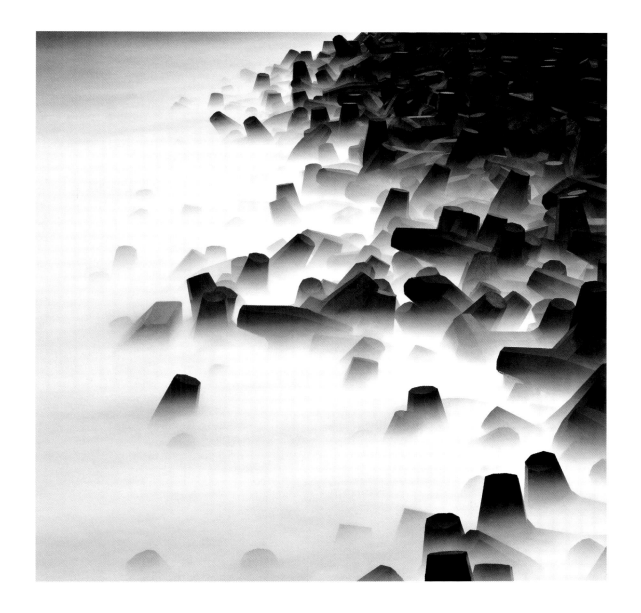

✝ DONALD CAMERON

Quietus
Sea Defence Wall, Torness Power Station, Scotland

My intention was to create a surreal abstract study of perhaps the most unusual place I've ever photographed — the sea defence wall at Torness Power Station on the east coast of Scotland. Littered with thousands of huge interlocking concrete blocks known as 'dolos', which together can withstand a storm of a severity predicted only once every 10,000 years, this remarkable structure seemed tailor-made for this style of image. I used a long exposure to smooth out the sea into a fine mist, contrasting strongly with the jagged shapes and further emphasised by the conversion to black and white. I think it shows that landscape photography isn't limited to rolling hills and sweeping vistas.

DANNY BEATH

Mist on the Welsh Marches
England/Wales

This image shows the Welsh Marches near Welshpool on a surreal November morning.
It was taken from the Breidden Hills, looking down the River Severn floodplain, with the
spire of Leighton Church visible in the distance. Mists like these are fairly rare and a local
told us he had not seen it like this for at least 20 years.

Dedicated to my Mother

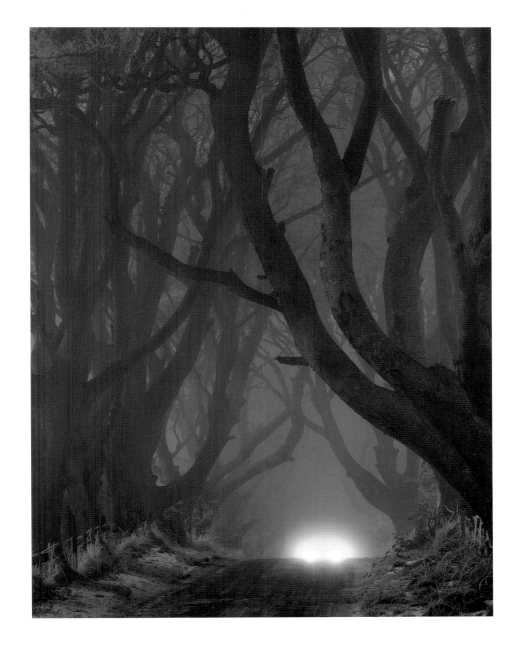

✝ **BOB McCALLION**

Light in the Dark Hedges
County Antrim, Northern Ireland

As darkness approached, a cloak of freezing fog descended on these ancient beech trees and my thoughts turned to home and the comfort of a warm fire. My tripod-mounted camera and lens were gradually icing over, but while preparing to return to the car, the only other vehicle on the road that night appeared and I opened the shutter in anticipation. The elements had played havoc with the camera's white balance, but I decided to leave the image as it was, to remind me of the biting coldness of that deep midwinter evening.

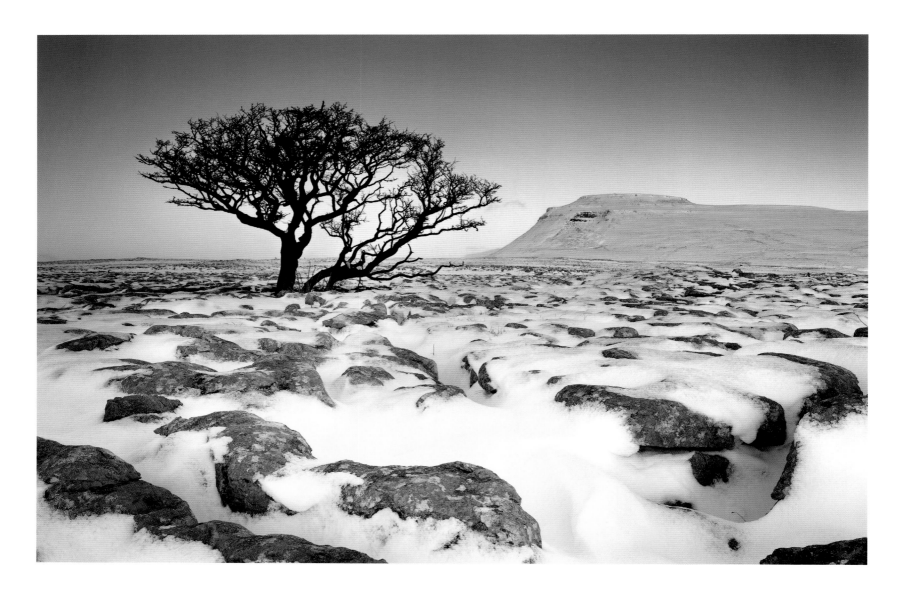

✝ MIKE GREEN

White Scars Limestone Pavement
North Yorkshire, England

Limestone pavements are remarkable features in any weather, but they seem most dramatic and alien to me in moderate snow, frozen in time somehow, as here. This is the White Scars pavement, with its lone hawthorn tree, high above Ingleton in the Yorkshire Dales. The hill is Ingleborough, one of the Yorkshire Three Peaks. What attracted me to this scene was the glow of evening colour in the east and the starkness of the snow on the rock. The tree's alignment with the slope of Ingleborough's northern face is also a great help. The temperature, 13 degrees below freezing when the image was captured, was certainly not an attraction, however!

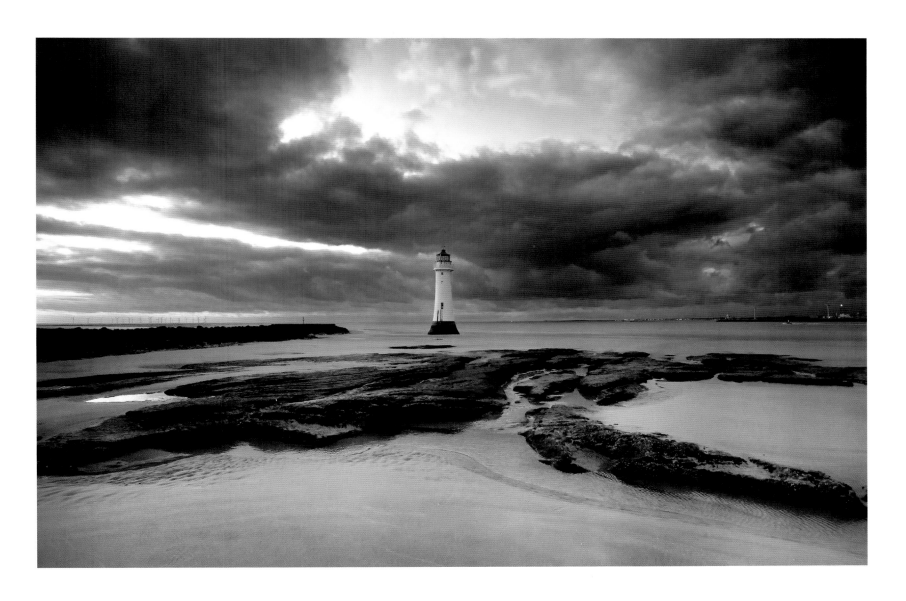

STEPHEN BRIANT

The Lighthouse at New Brighton
Wirral, England

There has been a lighthouse of sorts here since 1683. Drawings, paintings and numerous photographs have been made of the current one. So what hope have you got of creating something a little different? What if the lighthouse were merely incidental to the composition? Here I have concentrated on brooding, sinister clouds. By careful use of a wide-angle lens, the building is reduced to a tiny insignificant speck. Caught in the eye of a powerful storm and about to be battered, I almost feel sorry for it.

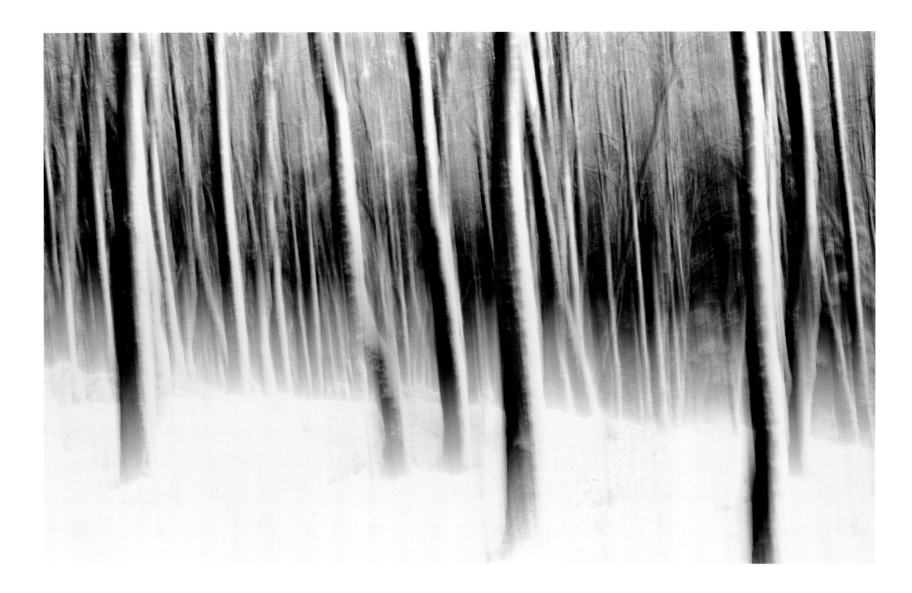

✝ FORTUNATO GATTO

Tay Forest in Winter
Perthshire, Scotland

After a heavy snowfall through the night, the scenery in Tay Forest turned magic. With the temperature below zero, the snow and silence painted a perfect picture of winter. Alone with my camera, I tried to capture this special moment when the forest came to life...

JAMES APPLETON ⋯⋗

Unmoving
Castlerigg, Cumbria, England

I have always felt that it's incredibly important to not just show the beauty of a place, but also tell something of its story. With this image of Castlerigg, a stone circle that has lasted through thousands of years, it seemed fitting to use a style of photography that itself shows the passing of time. And in the middle, the stone circle stands, unmoving.

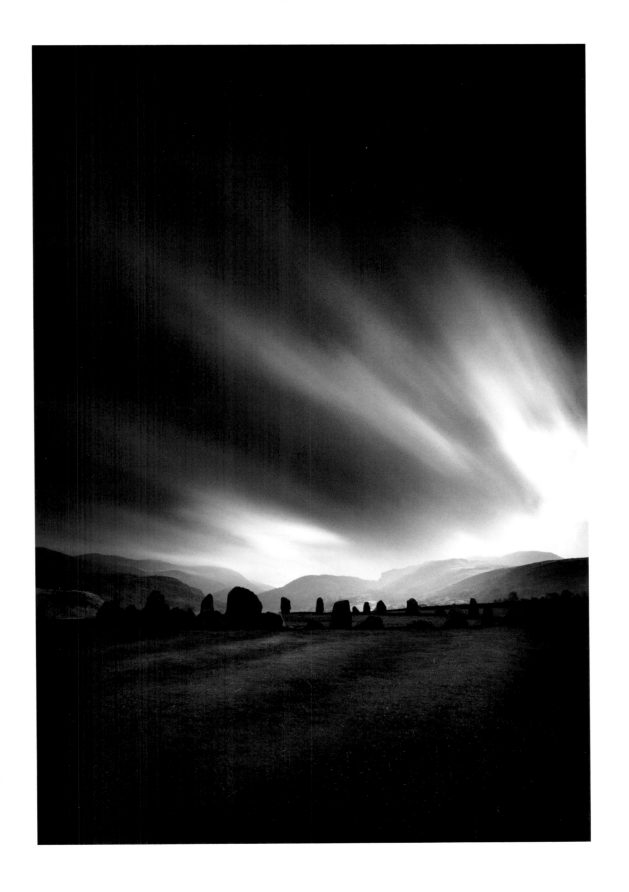

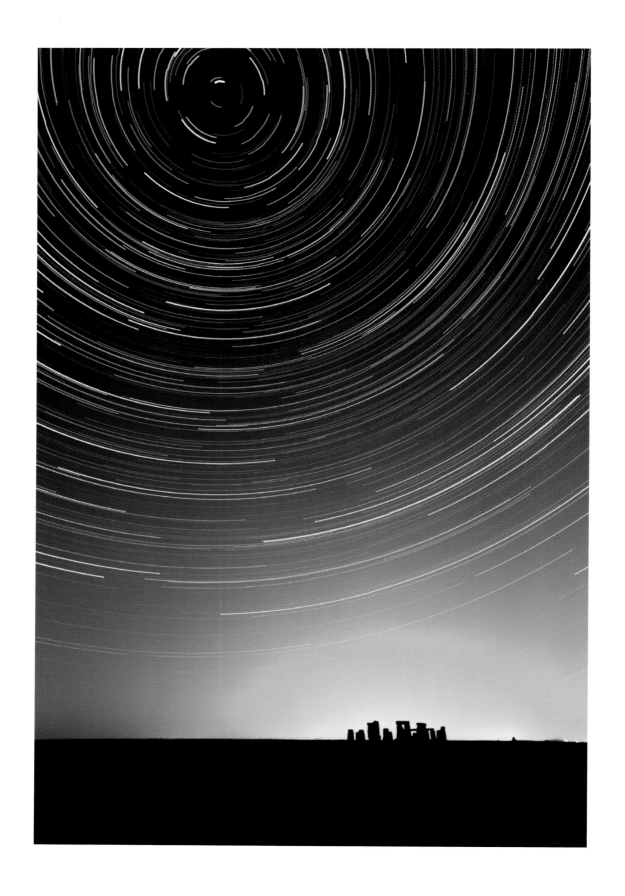

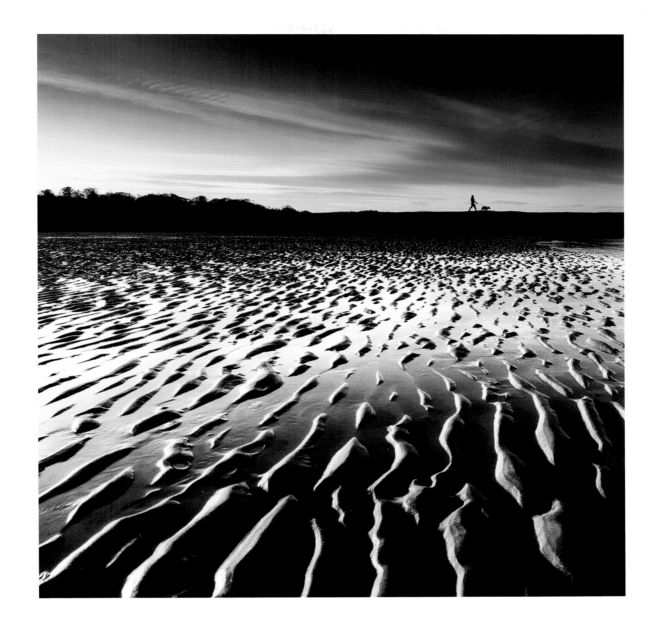

DAVID SHARP

Stonehenge Star Trails
Wiltshire, England

The skies above Stonehenge are some of the darkest in southern England but, even here, the light pollution rising from the Larkhill army town turns the horizon bright orange on long exposures. Light pollution, so often seen as the enemy of night photography can, with experience, become a much-loved friend. Star trails are created by using very long exposures, or combining a large number of shorter exposures, to capture the stars moving across the sky as the Earth rotates. I wanted to include Polaris (the pole star) in the picture to create the circular effect as the stars appear to orbit the pole star.

BRIAN McMEECHAN

Cramond Gold
Edinburgh, Scotland

A spring afternoon at Cramond beach, just outside Edinburgh. We take our daughter there a lot as it's the nearest beach. I ventured off as my wife and daughter played on the beach, and noticed this person walking along the causeway which goes out to Cramond Island.

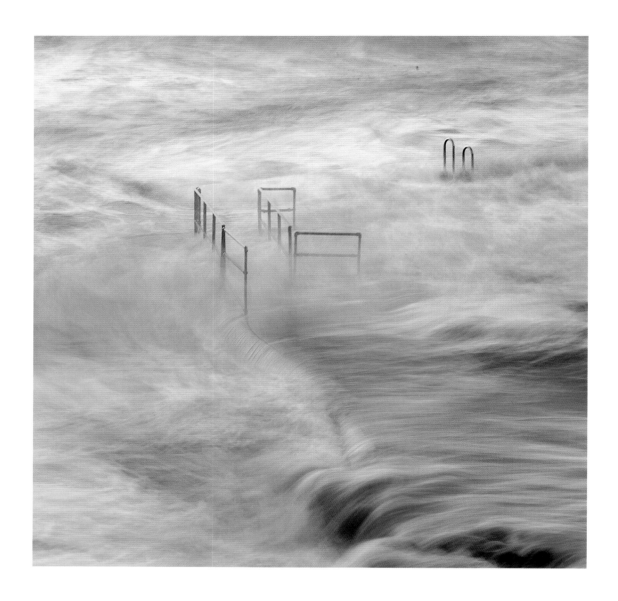

🕈 **SUSAN BROWN**

Turbulent Waters at Spring Tide
Bude, Cornwall, England

Whenever I feel at a loss for inspiration, I visit the wonderful Summerleaze Sea Pool at Bude. This image was taken during the winter months in late afternoon. The high seas were exhilarating and causing a lot of spray. I therefore took the picture from a high viewpoint, which also enabled me to dispense with the sky. When the weather is like this, the pool becomes like a washing machine with sea pouring in from all directions and rushing over the edges of the rocks. There was a lovely soft winter light giving these subdued colours. I chose the right shutter speed to create movement but still retain detail.

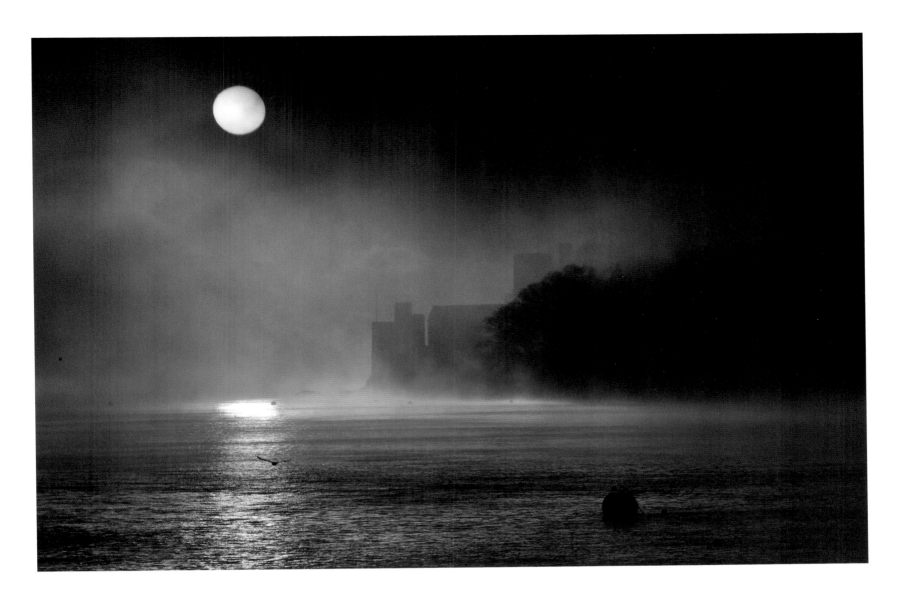

✝ **NICK SHEPHERD**

Eerie Castle
Dartmouth, Devon, England

A wonderfully atmospheric photo of Dartmouth Castle about an hour after sunrise. The weak winter sun is endeavouring to penetrate the thick mist and an eerie glow has been created (almost 'moon-like'). The silhouette of the flying gull against the shimmering river adds another dimension to the image.

ALLAN MACDOUGALL

Iced Grass
Wales

This ice-encrusted grass was found near a waterfall in the Black Mountains above the Olchon Valley near the Welsh Border. The build-up of ice was from the continuous spray from the waterfall, combined with a succession of freezing nights. The ice was 4–5cm thick in places.

FORTUNATO GATTO

Rattray Head in Winter
Aberdeenshire, Scotland

One morning, I decided to make the most of the adverse weather conditions being shaped by the strong winds. Using the Big Stopper filter, I managed to expose this image for about two minutes. The exposure time allowed me to register the movement of the clouds, the sea and the grass, made golden by the light, recording an ethereal atmosphere.

OMER AHMED

Milton Pond
Trossachs National Park, Scotland

For me the Trossachs National Park in winter is all about rolling mist and fog on a cold, still morning. This particular morning was as quiet as a monastery. Perfect.

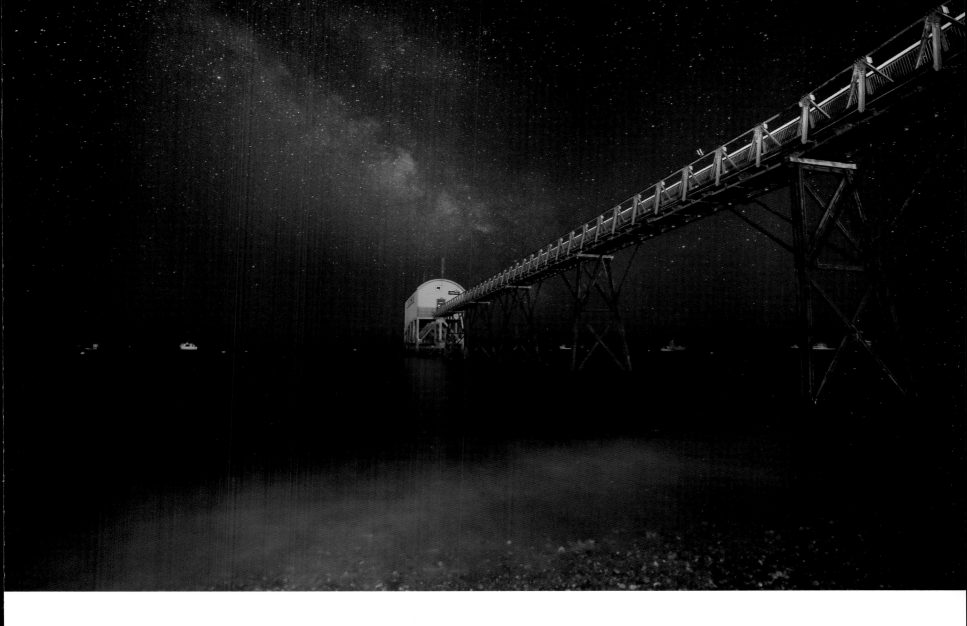

🔱 SIMON PARSONS

The Summer Milky Way
Selsey Bill, West Sussex, England

Selsey Bill is one of the best dark sky places along the South Coast, making it great for star gazing and astro photos. It made perfect sense to capture the summer Milky Way over the lifeboat station. The image was taken during a brief window of ideal conditions that lasted for only a few days before the moon influenced the sky and clouds rolled in.

GEORGE BARKER

Head of Barley (left) and Sea of Barley (above)
Nettleham, Lincolnshire, England

Drawn to the wave-like qualities of the barley, I experimented with longer exposures to try
to capture the motion of the scene.

ROWLEY TAYLOR

A Pheasant Walking Down a Track
Suffolk, England

I took this photograph in the early evening of 15 July 2012. The photo was taken on a track at a farm in Suffolk, next to a field of wheat. This farm is where I have lived for my whole life and I could never get tired of seeing the game birds and other wildlife moving around the land. The emphasis of the photograph is on the pheasant and the vivid red colour of the wattles on his face.

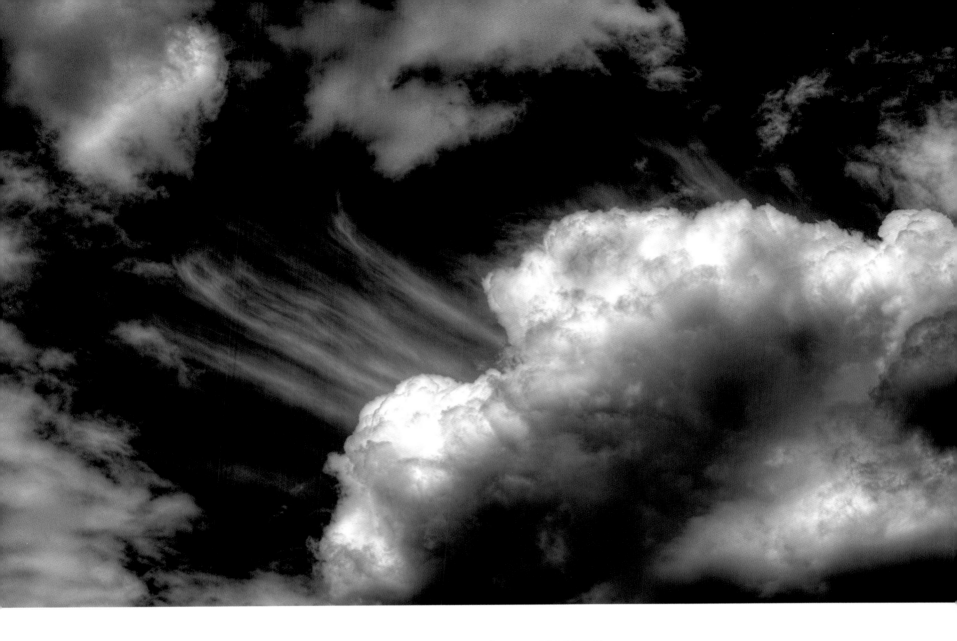

GEORGE BARKER

Cumulonimbus Cloud Formations
Southeast England

Clouds are one of my favourite things to photograph; you never have to walk far for a good view of the sky, and their formations are fascinating. Here, I took advantage of the contrast between the blue sky and white clouds with a mono conversion.

CATHY ROBERTS (p.3)
Canon EOS 40D with 18–200 IS lens. 1/160 sec, f/11. Two shots combined in Adobe Photoshop CS5, some dodging and burning, sharpening and a square crop.

KEVIN SKINNER (p.5)
Canon EOS 5D MkII with EF 28–70mm f/2.8 L USM @ 70mm. 1/2 sec, f/14, ISO100. Square cropped with minor tonal adjustments in Adobe Photoshop CS5.

CHRIS GILBERT (p.13)
Canon EOS 5D with 17–40mm L @ 17mm. 1/6 sec, f/20, ISO50.

DAVID BYRNE (p.16)
Nikon D700 with Nikkor 24–70mm f/2.8 lens, 1/80 sec, f/16, ISO200, Heavy B&W processing.

STEPHEN COLBROOK (p.19)
Canon EOS 450D with EF-S18–55mm f3.5–5.6 IS at 55mm. 2.5 sec, f/11, ISO 200. Converted to B&W during Raw conversion. Focus stacked in Adobe Photoshop to increase detail and cropped slightly.

GRAHAM HOBBS (p.20)
Pentax K10D with 18–55mm @ 50mm. 0.3 sec, f/22, ISO100. Rebalancing in Adobe Lightroom 3.6 to restore image to the way it was seen.

GETHIN THOMAS (p.22 top)
Canon EOS 1000D with EF-S 18–55mm IS lens @ 28mm. 1/100 sec, f/8, ISO100. Some sharpening, straightening, and contrast adjustments and slight crop.

ROHAN REILLY (p.22 bottom)
Canon EOS 450D with 50mm 1.8 II. 1/200 sec, f/8, ISO100. Hand-held. Very slight gradient and vignette added in Lightroom to draw the viewer into the mist.

MARK VOCE (p.23)
Panasonic Lumix DMC-GX1 with 14–45mm lens @ 14mm. 1/160 sec, f/5.6. Hitech 1.2 hard graduated ND filter.

MARTYN BUTTON (p.24 top)
Canon EOS 20D with 17–40mm f/4 L @ 40mm. 0.8 sec, f/8, ISO400. Tripod mounted with a cable release.

JACK BEESTON (p.24 bottom)
Sony Alpha 450 with 16–80mm Carl Zeiss lens @ 16mm. 10 secs, f/5.6, White balance: cloudy. Slight adjustments to saturation, brightness and exposure.

DAVID BREEN (p.25)
Canon EOS 5D MkII with TS–E 24mm f/3.5L II. Lee ND grad 0.6, Gitzo tripod and RRS ballhead. Three image panorama stitched in Adobe Photoshop CS6.

CLAIRE CARTER (p.26 top)
Canon EOS 5D MkII with EF 16–35mm F/2,8L II USM @ 16mm. 8 secs, f/10, ISO100. Detail reduced to give screenprint quality in Adobe Photoshop.

KASIA NOWAK (p.26 bottom)
Nikon D700 with Nikkor 70–300mm VR lens @ 300mm. 1/320 sec, f/8, ISO200.

HILARY BARTON (p.27 top)
Canon Powershot G12 at 30.5mm (equivalent of 140mm). 1/320 sec, f/4.5, ISO80. Cropping in Adobe Photoshop CS6 levels and colour vibrancy adjustments.

GRAHAM ROOSE (p.27 bottom)
Canon EOS 5D MkII with EF 24–105mm F4 IS USM lens @ 45mm. Exposure was 1/400 sec, f/4, ISO400. Highlights manipulated in Photoshop Elements 9 to make the train on the viaduct into a silhouette.

DAVID BYRNE (p.31)
Converted Nikon D200 with Nikkor 10–24mm f/2.8 lens, 1/60 sec, f/14, ISO400, B&W filter rated at 830nm.

SIMON PARK (p.32)
Nikon D3 with 70–200mm, 1/1000 sec, ISO 1000. Tonal and colour adjustments in Adobe Lightroom.

STEVEN HORSLEY (p.33)
Canon EOS 5D MkII with EF 70–200mm f/2.8 lens @ 145mm. 1/350 sec, f/5.6 + 1.5 EV, ISO200.

TONY SIMPKINS (p.34–35)
Canon EOS 40D with EF 24–105mm f/4 lens @ 24mm, 1/80 sec, f/8, ISO100, three images stitched.

PAUL KEENE (p.36)
Canon EOS 7D with 70–200mm f2.8 L IS @ 105mm. 1/125 sec, f/7.1, ISO200.

ANGUS CLYNE (p.37)
Canon EOS 5D Mk II @ 20mm. f/22, ISO50.

JOHN FINNEY (p.38)
Nikon D300 with 70–300mm f4.5–5.6 G AF–S VR IF–ED lens @ 165mm (247mm equiv.). 1/1000 sec, f/5.6. Exposure Bias -1 EV, ISO200, hand-held. Processed in Adobe Photoshop RAW.

KEN LESLIE (p.39)
Canon EOS 5D MkII with EF24–70mm f/2.8 lens at 70mm, 1 sec, f/16, ISO50, 0.9 soft ND grad, tripod.

CRAIG DENFORD (p.40–41)
Sony Alpha DSLR-A200 with 28–70mm lens @ 50mm. 1/2 sec, f/22, ISO100. 0.6 ND Grad. Stitched Panorama from 3 exposures.

LEE BEEL (p.42)
Canon EOS 5D MkII with EF 17–40mm lens @ 27mm. 1/15 sec, f/16, ISO100. Lee ND Grad filter. Manfrotto 190CXPRO3 tripod plus geared head.

ALUN DAVIES (p.43)
Canon EOS 5D Mk II with EF 16–35mm F2.8L @ 18mm. Exposure of 2 secs, f/19, ISO100. 0.6 ND grad, tripod and remote release. Processed via Adobe Camera Raw and Photoshop CS4 white balance adjusted and curves layer adjustment.

PETER RIBBECK (p.44)
Nikon D300 with Nikkor 18–200mm lens @ 170mm. f/11, ISO100. Saturation, sharpening and contrast adjustments in Adobe Photoshop.

HEATHER ATHEY (p.45)
Canon 400D with 18–55mm kit lens. 1/80sec, f/11, ISO200.

ADAM BURTON (p.46)
Canon EOS 1Ds MkIII with 24–70mm lens. 1/13 sec, f/16, ISO100.

ESEN TUNAR (p.47)
Canon EOS 5D Mark II with EF17–40mm f/4L USM @ 28mm. f/8, ISO400.

ROGER VOLLER (p.48)
Nikon D5100 with 70–300mm f/4.5–5.6 Nikkor Lens @ 195.0 mm. 1/250 sec, f/11, ISO200. Shot in RAW with general RAW processing to match view in lens. No localised edits.

KEVIN BLEASDALE (p.49)
Panasonic Lumix DMC-TZ5 @ 40.9mm. 1/200 sec, f/4.9, ISO100.

FORTUNATO GATTO (p.50–51)
Canon EOS 5D MkIII with Zeiss 21mm Distagon, NDG Reverse Filter plus Neutral Density, Tripod, Remote Control. Single Exposure. Level and colour adjustments using Adobe Camera Raw and Photoshop.

DUDLEY WILLIAMS (p.52)
Nikon D3x with 24–70mm lens @ 50mm. 1/2 sec, f/8, ISO100.

DAVID SMITH (p.53)
Canon EOS 5D MkII with 17–40mm lens @ 19mm. 1 sec, f/18, ISO125. Hoya ND4 filter.

JAMIE RUSSELL (p.54)
Nikon D300 with Sigma 17–70mm lens @ 34mm. f/16, ISO100. Lightning trigger.

LOUIS NEVILLE (p.55)
Nikon D90 with Nikkor 50mm lens. 1/15 sec, f/13, ISO200. Contrast and levels in Adobe Photoshop CS5.

ALEX NAIL (p.56)
Canon EOS 5D MkII with 17–40mm f/4 lens. 6 vertical frames, 3 stops of exposure bracketing.

IAN CAMERON (p.57)
Pentax 67II with 55–100mm zoom, 1/2 sec, f/22, Fuji Velvia 50, 0.45ND hard grad.

FORTUNATO GATTO (p.58)
Canon EOS 5D MkIII with Zeiss 21mm Distagon, NDG Reverse Filter, Polariser, Tripod, Remote Control. Single Exposure. Level and colour adjustments using Adobe Camera Raw and Photoshop.

BILL BARRACLOUGH (p.59)
Nikon D300 with Sigma 10–20mm. 1/13s and 1/50s (2 frames: 0EV and −2EV), f/11, ISO100. Lee 0.6 + 0.9 ND soft grads. RAW conversion and blend in Photoshop CS3.

ANDY AUGHEY (p.60)
Nikon D90 with Sigma 10–20mm f/4 lens @ 10mm. f/18, tripod.

IAN LEWRY (p.61)
Canon EOS 1DS MkIII with 17–40mm lens @ 36mm. 1/125 sec, f/10, ISO50. Tripod and a big pair of wellies on my feet.

JOHN HODDINOTT (p.62)
Canon EOS 5D MkII with EF24–105mm f/4L IS USM lens @ 45mm, 1/10 sec, f/16, ISO100, tripod and remote shutter release. Local contrast adjustments and dust spot removal carried out in Photoshop.

MIREK GALAGUS (p.63)
Nikon D800 with Nikkor 16–35mm f/4 lens @ 16mm. f/13, ISO100. Lee filter, remote control. Contrast slightly adjusted, shadows slightly recovered.

SUSAN BROWN (p.64)
Canon EOS 50D with EF 70–300mm f/4–5.6L @ 176mm. 1/100 sec, f/14, ISO100.

DUDLEY WILLIAMS (p.65)
Nikon D3x, 53 seconds, f/11, ISO100.

PADDY DYSON (p.66)
Canon EOS 5D with 17–40mm lens @ 17mm. 1/160 sec, f/13, ISO100. 3 stop ND graduated filter, tripod, shutter release.

PAUL MORGAN (p.67)
Canon EOS 5D Mk II with EF 17–40mm f/4 L USM @ 17mm. 2.5sec, f/16, ISO100. Three exposures manually blended in Photoshop to cover full dynamic range.

COLIN MILL (p.68)
Canon EOS 5D with Sigma 17–35mm lens @ 17mm. 1/15 sec, f/16, ISO100.

DAVID ROE (p.69)
Canon EOS 5D MkII with 17–40mm lens @ 40mm. 1/60th sec, f/4. Minimal post processing, just adjustments to levels, curves & saturation.

JOHN FANNING (p.70–71)
Canon EOS 1Ds MkII @ 28mm. 5 mins, f/18. Tripod, Remote Release, LEE 0.9 ND Graduated Filter, Hotshoe Spirit Level.

RICHARD THOMAS (p.72)
Canon EOS 5D MkII with 24–105mm lens @ 105mm. f/11 ISO100. Cropped to square format in Adobe Photoshop and checked for sensor spots, a few flies were removed from the sky with healing brush.

JOHN FINNEY (p.73)
Nikon D300 with 12–24mm f/4 G AF–S IF–ED DX lens @ 14mm. 1/5 sec, f/11, ISO100. Exposure Bias 0EV, Lee Filter 0.3 hard grad, spirit level. Processed in Adobe Photoshop RAW, sharpened.

DAVID WATERHOUSE (p.74)
Canon EOS 50D with Tamron 17–50mm f2.8. Bulb Mode: 29 seconds at f/2.8, ISO800, manual focus. Processed from RAW to JPG in Adobe Lightroom 3, then slight adjustments applied in Adobe Photoshop CS4.

STUART LOW (p.75)
Canon EOS 5D Mk II with Zeiss Distagon 21mm f/2.8. 1/15 sec, f/16, ISO 100.

GARY WAIDSON (p.76)
Canon EOS 5D with EF70–200mm f/2.8L IS USM, 4 secs, f/8, ISO100. Perspective correction and local contrast management in Adobe Photoshop.

GRAHAM McPHERSON (p.77)
Canon EOS 5D MkII with 17–40mm L @ 17mm. 2 sec, f/13, ISO100.

COLIN BELL (p.78)
Canon EOS 7D with EF 24–105mm f/4L IS USM @ 88mm. 1/20 sec, f/16. ISO125.

ADAM BURTON (p.79)
Canon 1Ds MkIII with 24–70mm lens. 6 secs, f/16, ISO100.

ANDREW WHEATLEY (p.80)
Canon 5D MkI with 17–40mm f4 L. 1/15 sec, f/13, ISO100. Lee .9 ND Grad, Tripod, Cable release. Slight adjustments to colour, contrast and levels in Adobe Camera Raw and Photoshop.

MATT WHORLOW (p.81)
Canon EOS 5D MkII with 17–40mm lens @17mm. 2.6 sec, f/16, ISO50. Polariser and 0.6 ND grad.

ALAN NOVELLI (p.82)
Nikon D3 with 70–200mm IF ED lens @ 180mm. 20 secs, f/8, ISO200. Manfrotto Tripod and Cable Release.

JOHN ROBINSON (p.83)
Nikon D3x with Nikkor 24mm PC-E. f/11, ISO100. Lee 0.3 and 0.6ND Graduated Filters. Remote release cable, tripod.

DAVID MOULD (p.84)
Samsung GX-10 with Sigma10–20mm @ 12mm, 1.0 sec, f/16, ISO100. Lee ND 0.2 filter, Manfrotto Tripod. Cropped in Adobe Photoshop, rain spots removed.

GREG COVINGTON (p.85)
Panasonic Lumix DMC-FZ28 @ 307mm, 1/250 sec, f/5.6, ISO100. Tripod. Adjustments in Adobe Photoshop to levels, sharpening and contrast.

ALASTAIR SWAN (p.86)
Canon EOS 5D 24–105mm @ 24mm. Approx 5 secs, f/20, ISO160.

SHINWOOK KIM (p.87)
Canon EOS 5D MkII with EF24–70mm f2.8L USM @ 32mm. Long exposure, f/8, ISO400.

SIMON ATKINSON (p.88)
Canon EOS 5D MkII with 17–40mm lens @ 17mm. 1/2 sec, f/16.

DAVID DUMMETT (p.89)
Canon EOS 5D MkII with EF 17–40mm f/4 L ISUSM lens @ 24mm, 129 secs, f/5, ISO400. Tripod and remote timer. A single shot with some adjustments to levels and curves.

ADAM BURTON (p.90)
Canon 1Ds MkIII with 16–35L II. 1/2 sec, f/16, ISO100.

PAUL NEWCOMBE (p.91)
Nikon D90 with Tamron 10–24mm @ 10mm. ISO100. RAW file processed in Adobe Camera RAW and Photoshop from two exposures.

SAMUEL BAYLIS (p.94)
Nikon D90. 3 secs, f/16, ISO200. Small adjustments to brightness, sharpening etc.

EMMA HOLLINGS (p.95)
Konica Minolta camera @ 40mm 1/250 sec, f/13. Minor digital adjustments to contrast in Adobe Photoshop.

PAUL BUNDLE (p.98–99)
Pentax K20D with DA 50–135mm f2.8 lens @ 135mm. 1/15 sec, f/16, ISO100. Polarising filter and a Lee 0.6 ND graduated filter. Raw image processed in Lightroom 3 with minor exposure adjustment.

LES BENNETT (p.100)
Nikon D300s with 70–300mm f/4–5.6 DL @ 78mm. 1/160 sec, f/5.6, ISO400. Converted from Raw and sharpened.

ROBERT MOWLE (p.101)
Cannon EOS 100 with Fuji Velvia. Slight increase in saturation even though Velvia gives good value!

CHRIS BEESLEY (p.102)
Pentax K100D Super 6 MP DSLR with Sigma 10–20mm lens @ 15mm. f/8, ISO200. Adjustments to contrast and sharpness.

DAVID BYRNE (p.103)
Nikon D700 with Nikkor 70–200mm f/2.8 lens. 1/800 sec, f/16, ISO200.

BILL CROOKSTON (p.104)
Canon PowerShot G11. 1/500 sec, f/4.5, ISO200. Darkened slightly across the foreground to improve composition.

NICK LIVESEY (p.105)
Samsung S760 @ 15mm. 1/180 sec, f/4, ISO80. Levels and white balance adjusted in Adobe Lightroom.

TATIANA ZIGAR (p.106)
Canon EOS 5D MkII with EF 50mm f/1.4 USM lens. 1/250 sec, f/6, ISO200.

KAYODE OKEYODE (p.107)
Canon 5D MkII with 50mm lens. 1/160 sec, f/2, ISO3200. Raw Image processed and cropped with Adobe Lightroom. Converted to B&W with a Lightroom plug-in, Alien Skin Exposure.

ROGER VOLLER (p.108–109)
Nikon D3100 with Nikkor 70–300mm f/4.5–5.6 lens @ 112mm. 1/60 sec, f/11, ISO 200. Shot in RAW and general RAW processing to match view in lens. No localised edits.

SAMANTHA JONES (p.110)
Canon EOS 5D Mk II with EF 15mm f/2.8 fisheye lens. 1/100 sec, f/20, ISO100.

NICK SHEPHERD (p.111)
Nikon D80 with Nikkor 18–200mm lens @ 95mm (equivalent of 142mm). 1/500 sec, f/11, ISO200.

RAY BEER (p.112)
Sony DSC-T9. 1/25 sec, f/3.5, ISO200. Adjusted in Adobe Photoshop CS4.

ANNA STOWE (p.113)
Canon EOS 1Ds MkII with EF 24–105mm f/4 lens @ 105mm, 1/10 sec, f/11, ISO100. Colour balance, levels and curves adjusted in Adobe Camera Raw and Photoshop.

IAN LAMOND (p.114)
Nikon D3 with Nikkor 24–70mm lens @ 60mm. 5.0 secs, f/20, ISO250.

PAUL WILSON (p.115)
Nikon D2x with 70–200mm f2.8 lens @105mm. 1/500 sec, f/6.3, ISO100. Shot in RAW, processed using Adobe Photoshop CS5 with minor adjustments to levels, contrast and saturation.

BOB McCALLION (p.116)
Olympus E520 with Zuiko 70–300mm lens @ 149mm. 1/50sec, f/14, ISO400, tripod. Brightness, contrast and sharpness adjusted in Olympus Master 2 software. Selective 'burning-in' in Adobe Photoshop.

OMER AHMED (p.117)
Canon 5D MkIII with EF70–200L @ 95mm, 1/500 sec, f/11, ISO200. RAW file processed in Adobe Lightroom 4 and subtle sharpening using Niksoft Sharpener Pro.

PHILIP STEWART (p.118)
Canon EOS 450D with Sigma 10–20mm lens @ 10mm. Two exposures: 1.6 sec and 0.3 sec, f/14, ISO100.

PETER LAURENCE DOBSON (p.119)
Canon EOS 5D Mk II with 120mm lens. 1/320 sec, f/9.

MATT WOODS (p.123)
Kodak Easyshare Z1012 IS. 1/1000 sec, f/4.8, ISO250. No manipulation.

SIMON BUTTERWORTH (p.127)
Canon 1DS MkIII with Canon EF 400mm f5.6L USM. 1/100 sec, f/11, ISO200.

BILL TERRANCE (p.128)
Canon EOS 5D MkII with EF 24–105mm f/4L IS USM @ 50mm. 1/125 sec, f/8, ISO200.

ALEX HARE (p.130–131)
Nikon D200 with Tamron 17–50mm f/2.8 @ 50mm. 1/200 sec, f/5.6, ISO100.

STEPHEN CHUNG (p.132)
Nikon D300 with Nikkor 18–70mm f/3.5-4.5 @ 18mm. 41 secs, f/16, ISO200. Processed in Adobe Lightroom.

GILES McGARRY (p.133)
Nikon D300 with 50mm lens. 1.6 secs, f/2.8, ISO200. Converted to mono in Adobe Photoshop CS5 and Silver Efex Pro 2.

ROSALIND FURLONG (p.134)
Canon EOS 5D MkII with 24–70mm f/2.8 L @ 70mm. 1/60 sec, f/11, ISO800. Edited in Adobe Lightroom with tone, presence and tone curve adjustments plus some sharpening and noise reduction.

RUSS BARNES (p.135)
Nikon D700 with 24mm f/3.5 PC-E (Tilt Shift). 1/500 sec, f/8, ISO200, Hand-held.

ION PACIU (p.136–137)
Canon EOS 5D MkII with 15mm f/2.8 fisheye lens. 1/20 sec, f/4.5, ISO1000. Hand-held.

KAREN ATKINSON (p.138)
Nikon D7000 with Nikkor 40mm f/2.8G AF-S DX Micro lens. 70 secs, f/22, ISO 100, B+W 106 ND filter. Processed in Adobe Lightroom and Photoshop CS5.

MIK DOGHERTY (p.139)
Panasonic Lumix DMC FZ38. 1/320 sec, f/5.6, ISO80. Raw file processed in Adobe Lightroom 4 with B&W conversion in Silver Efex Pro 2.

KATE BARCLAY (p.140)
Nikon D700 with 24–70mm f/2.8 lens @ 28mm. 1/25 sec, f/10, ISO200.

RADEK VIK (p.141)
Nikon D300 with 24–70mm f/2.8 lens @ 45mm. 1/160 sec, f/6.3, ISO400.

SLAWEK KOZDRAS (p.142–143)
Canon EOS 7D with EF50mm f/1.8 II lens. 1/10 sec, F/8, ISO800. No digital manipulation.

IAN BRAMHAM (p.144)
Nikon D700 with 70–300mm VR lens @ 125mm. 1/125 sec, f/5.6, ISO200. No adjustments apart from square crop and conversion of Raw file to B&W.

STU MEECH (p.145)
Nikon D300s with 18–70mm f/3.5-4.5 lens @ 18mm. f/8, ISO400.

IAN BRAMHAM (p.146)
Nikon D700 with 16–35mm VR lens @ 16mm. 2 mins, f/8, ISO200. Tripod. 6-stop ND filter. No digital manipulation.

DAVID BAKER (p.147)
Canon 5D MkII with 24–105mm lens at 35mm. 960 secs, f/16, ISO100. Lee 'Big Stopper' filter.

HOWARD KINGSNORTH (p.148–149)
Nikon D3x with 14mm f/2.8 lens. 1/2000 sec, f/2.8, ISO250.

IAN BRAMHAM (p.150)
Nikon D40 with Sigma 10–20mm lens @ 14mm. 3 mins, f/5.6, ISO200. Tripod. 2 x ND filters giving 16 stops of light reduction. No digital manipulation apart from straightening, minor crop and conversion to B&W.

RICHARD FRASER (p.151)
Canon EOS 5D MkII with EF 24–105mm L IS USM @ 24mm. 31 secs, f/8, ISO400, tripod, shutter release cable. Conversion to mono, curves adjustment.

GABRIEL DE SOUSA (p.155)
Nikon D80. Cropped and colour/contrast adjustments and minimal filtering during processing.

DAVID BAKER (p.158–159)
Canon EOS 5D MkII with 70–200mm f/4 @ 131mm. 0.6 secs, f/16, ISO100. Gitzo tripod and RRS ballhead.

ROBIN HEPBURN-EVANS (p.160)
Canon EOS 5D MkII @ 105mm. 1/800 sec, f/8, ISO250. No filters. Slight adjustments to contrast, light and sharpening in Adobe Photoshop Elements 7.

ANDREW COSWAY (p.161)
Canon EOS 5D MkII with 17–40mm f/4L USM at 17mm. 1/6 sec, f/16, ISO50, +1 1/3 EV, WB cloudy. No major manipulation other than raw conversion and a few tweaks.

SIMON BUTTERWORTH (p.162)
Canon 1Ds MkIII with TSE 24mm f3.5LII. 1/13 se, f/16, ISO100.

GRAHAM EATON (p.163)
Nikon D3 with 600mm f/4 lens. 1/1500 sec, f/4.8, ISO800.

GRAHAM COLLING (p.164)
Nikon 1 V1 with 10–30mm f/3.5-5.6 lens. 1/4 sec, f/8. Lee RF75 0.6ND Graduated Filter.

GRAHAM EATON (p.165)
Nikon D200 with 12–24mm lens. 1/125, f/11, ISO100. Sea & Sea underwater housing with 2 strobes.

STEPHEN EMERSON (p.166)
Canon EOS 5D Mk II with EF 17–40mm. 30 sec, f/6.3 for foreground, ISO800. Two separate exposures used to balance moon and sky. Merged in Adobe Photoshop CS5.

KERSTEN HOWARD (p.167)
Nikon D3x with Nikkor 16–35mm f/4 lens. 1/30 sec, f/11, ISO50. Lee ND grad filters used to hold back the sky. Reflections added in Adobe Photoshop.

ANTHONY WORSDELL (p.168)
Nikon D90 with Sigma 105mm lens. 1/4000 sec, f/2.8, ISO200. No manipulation other than slight levels adjustment and split toning in Adobe Lightroom.

SUSAN BROWN (p.169)
Canon EOS 5D MkII with 16–35mm F2.8L series @ 25mm with a 10-stop ND filter. 80 secs, f/14, ISO200. Minimal digital work. Colour balance corrected for filter, normal sharpening etc.

DAN SANTILLO (p.170–171)
Canon 5D MkII with TS-E 24mm f/3.5L. 1/60 sec, f/16, ISO100. Tripod, Polariser.

VALDA BAILEY (p.172)
NikonD800 with 70–200mm lens @ 200mm. 30 sec, f/16, ISO100. White balance, sharpening and contrast adjustment.

TONY GILL (p.173)
Canon 5D MkII with 24–105 mm lens @ 105mm. 10 secs, f/13, ISO100.

NICOLA WILDING (p.174)
Nikon D80 with 11–16mm f/2.8 lens @ 11mm. 1/1000 sec, f/5, ISO100. Adobe Photoshop sharpening and some levels adjustments.

PETER LAURENCE DOBSON (p.175)
Canon EOS 5D MkII with 17–35mm lens @ 17mm. 1/125 sec, f/5, ISO400.

JUSTIN MINNS (p.176)
Canon EOS 7D with 17–55mm f/2.8 IS @ 55mm. 20 secs, f/11, ISO100.

JOHN PARMINTER (p.177)
Nikon D300 with Sigma 17–70mm @17mm. 1/6 sec, f/11, ISO200. Lee 0.9 ND graduated filter. Tripod, cable release and spirit level. Minor local contrast adjustments and dust spot cloning.

MARTIN CHAMBERLAIN (p.178)
Canon EOS 40D with EF 24–105mm lens @ 105mm. 1/125 sec, f/4, ISO200. Hand held. Processed from Raw file in Adobe Lightroom.

HOWARD KINGSNORTH (p.179)
Nikon D3x with 14mm f/2.8 lens. 1/100 sec, f/5, ISO100.

ERIC BALDAUF (p.180)
Nikon D200 with Nikkor 18–70mm lens @ 31mm. 1/60 sec, f/9, ISO100.

DAVID WATERHOUSE (p.181)
Canon EOS 400D with Tamron 17–50mm f/2.8 lens @41mm. 74 secs, f/9, ISO100, B&W 10 Stop Filter. Two exposures (one sky, one cliffs) processed from Raw to Jpeg in Adobe Lightroom, then blended in Photoshop.

Omer Ahmed www.wytchwood.net

James Appleton www.jamesappleton.co.uk

Heather Athey www.heatherathey.com

Simon Atkinson www.SimonAtkinsonPhotography.co.uk

Karen Atkinson www.photomuso.co.uk

Andy Aughey www.landscapeandlightphotography.com

Valda Bailey www.valdabailey.co.uk

David Baker (p.147) www.davidbakerphotography.co.uk

David Baker (p.158–9) www.milouvision.com

Kate Barclay www.katebarclay.co.uk

George Barker www.barkerphotography.wordpress.com

Russ Barnes www.russbarnes.co.uk

Danny Beath www.flickr.com/photos/flickering_velvet

Lee Beel www.lee-beel-photography.co.uk

Chris Beesley www.flickr.com/fancithat

Colin Bell www.lakemoments.com

Ian Bramham www.ianbramham.com

David Breen www.nelight.co.uk

Stephen Briant www.glasseyephotos.co.uk

Jean Brooks www.jeanbrooksphotography.co.uk

Susan Brown www.susanbrownphotography.co.uk

Paul Bundle www.paulbundle.com

Adam Burton www.adamburtonphotography.com

Simon Butterworth www.simonbutterworthphotography.com

David Byrne www.85mm.co.uk

Ian Cameron www.transientlight.co.uk

Donald Cameron www.monophotography.co.uk

Claire Carter www.carterart.co.uk

Martin Chamberlain www.martinchamberlain.com

Stephen Chung www.wasabiphoto.zenfolio.com

Angus Clyne www.angusclyne.co.uk

Graham Colling www.grahamcolling.com

Andrew Cosway www.andrewcoswayphotography.weebly.com

Bill Crookston www.billcrookston.com

Alun Davies www.alundaviesphotography.co.uk

Gabriel de Sousa www.gabrieldesousa.com

Craig Denford www.craigdenfordphotography.co.uk

Peter Laurence Dobson www.plaurence.co.uk

Mik Dogherty www.mikdoghertyimages.com

David Dummett www.davedummettphotography.co.uk

Paddy Dyson www.paddydyson.com

Graham Eaton www.eatonnature.co.uk

Stephen Emerson www.captivelandscapes.com

John Fanning www.johnfanning.co.uk

John Finney www.johnfinneyphotography.com

Richard Fraser www.richardfraserphotography.co.uk

Rosalind Furlong www.rosalindfurlong.com

Edward Fury www.edwardfury.co.uk

Fortunato Gatto www.fortunatophotography.com

Chris Gilbert www.ravenseyegallery.co.uk

Tony Gill www.tonygillimages.com

Mike Green www.mikegreenimages.com

Alex Hare www.alexharephotography.com

Robin Hepburn-Evans www.flickr.com/photos/tornadooo

Steven Horsley www.stevehorsley.com

Kersten Howard www.khowardphotography.com

Barry Hutton www.lakescape.co.uk

Samantha Jones www.islandscapephotography.co.uk

Paul Keene www.avico.co.uk

Brian Kerr www.briankerrphotography.com

Shinwook Kim www.shinwookkim.com

Howard Kingsnorth www.howardkingsnorth.com

Slawek Kozdras www.slawekkozdras.com

Ian Lamond www.ianlamond.co.uk

Ken Leslie www.kenlesliephotography.co.uk

Dominic Lester www.dominiclester.com

Nick Livesey www.nickliveseymountainimages.co.uk

Stuart Low www.stuartlowphotography.co.uk

Giles McGarry www.kantryla.net

Brian McMeechan www.brianmcmeechanphotography.co.uk

Graham McPherson www.grahammcpherson.com

Stu Meech www.flickr.com/photos/stumeech

Colin Mill www.colinemill.co.uk

Justin Minns www.justinminns.co.uk

Paul Morgan www.blurredvisionz.com

David Mould www.davidmould.co.uk

Robert Mowle www.robertmowle.com

Alex Nail www.alexnail.com

Louis Neville www.500px.com/LouisNeville

Paul Newcombe www.paulnewcombephotography.co.uk

Alan Novelli www.alannovelli.co.uk

Kasia Nowak www.kasianowak.com

Kayode Okeyode www.flickr.com/photos/kayodeok

Ion Paciu www.photoion.co.uk

Simon Park www.simonparkvisions.co.uk

John Parminter www.viewlakeland.com

Simon Parsons www.sussexlandscapephotography.co.uk

Rohan Reilly www.rohanreilly.com

Peter Ribbeck www.flickr.com/PeterRibbeck

Cathy Roberts www.cathyrobertsphotography.co.uk

John Robinson www.johnrobinsonphoto.com

David Roe www.davidroephotography.com

Dan Santillo www.dansantillo.com

David Sharp www.sharpimage.net

Nick Shepherd www.southdevonphotos.co.uk

Kevin Skinner www.kevinskinnerphotography.com

Philip Stewart www.pstewartphotography.com

Anna Stowe www.annastowephotography.co.uk

Alastair Swan www.uglyducklingimages.co.uk

Jason Theaker www.jasontheaker.com

Richard Thomas www.richardthomasphotography.co.uk

Gethin Thomas www.gethinsart.co.uk

Esen Tunar www.esentunar.com

Radek Vik www.vikphotography.com

Mark Voce www.markvoce.com

Roger Voller www.rogervollerphotoart.com

Gary Waidson www.waylandscape.co.uk

David Waterhouse www.davidwaterhouse.co.uk

Andrew Wheatley www.andrewwheatleyphotography.com

Matt Whorlow www.Matt-Photo.co.uk

Nicola Wilding www.flickr.com/photos/nicwilding

Dudley Williams www.dudleywilliams.com

Paul Wilson www.paulanthonywilson.co.uk

Scott Wilson www.flickr.com/photos/wilsonaxpe

Tatiana Zigar www.tatianazigar.com